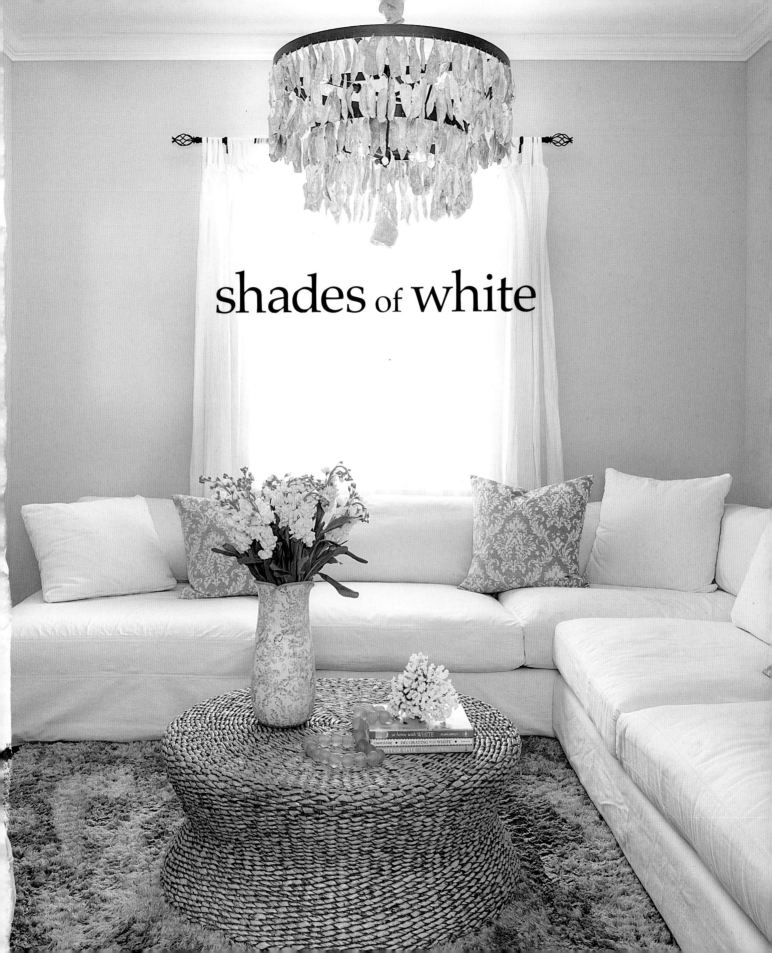

shades of white

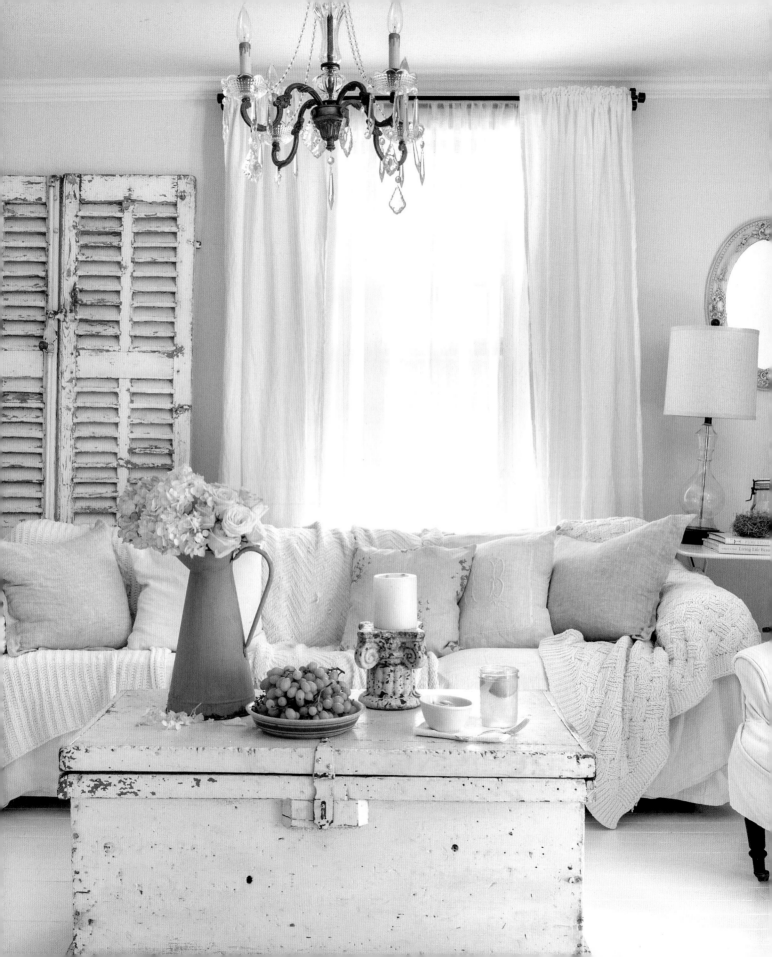

shades of white

SERENE SPACES FOR EFFORTLESS LIVING

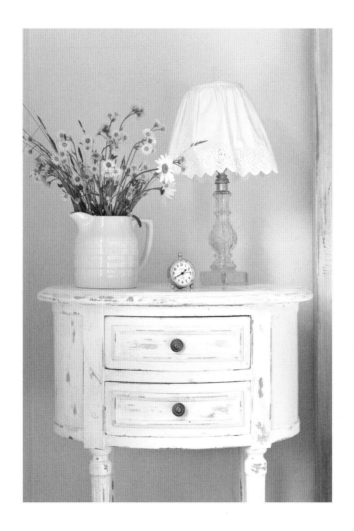

fifi o'neill
photography by mark lohman

CICO BOOKS
LONDON NEW YORK

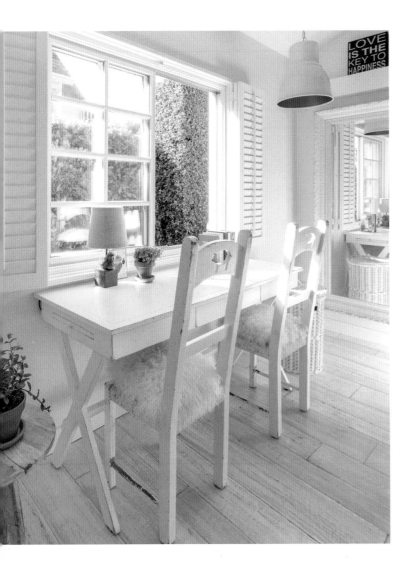

Published in 2021 by CICO Books
An imprint of Ryland Peters & Small Ltd

20–21 Jockey's Fields 341 E 116th St
London WC1R 4BW New York, NY 10029

www.rylandpeters.com

10 9 8 7 6 5 4 3 2

A CIP catalog record for this book is available from the Library
of Congress and the British Library.

ISBN: 978 1 80065 060 2

Printed in China

Photographer: Mark Lohman
Editor: Martha Gavin
Art director: Sally Powell
Production manager: Gordana Simakovic
Publishing manager: Penny Craig
Publisher: Cindy Richards

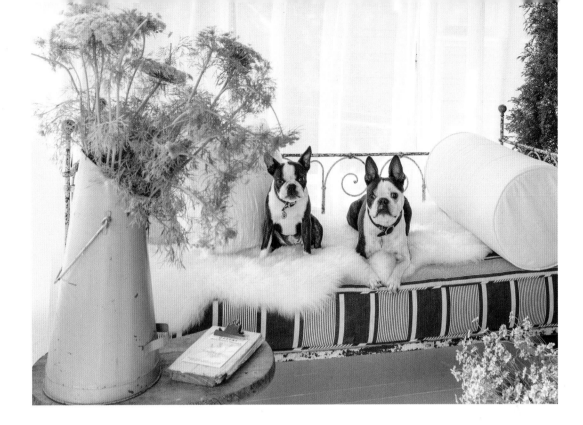

CONTENTS

Introduction 6

"The first of all single colors is white. We shall set down white for the representative of light, without which no color can be seen."

Leonardo da Vinci

INTRODUCTION

WHITE HAS LONG INSPIRED VISIONS OF SERENITY AND EFFORTLESS ELEGANCE. LIKE A CHAMELEON, IT HAS THE UNCANNY ABILITY TO MORPH INTO MANY SHADES FROM EARTHY TO ICY WITH MANY NUANCED HUES IN BETWEEN. SIMPLY PUT, IN ALL ITS INCARNATIONS, WHITE IS MAGICAL.

WHETHER AS A BACKDROP OR ON FURNISHINGS, MUTED PALETTES AND SUBTLE SHADES RESULT IN SOOTHING AND STYLISH SPACES THAT LEND THEMSELVES TO ENDLESS DECORATING POSSIBILITIES. THERE ARE HUNDREDS OF SHADES OF WHITE. EVERY COLOR IN THE SPECTRUM HAS A WHITE VERSION WITH UNDERLYING FAINT HINTS OF TONALITY, EACH WITH ITS OWN UNIQUE BEAUTY. FROM FEMININE PASTELS TO EARTHY TONES AND UNDERSTATED NEUTRALS, WHITE IS NIMBLE, TIMELESS, AND ADAPTABLE TO ANY STYLE, WHETHER IT BE RUSTIC, MODERN, ROMANTIC, VINTAGE, OR CLASSIC. IT PAIRS EQUALLY WELL WITH PERIOD OR ECLECTIC FURNISHINGS AND ACCESSORIES, AND EASILY MAKES FRIENDS WITH OTHER COLORS.

THE HOMES FEATURED IN THIS BOOK EMBRACE THE ETHEREAL QUALITY SHADES OF WHITE IMPART TO INTERIORS, AND DEMONSTRATE WHY THE PEACEFUL HUE'S SOOTHING GRACE AND TRANQUIL CHARMS MAKE IT A PERENNIAL FAVORITE THE WORLD OVER.

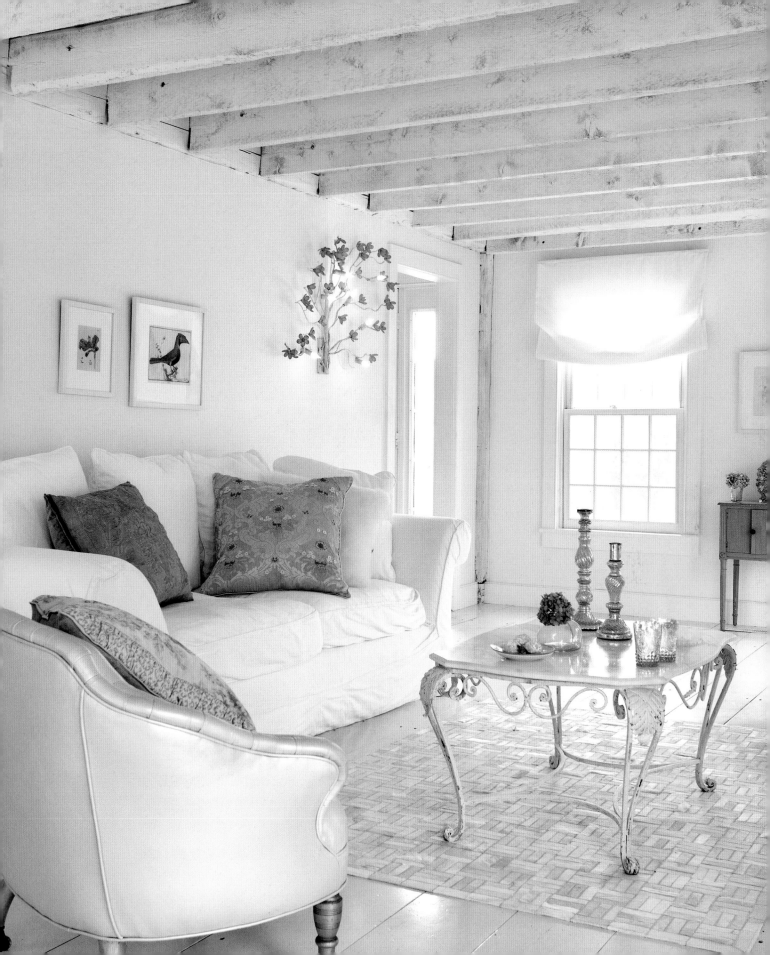

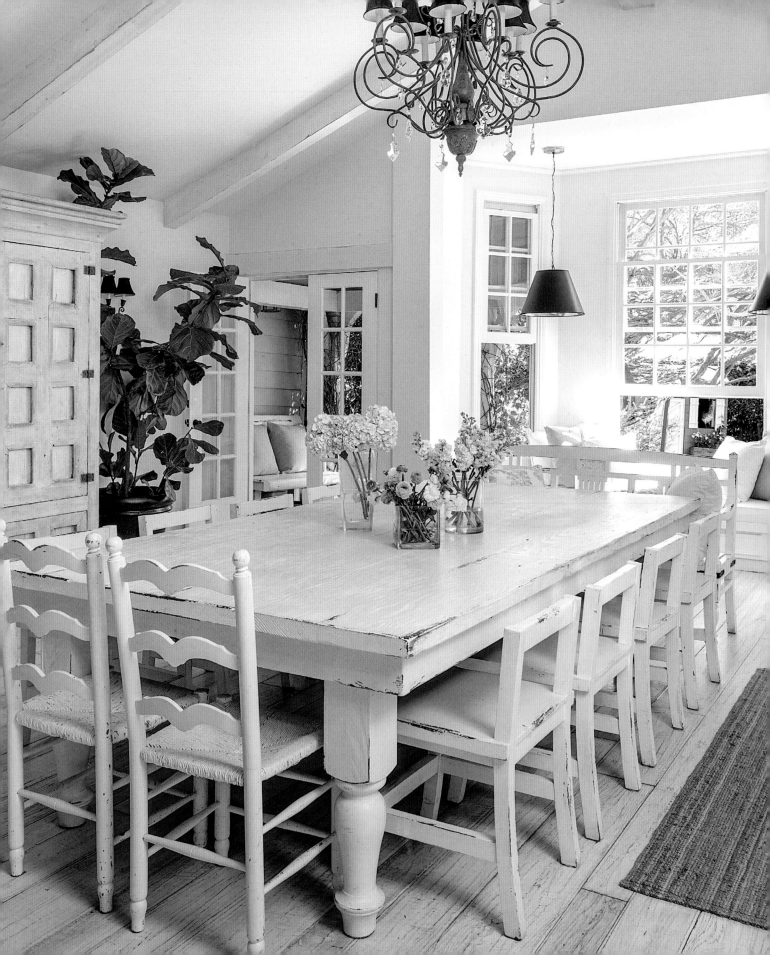

PART 1 INSPIRATIONS

THE POWER OF WHITE

A NEUTRAL PALETTE OF COOL WHITES MAXIMIZES LIGHT AND SPACE
AND, WHEN LAYERED WITH TEXTURES AND TONE-ON-TONE HUES,
CREATES A COCOON-LIKE CANVAS, MAKING IT EFFORTLESS TO USHER
IN SUBTLE COLOR ACCENTS AND UNIFY ECLECTIC FURNITURE.

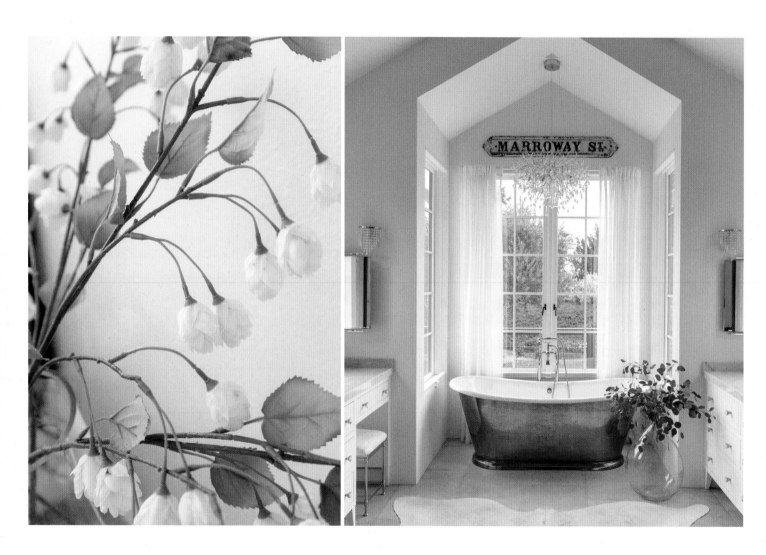

ABOVE White is a classic symbol of purity.
Delicate clusters of nodding blossoms never
fail to make a space feel tranquil and magical.

ABOVE Nature and light frame an
intimate alcove where whites and
a silver soaking tub up the spa-like
atmosphere of a pristine bathroom.

OPPOSITE Gleaming whites and
mixed materials give this minimalist
landing its harmonious appeal.

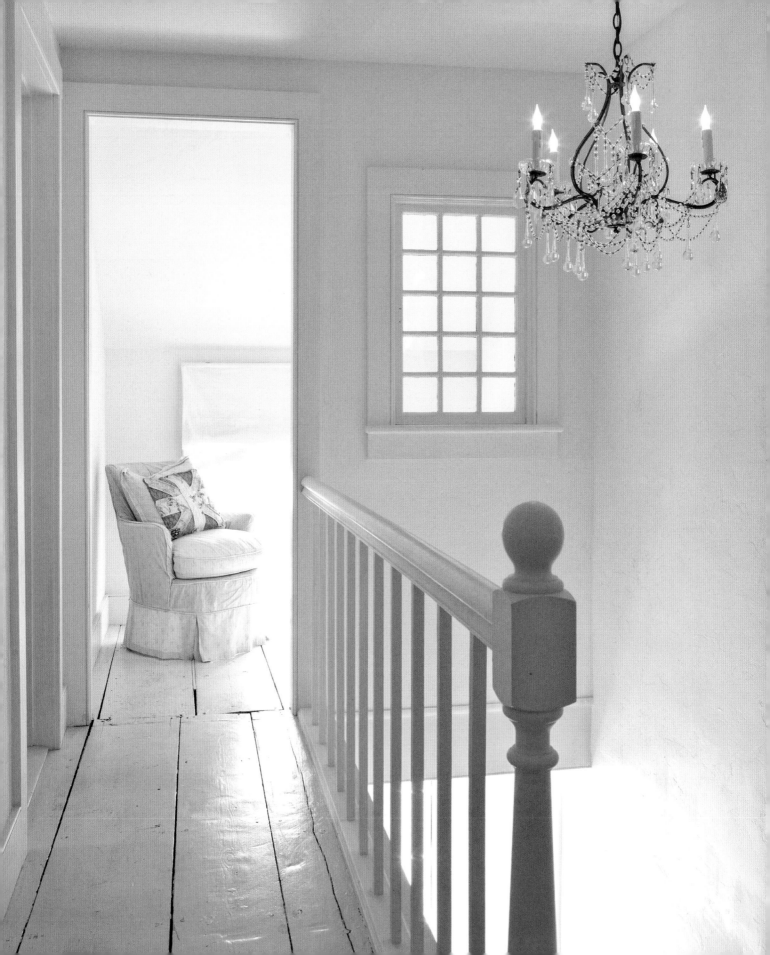

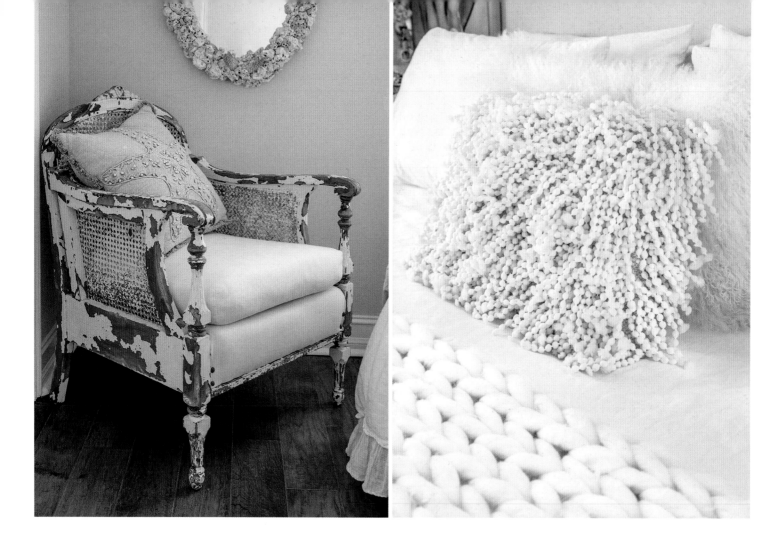

TEXTURES

IN FINISHES, FABRICS, AND DESIGN ELEMENTS, TEXTURES
THAT BEG TO BE TOUCHED PLAY A STARRING ROLE IN
KEEPING WHITES WARM AND INVITING. LAYERING TEXTILES,
WOVEN RUGS, WOODS, BOOKS, ORGANIC ACCESSORIES,
ARCHITECTURAL ITEMS, SEAGRASS, AND RATTAN BRINGS
INSTANT INTEREST, HEIGHTENS THE COZINESS QUOTIENT
OF ANY ROOM, AND CONTRIBUTES CALM, SERENITY, AND
A WARM WELCOME. TEXTURE IS NOT ALWAYS ABOUT MATERIAL.
PATTERNS CAN ALSO ADD A VISUAL DIMENSION BUT, AS
WITH OTHER DECORATING COMPONENTS, BALANCE IS KEY.

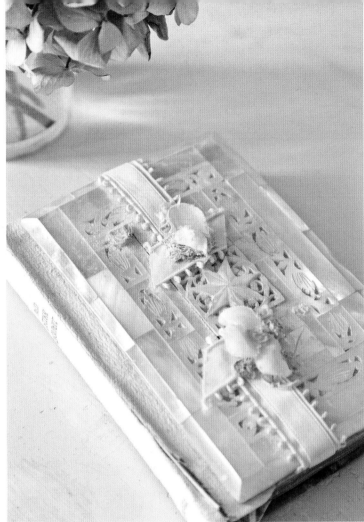

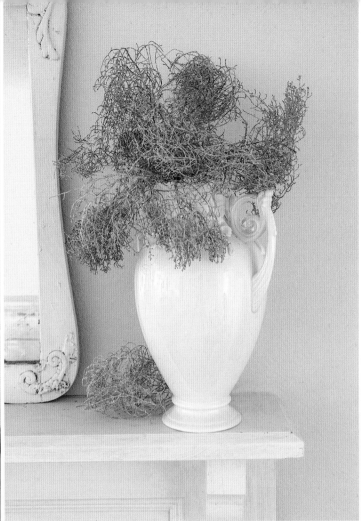

OPPOSITE LEFT When paint naturally loosens itself from a surface it reveals the character and age of the item. Although practicality requires the paint to be replaced, aesthetics allow it to continue its beautifully textural decay.

OPPOSITE RIGHT Combining different textiles, materials, shapes, and sizes is a great and easy way to show depth. Mixing knits, fabrics, faux fur, and more produces an organic, lived-in vibe. Here, white in shades of ivory, wax, and milk, is the unifying factor for linen, cotton, faux fur and shaggy pillows, and a chunky, creamy knitted throw.

ABOVE LEFT Bleached leather, beautiful and intricate carvings on the Bakelite cover, and snippets of vintage ribbons and flowers give this handmade prayer book its eloquent beauty.

ABOVE RIGHT Contrasting elements are proof that opposites attract. Function and form come together in the lustrous smoothness of the vase and the organic disheveled appearance of remnants of dried twigs. Each element amplifies the finish and texture of the other.

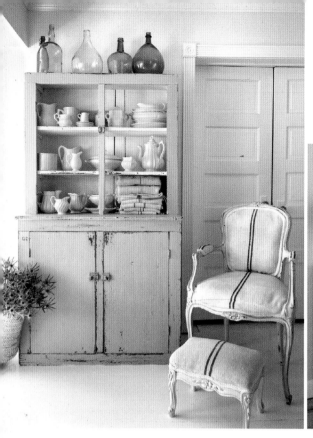

FAR LEFT Pairing a chair upholstered in antique grain sack with a simple hutch in a dove gray weathered finish sets an air of rural ease.

LEFT Aesthetically appealing carvings give a new and simple wood cabinet a subtly exotic vintage charm that makes it an eye-catching piece.

BELOW An imposing floor mirror's rectangular form is cleverly disguised by the intricate frame's baroque carvings that give it a bold dose of character. The tarnished-gold finish exudes an age-old sophistication.

FURNISHINGS

JUST LIKE TEXTURES, FURNITURE IS AN INTEGRAL ELEMENT THAT DEFINES THE AESTHETIC AND FEEL IN PREDOMINANTLY WHITE INTERIORS. ORNATE DETAILS AND ELABORATE CARVINGS GIVE OLD WORLD PIECES THEIR UNIQUE PRESENCE; FLUID AND POLISHED ITEMS DEFINE MODERNITY; PAINTED FURNISHINGS DRESSED IN EASY- GOING TEXTILES CHARACTERIZE COTTAGE INTERIORS; AND HANDMADE, NATURAL COVERINGS AND RAW SURFACES EVOKE RUSTICITY.

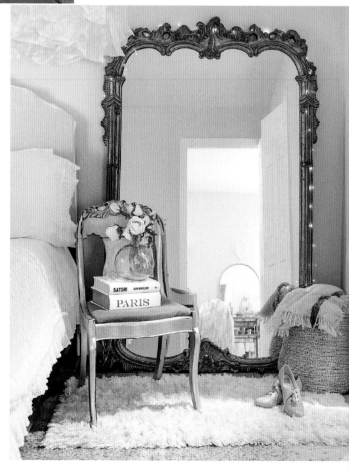

OPPOSITE A French buffet's artisanal simplicity, shape, and beautifully aged surface take center stage in this neutral space. The elegant lines of the mirror and the small table strike a pleasing counterpoint with the rustic piece.

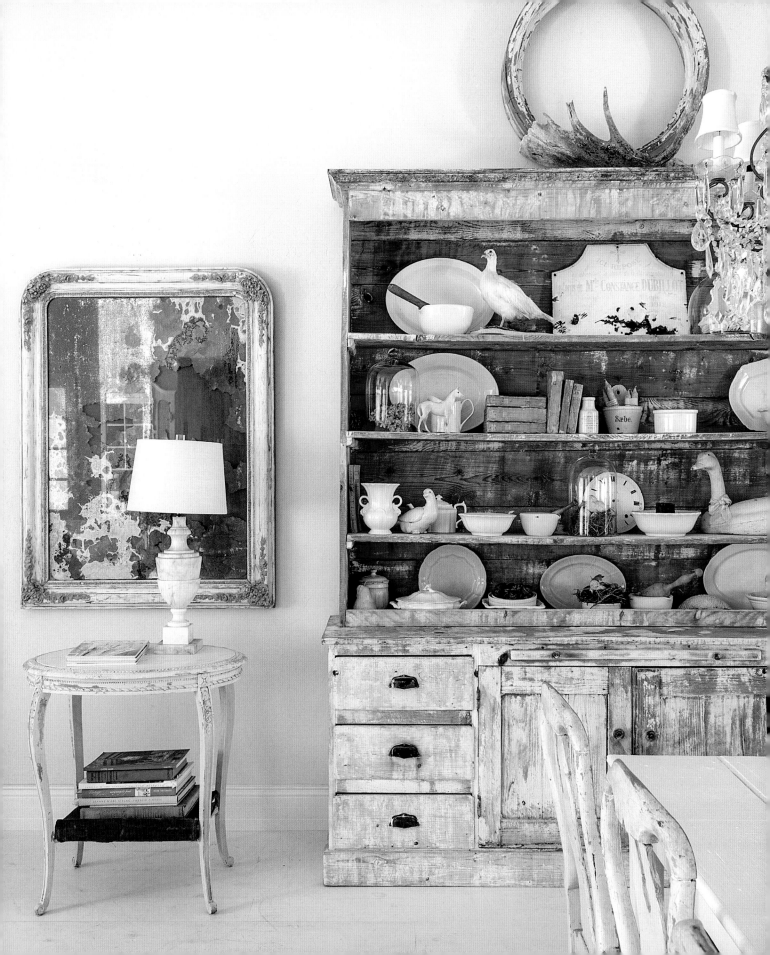

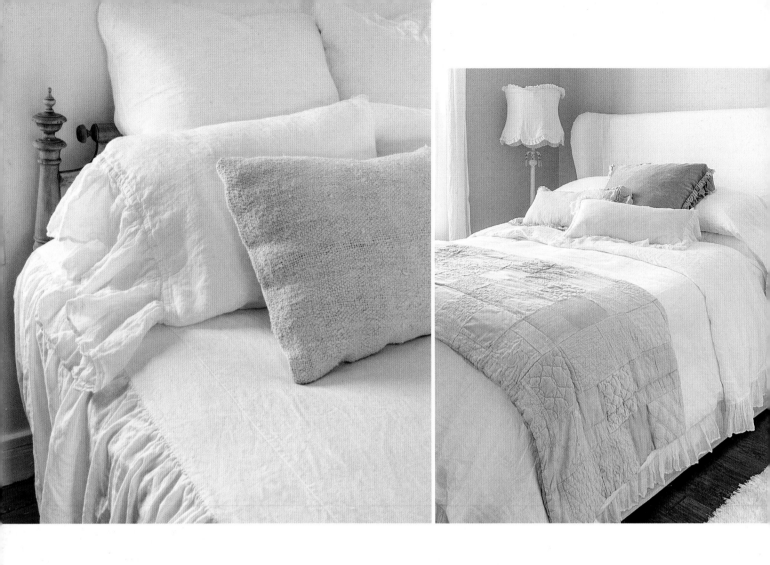

FABRICS

FROM NATURAL TO SYNTHETIC FIBERS AND KNITTED
TO WOVEN PIECES, FABRICS HAVE COUNTLESS QUALITIES
AND APPEARANCES RANGING FROM STURDY TO DELICATE,
ETHEREAL TO COZY, AND MANY MORE VARIATIONS. USING
A COMBINATION OF TEXTILES GIVES A ROOM A CURATED
FEEL. LINEN, COTTON, AND CANVAS HAVE A TACTILE QUALITY
WHILE CASHMERE, SILK, AND LACE IMPLY SOPHISTICATION.
SHEEPSKIN, CHENILLE, AND WOOL ARE ALL ABOUT COMFORT.
WITH ITS UNEVEN GRAIN, DISTRESSED LEATHER ADDS WARMTH,
WHILE FLUFFY FUR EQUATES WITH SOFTNESS, ALTHOUGH IF
YOU'RE A TRUE ANIMAL LOVER, GO STRICTLY FAUX.

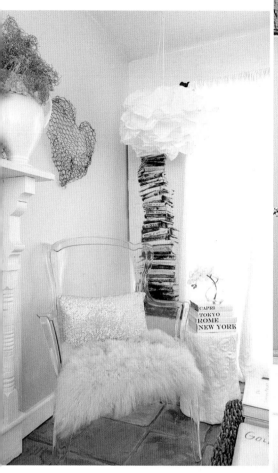

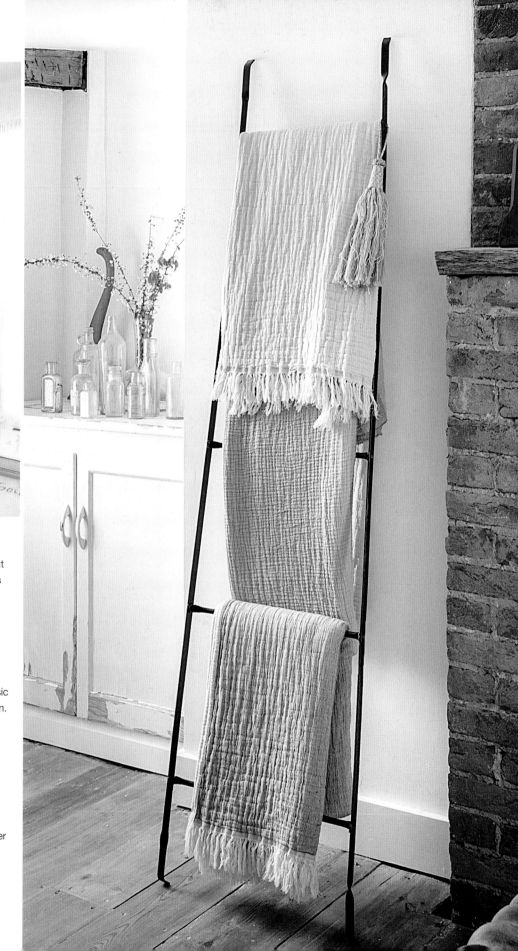

OPPOSITE LEFT White is the common thread unifying a bedspread and pillows, but a variety of linen blends and weavings gives each item its distinctive characteristics.

OPPOSITE RIGHT Blue and white is a much-loved combination that evokes the unfussy charm of coastal cottages and farmhouses. Blue and white are like soul mates: they are always in sync, inspiring classic elegance and celebrating modern romanticism.

ABOVE The unexpected pairing of fabrics from fluffy dusty-pink faux fur with shimmering satin and glamorous sequins creates a rich visual and sensual mix that brings about a stylish approachability.

RIGHT Whether hung from a rack, draped over a chair, laid on the end of a bed, or tossed artfully on the arm of a sofa, throws and blankets contribute a homey, layered look.

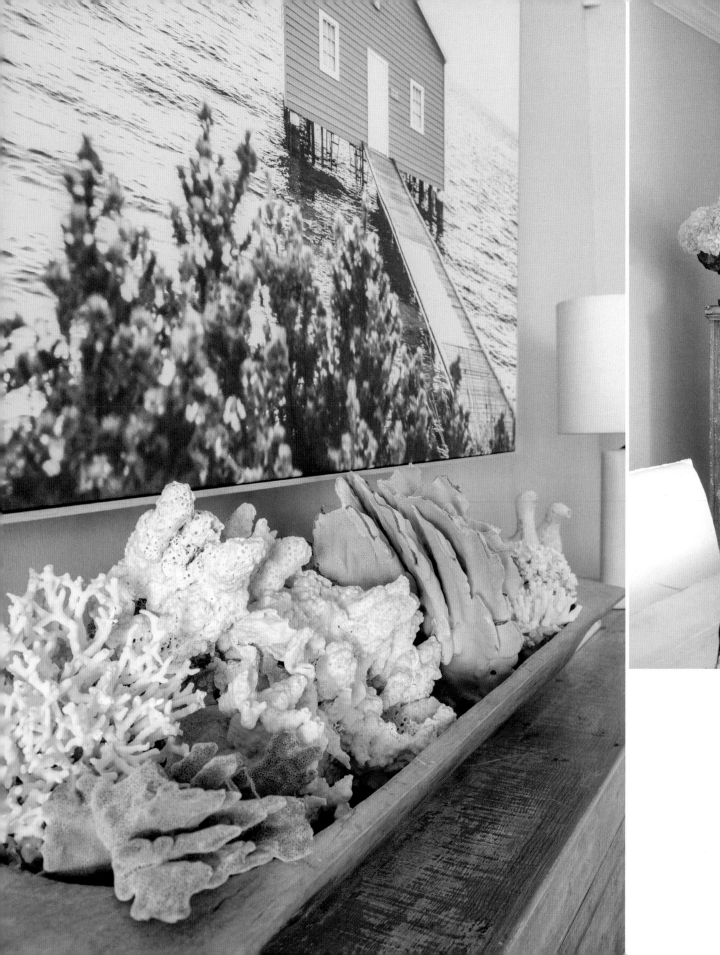

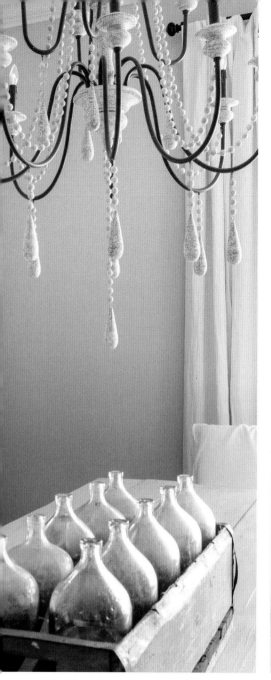

ACCESSORIES

NEUTRAL ROOMS ARE NATURALLY CALMING, BUT WITHOUT THE PROPER ACCESSORIES THEY CAN MISS THE SWOON-FACTOR. THE RIGHT ITEMS CAN SET THE MOOD, ADDING CONTINUITY AND CHARACTER TO A WHITE SCHEME AND A FASHION-FORWARD ALLURE TO MORE LAID-BACK ROOMS. ACCESSORIES CAN SHARE SIMILAR FINISHES, SHAPES, OR MATERIALS, BUT WHEN IT COMES TO WHITE INTERIORS, KEEPING A NEUTRAL TONALITY IS BOTH STYLISH AND DYNAMIC.

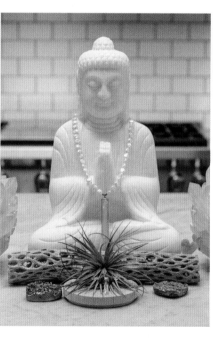

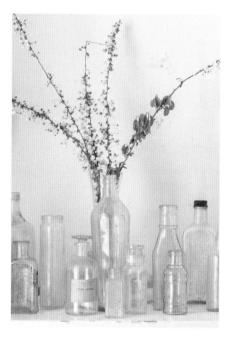

OPPOSITE If you live by the sea (or wish you did) coral, shells, and other beachcombed accents paired with coastal art in the same color family hit all the right notes.

ABOVE Relics from the past evoke nostalgia. They are a meaningful reflection of treasured items and locations. Combining elements of complementary color, shape, texture, and style is key to a display with artistic flair.

ABOVE Religious and cultural symbols have become inclusive decorating elements in interiors and are often considered artistic interpretations. The iconic Buddha is believed to bring good luck and prosperity. Its peaceful presence adds a tangible sense of serenity, harmony, and balance.

ABOVE Decorating with collections is a quick and easy way to add panache and personality to a space. There is power in numbers as showcased in this curated assortment of vintage bottles. Keeping the palette subdued in the display of varying sizes and shapes gives the grouping its rhythm and makes it visually pleasing and effective.

ART

MUTED WALLS ARE GALLERIES, READY AND
PERFECTLY SUITED TO SHOW OFF ART LIKE
PHOTOGRAPHS, PAINTINGS, CANVASSES, POSTERS,
TAPESTRIES, MURALS, WALL HANGINGS, AND
ARTFUL OBJECTS OF SIMILAR VALUE LIKE BASKETS
OR PLATTERS. ALTHOUGH THERE ARE SOME RULES
OF SCALE, BALANCE, AND PROPORTION, THERE IS
NO REASON TO SACRIFICE USING WHAT YOU LOVE.

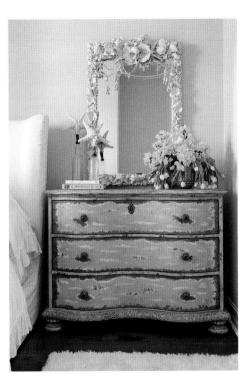

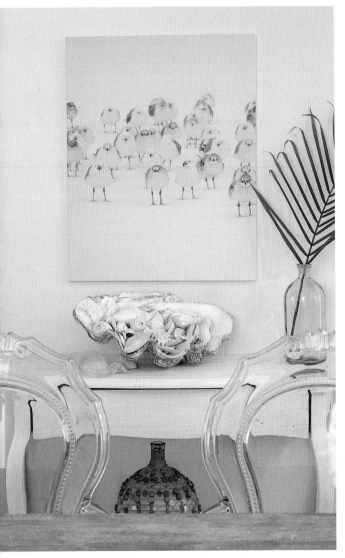

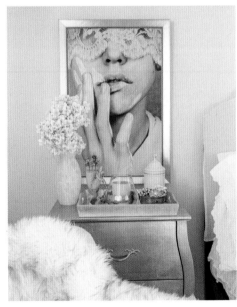

LEFT The innovation of canvas prints has created unique and inexpensive decorating options and a great alternative to generic prints. A favorite photograph—cityscapes to country lanes, beach scenes, and more—offers the possibility to personalize a wall with one-of-a-kind pieces of art.

ABOVE RIGHT Mirrors do more than amplifying light and making rooms appear larger. Shapes, sizes, and materials offer a plethora of decorating styles. The intricate design of this shell-encrusted frame adds an artful vibrancy, a dash of glamour, and a sense of intrigue.

RIGHT The right artwork injects personality into a space. A portrait in soft shades of pale gray and barely-there pink brings visual intrigue to a feminine bedroom.

OPPOSITE An artful display gets a cohesive look using a monochromatic palette that unifies layers of elements with disparate materials and finishes and significant, meaningful items. Here, words to live by take center stage. Art is in the heart of the beholder.

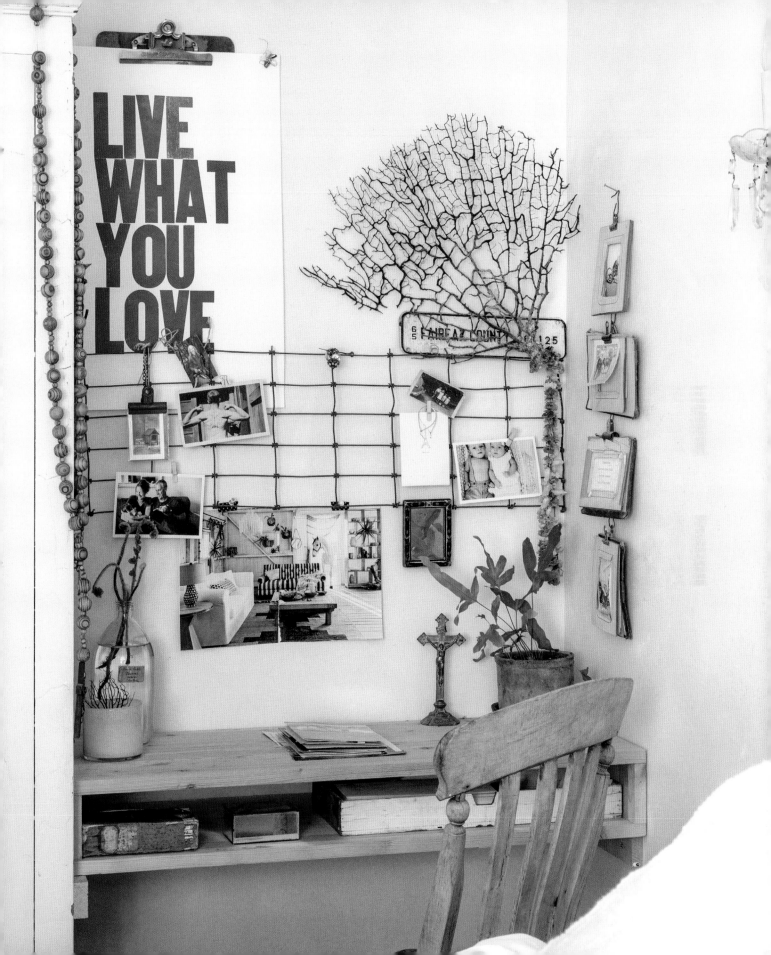

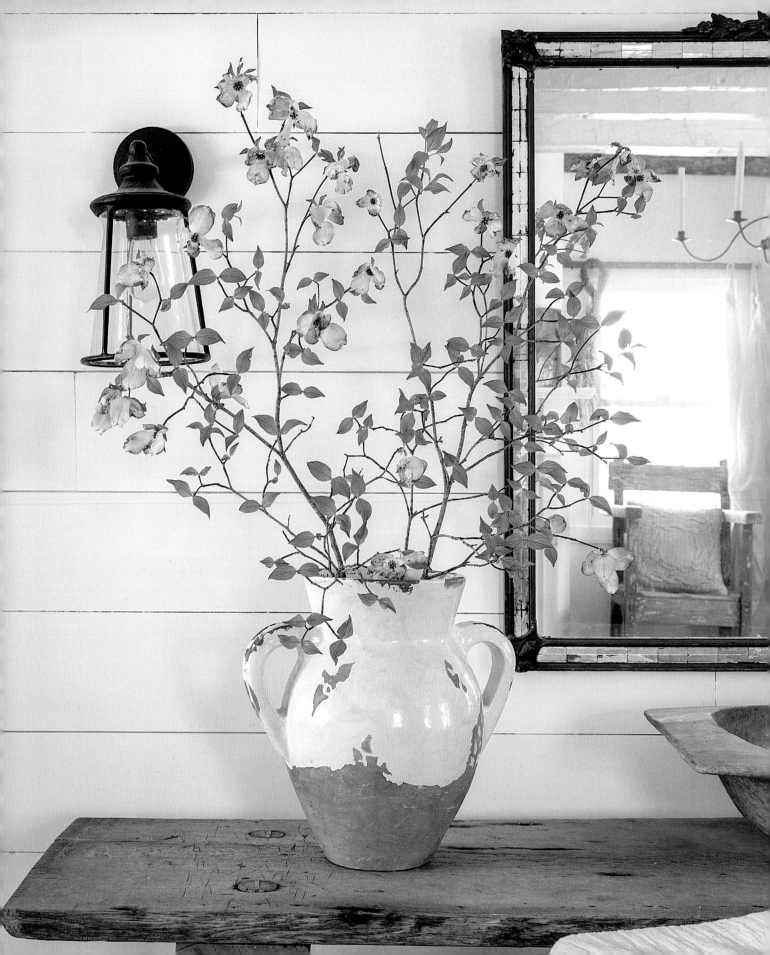

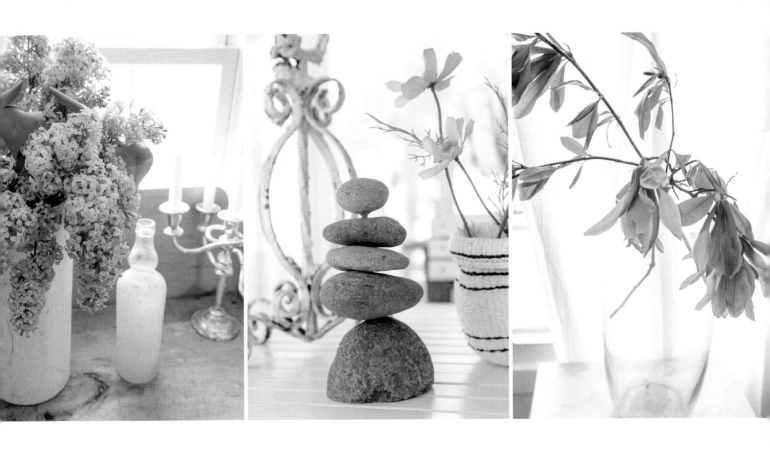

FINISHING TOUCHES

**EVERY HOME, REGARDLESS OF STYLE, NEEDS
ELEMENTS THAT GIVE IT PERSONALITY AND SOUL.
THESE LITTLE TOUCHES MAKE IT LOOK, WELL,
FINISHED. FRAGRANT CANDLES, SOFT LIGHTING,
CUSHY RUGS, SHEER CURTAINS, AND MORE ALL
COME INTO PLAY, BUT NOTHING HAS MORE IMPACT
THAN FLOWERS IN POLISHING A ROOM AND
BRINGING A SPACE ALIVE.**

OPPOSITE An artisanal urn's shape and finish make a perfect foil for the graphic elegance of lofty flowering branches.

ABOVE LEFT Lush lilacs spilling out from a simple bucket add subtle color, heady fragrance, and natural beauty to any room.

ABOVE CENTER In true wabi-sabi fashion a rusty candelabra, a stack of rocks, and dainty daisies acknowledge that while nothing is perfect, everything is beautiful in its own way.

ABOVE RIGHT A clear vase allows exquisitely hued blossoms to breathe life and romance into a bedroom corner.

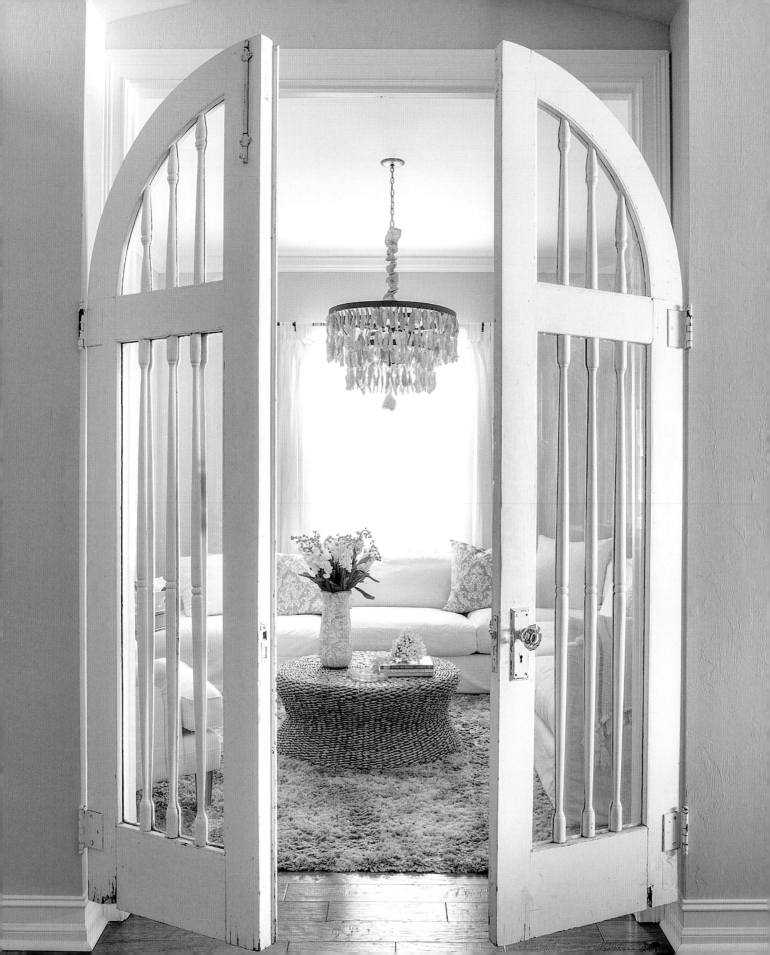

PART 2 THE HOMES

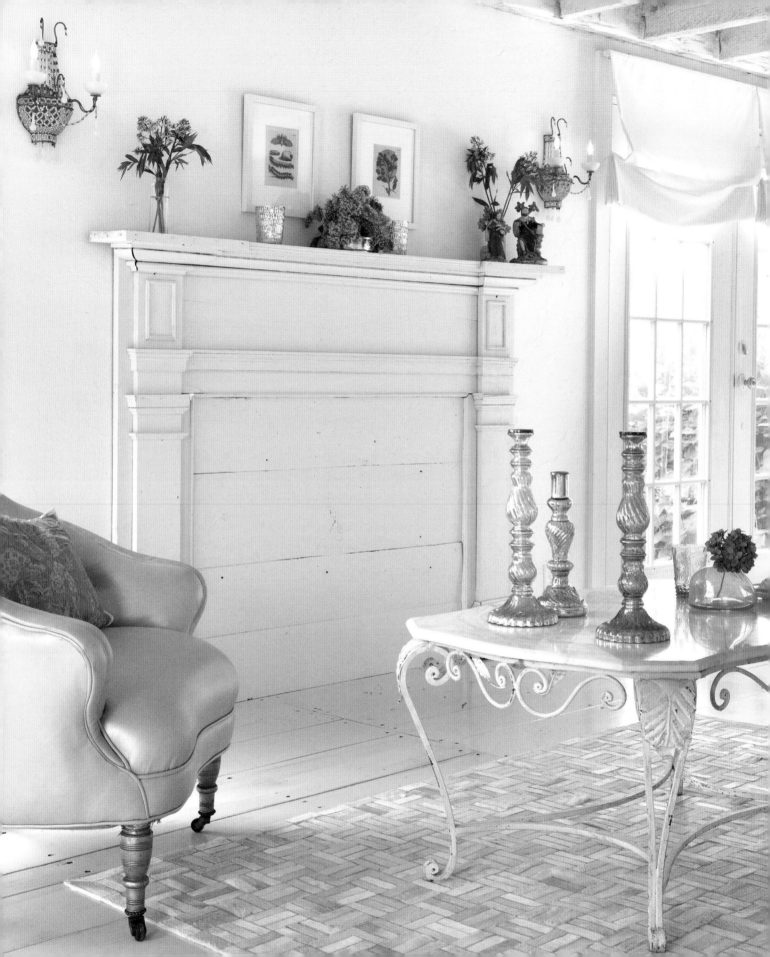

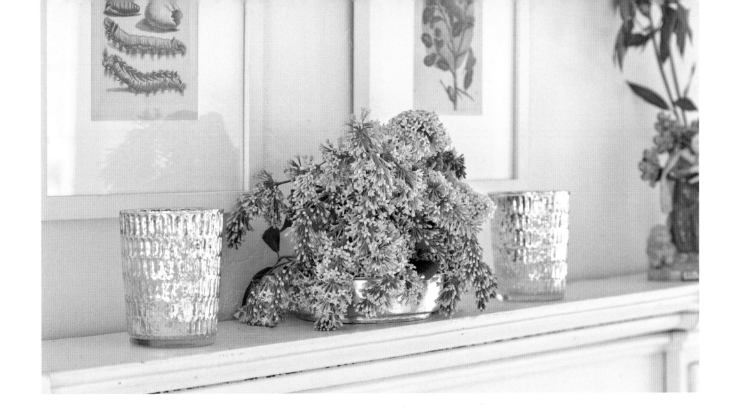

SUBLIMELY SIMPLE

FOR BETSY MEARS, IT WAS A LEAP OF FAITH TO SAY "YES" TO THE HOUSE IN VERMONT. HER DECISION WAS BASED SOLELY ON INTERNET PICTURES, AND A DESCRIPTION BY HER HUSBAND, GRAHAM, WHO PERSONALLY VISITED THE HOME WHILE BETSY AND THE CHILDREN WERE LIVING IN ENGLAND.

OPPOSITE Coated in white, the vintage mantel provides a discreet focal point and a staging area for seasonal and favorite items. A marble top gives a former garden table newfound elegance, heightened by a trio of mercury glass candleholders.

ABOVE Shimmering mercury glass, satiny silver, nature-inspired elements, and contrasting textures make magic in pale rooms.

Betsy was born in Louisiana and Graham in the UK. As a couple they lived all over the American South as well as 11 years in England on and off. "We wanted a completely different experience and New England fit the bill. We just sort of landed here," Betsy explains. "Relocating a family of six overseas was quite an undertaking. We couldn't bring a lot of furniture, so I had to be very selective. In the end that was a good thing as the house was then furnished in a simple style, which I love."

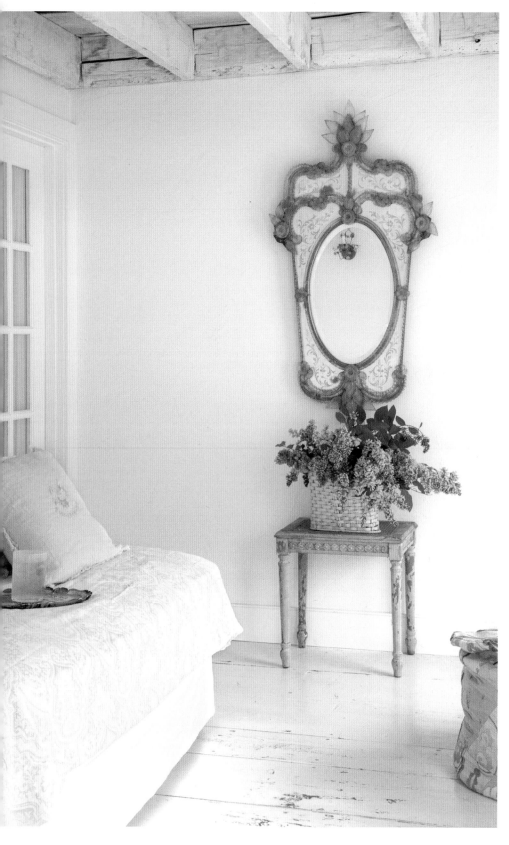

LEFT Betsy's sunny den is her private hideaway filled with items dear to her heart and always scented with garden flowers. "I spotted the Venetian mirror in the window of a shop in Dallas," she recalls. "My mom was with me and she bought it as my Christmas present." Betsy gave it pride of place in the room.

ABOVE AND OPPOSITE LEFT On the comfy sofa, an antique Italian tray rests near silky pillows and a handmade prayer book, a gift from a friend to Betsy on her wedding day.

RIGHT Displayed dramatically in a corner, a life-size French ecclesiastical statue has special significance for Betsy as it once sat in her home in England. Silver Sacred Hearts, also known as ex-votos, make thoughtful wall art. In the foreground, a white leather Moroccan pouf serves as a soft sculpture.

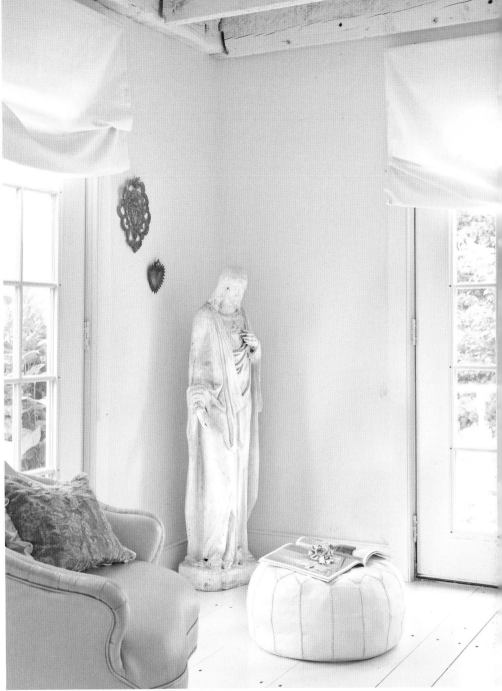

"Texture plays a very important role if you have mostly neutrals. I love sheepskin rugs, white cowhides, pale vintage pillows, and rugs in those lovely faded hues. They all add so much without weighing down the look."

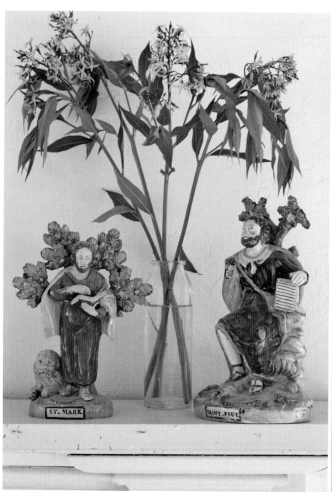

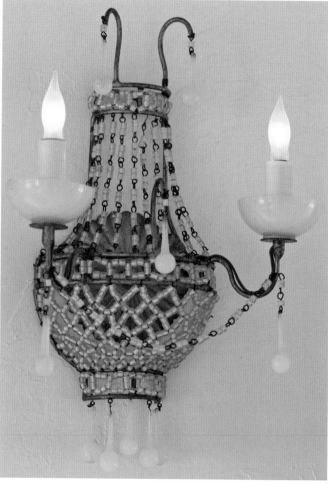

Built in 1870, the farmhouse had very few previous owners. "The man we bought it from grew up here, as well as his father and grandfather," Betsy recalls. "The property used to be a dairy farm, and at one time there was a huge barn on the grounds that fell into disrepair. When the previous owner renovated they judiciously incorporated much of the old barn's wood into the house."

Betsy indulges her feminine side by decorating predominantly with whites. "Texture plays a very important role if you have mostly neutrals," she notes. "I love sheepskin rugs on the floor in the winter, white cowhides, ottomans made with pieces of old fabrics, pale vintage pillows, rugs in those lovely faded hues, and linen window shades. They all add so much without weighing down the look." Keeping the airiness of the rooms in focus, she created uncluttered spaces with luscious details.

ABOVE LEFT Betsy scored these hand-painted figurines at a flea market. She chose them for their color and symbolism.

ABOVE RIGHT Opaline jade bobeches and beads contribute French Empire refinement.

OPPOSITE A chalky gray Swedish cabinet was a lucky find from a local consignment shop. "It was a spur-of-the-moment purchase," Betsy recalls. "I had no idea where I would put it when I bought it but it turned out to be perfect for this spot."

OVERLEAF Wide plank floors painted white and neutral walls set the stage for a sophisticated yet airy arrangement of furniture. Twin armchairs that Betsy reupholstered in pale leather show off flirty gilded legs.

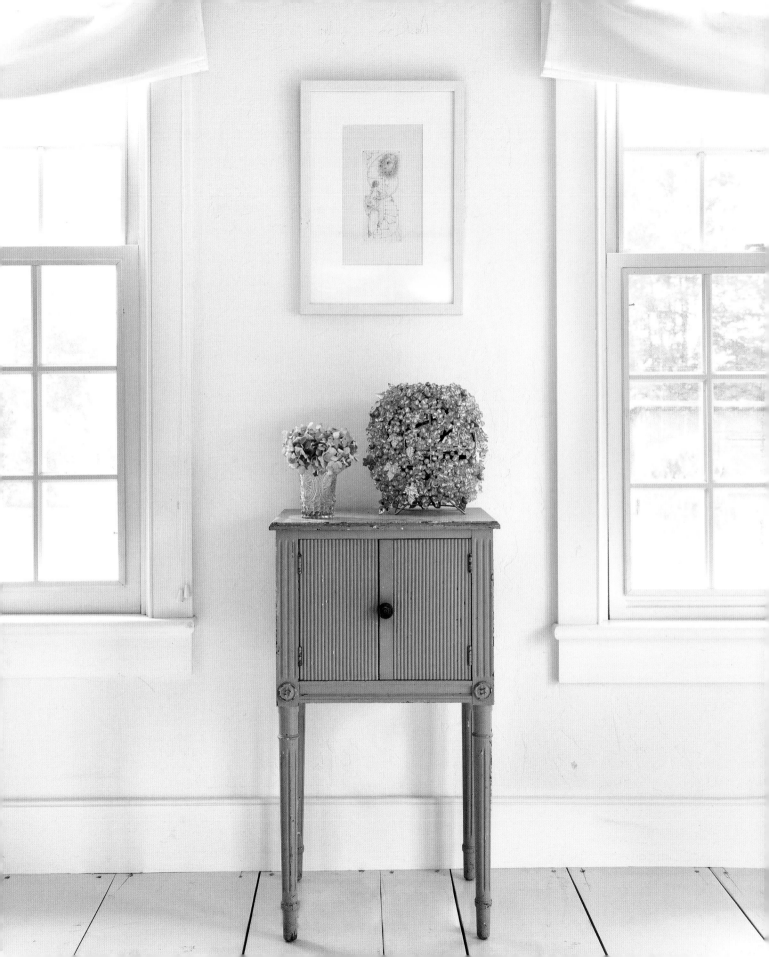

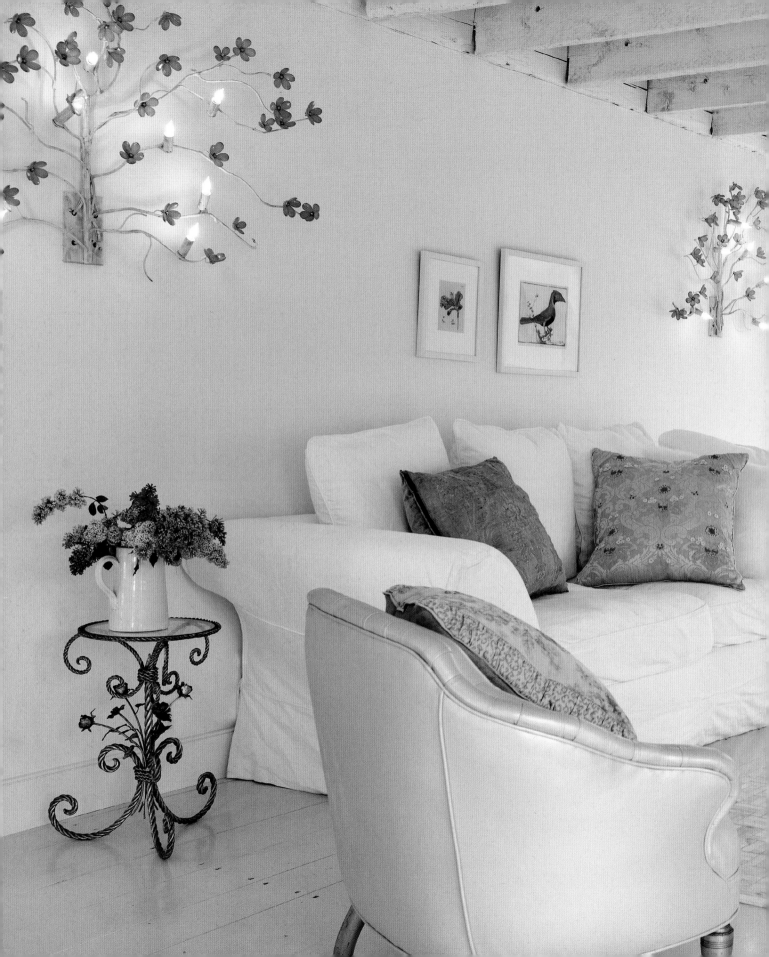

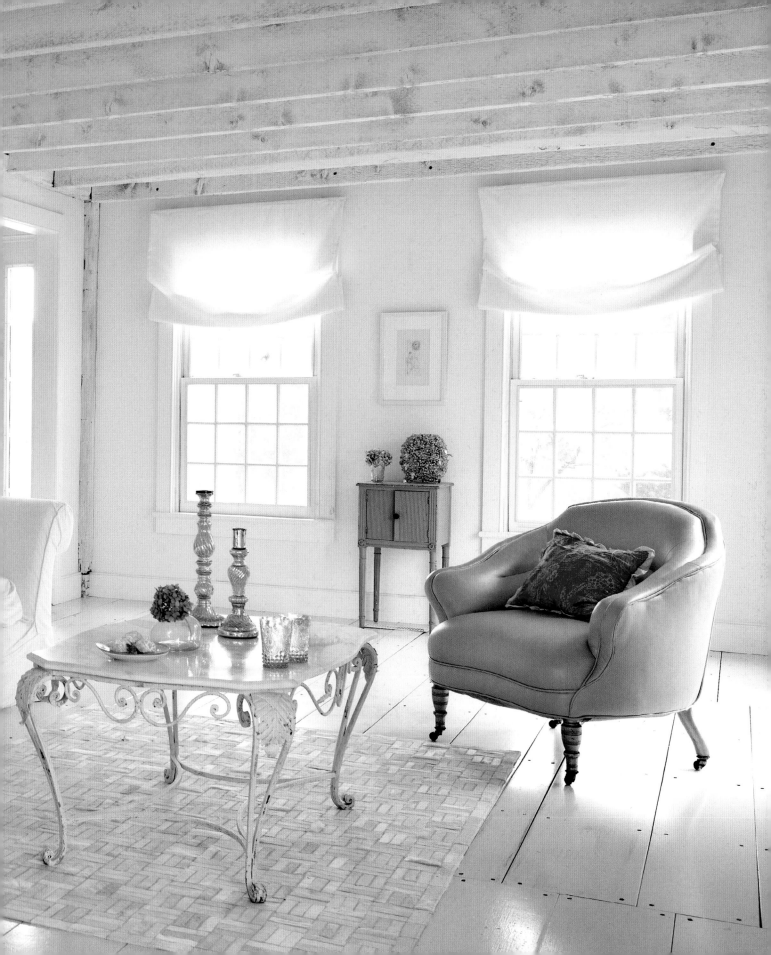

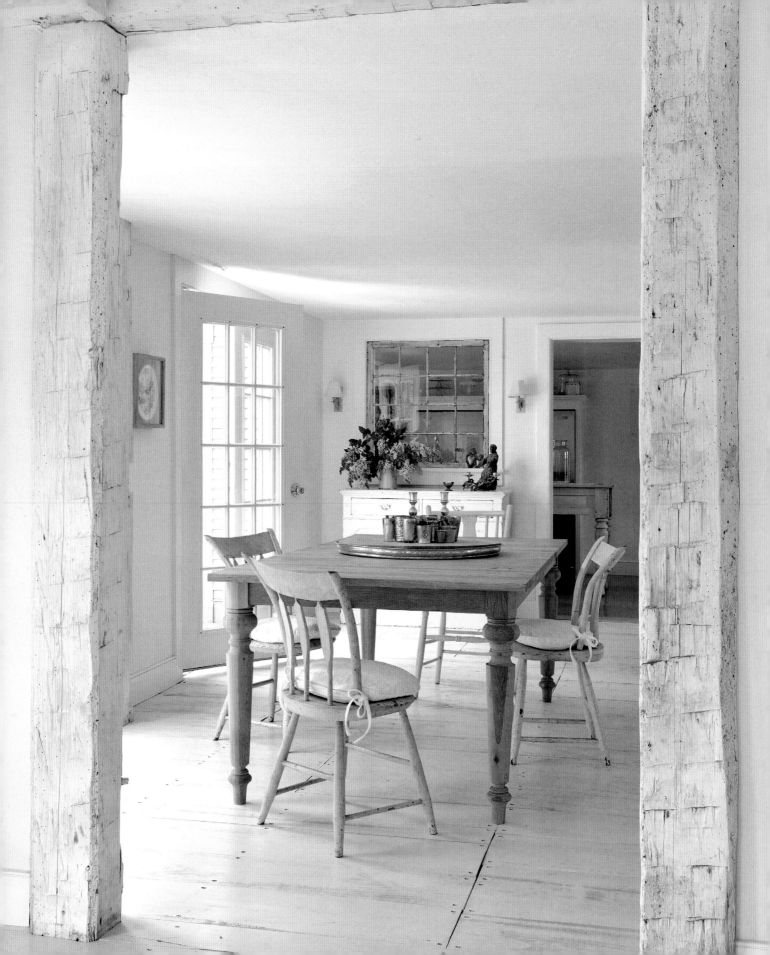

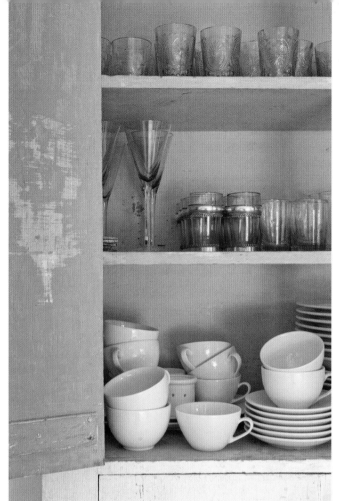

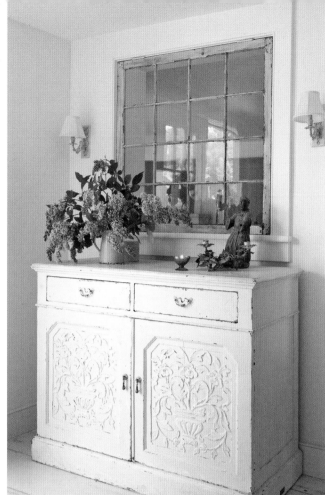

OPPOSITE The bleached oak table—a secondhand find—and chairs anchor the dining room with their warm tone while providing a gentle contrast. Located between the living room and the kitchen, the room's white floors and beams maintain a unified color scheme and provide an uninterrupted flow between the spaces.

ABOVE LEFT The weathered blue doors of a vintage wall cupboard attest to its age. It holds vintage silver-and-green Moroccan glasses mixed with antique English tumblers and pastel stemware.

ABOVE RIGHT Santos figurines and an iron candlestick stand guard on a cabinet from an Atlanta flea market. The window beyond adds architectural interest as well as providing more light to the adjacent kitchen.

The living room, for instance, features all white walls and wide plank floors painted in a lustrous cream, with a shellac finish for a soft glow. Vintage chairs with gilded legs are upholstered in supple, snow-white lambskin leather. Inexpensive thrift-shop tables and cabinets take on a rich look and help keep the rooms grounded. Vanilla-hued Moroccan poufs, favorite lounging spots for the family bulldogs, contribute a relaxed mood.

Betsy defines her look as "a very loosely soft and modern country style. It's feminine and comfortable, and it allows me to use pretty florals here and there without being too cute, which is essential when you live in a home with five males!"

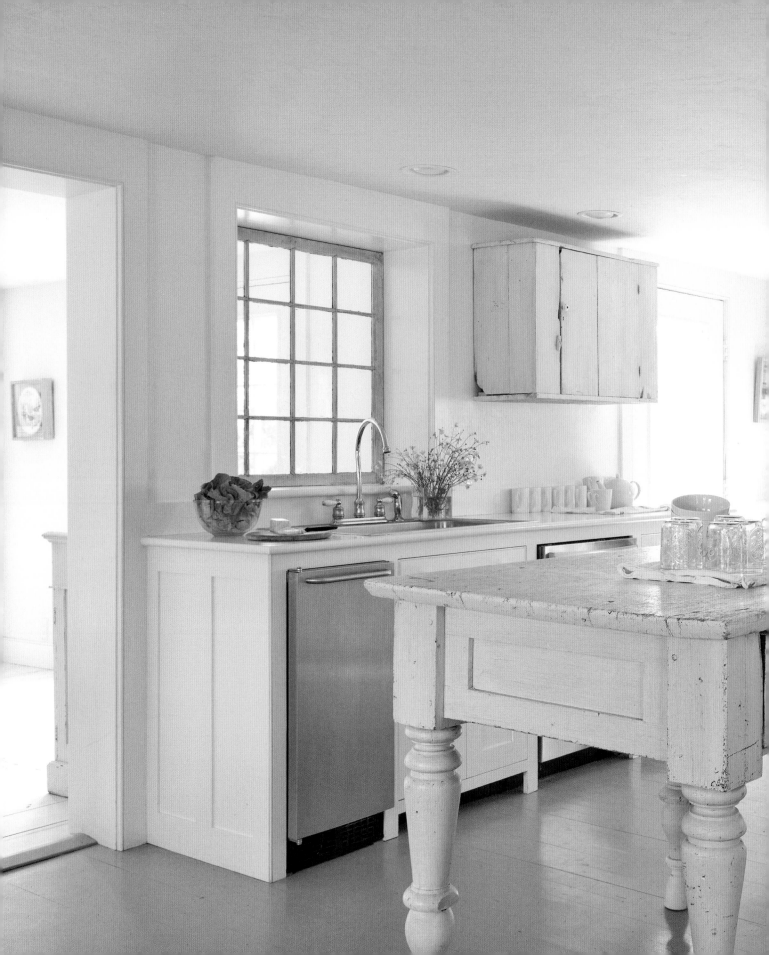

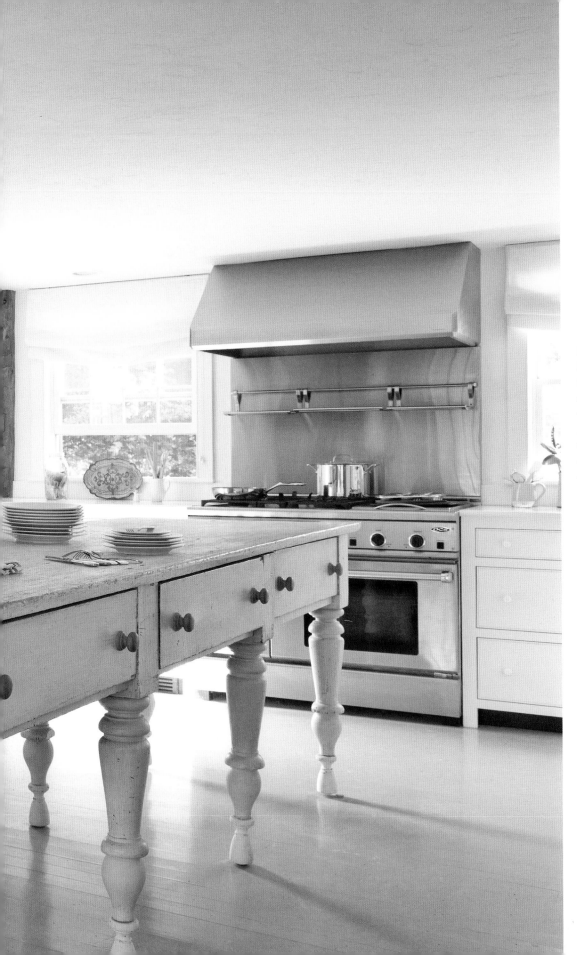

LEFT The streamline kitchen owes its simple beauty to the juxtaposition of modern appliances with vintage items. The antique French baker's table-turned-work island tempers the sleek style and finish of the stove. A rustic cabinet houses spices and baking items. Betsy speculates that the salvaged wood beam in the corner most likely came from the former barn on the property that was dismantled in the late 20th century. Its presence adds authenticity to the space.

RIGHT A French nightstand paired with a glass-base lamp and an eyelet-trimmed linen shade has a relaxed country charm.

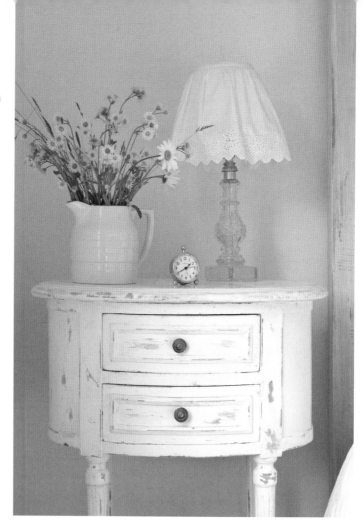

BELOW In the boys' bedroom the beds sport white denim headboards and pillows nodding to their country of birth. The walls are clad in salvaged wood boards painted white. Allowing the original knots to bleed through adds character.

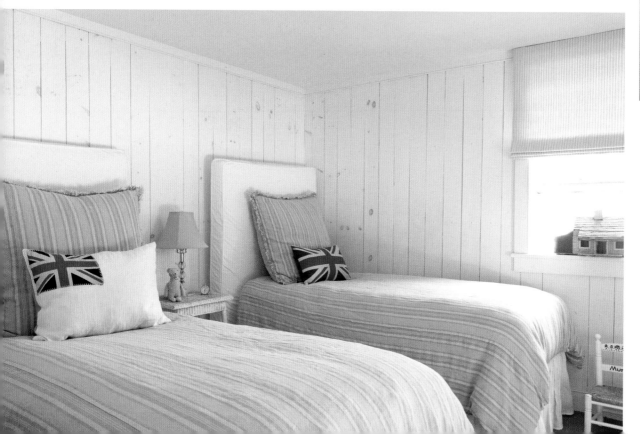

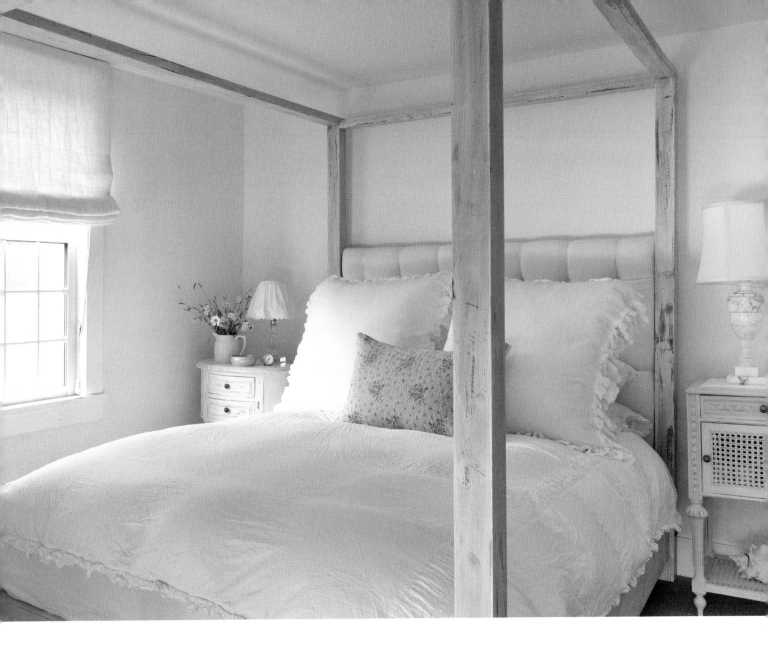

ABOVE A silvery-gray four-poster bed in the master bedroom frames Betsy's pretty bedding. The elegant linen-upholstered headboard plays off the rustic wood posts.

"I fell in love with it instantly. It was the old farmhouse I always wanted," says Betsy. "I love the floor plan as it's very open for such an old home. It's not what you picture when you think of New England. It's 4,600 square feet—big and rambling, yet light and airy and not at all typical Vermont vernacular."

BELOW A small pillow handstitched by a friend for Betsy holds fond memories and sentimental value.

RIGHT In the guest bedroom a Union Jack wall hanging and pillows pay tribute to the family's life in England. "I love decorating because it's such a fantastic creative outlet," Betsy says.

OPPOSITE The bathroom features a vintage sideboard fashioned into a vanity holding identical modern vessels on either side, while also offering drawers for necessities.

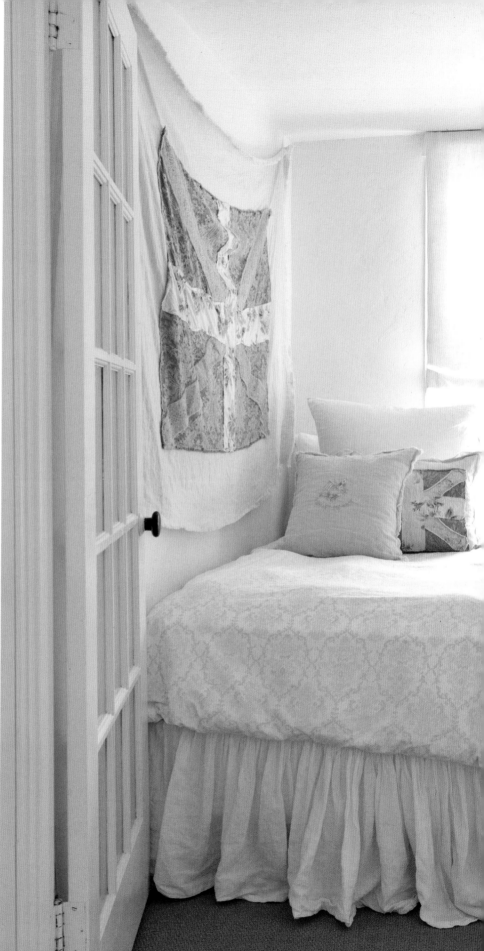

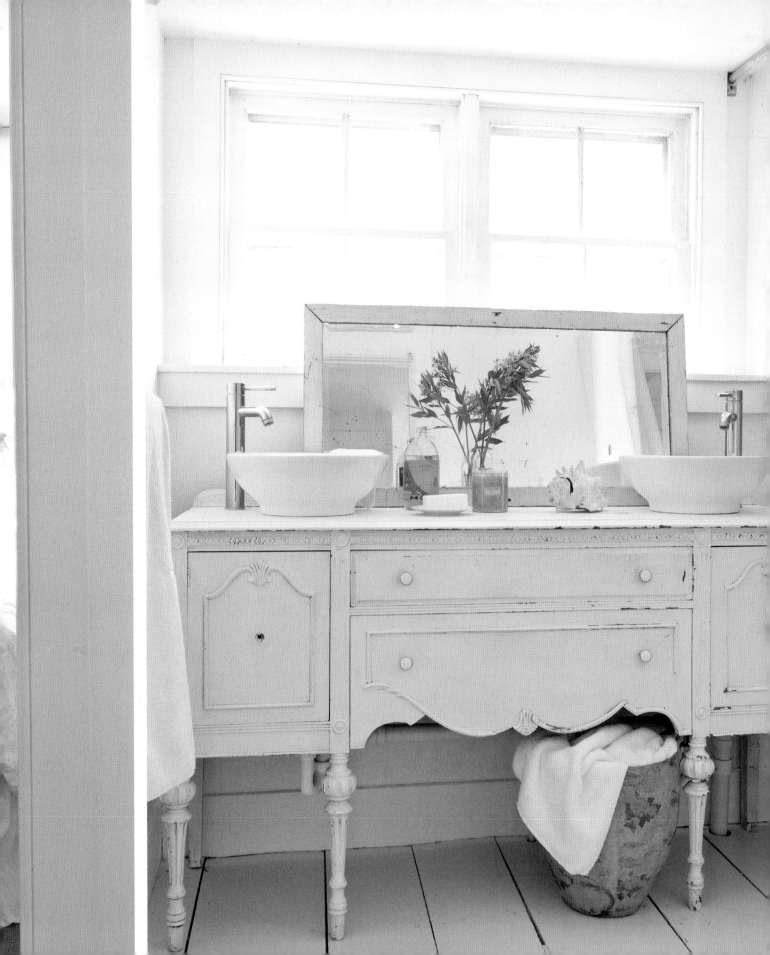

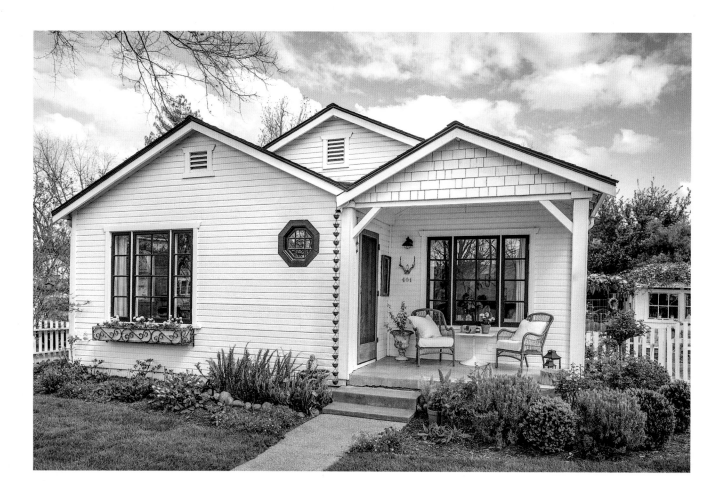

EARTHY INFLUENCES

AFTER MANY YEARS OF LIVING IN A SPACIOUS HOME, COLETTE MILLER AND HER HUSBAND, RANDY, WERE READY TO DOWNSIZE BUT WANTED TO STAY IN THE NORTHERN CALIFORNIAN CITY WHERE THEY HAD BEEN LIVING AND WORKING FOR OVER THIRTY YEARS.

As fate would have it, a little cottage in one of Vacaville's prized neighborhoods became available. However, the tiny home was for rent only. "Randy and I always loved the area, especially the beautiful tree-lined streets," Colette recalls. "When we were first married, we would park on one particular street and dream about living there. That's why, when we were given the opportunity to rent the home

ABOVE Built for the historic Buck Mansion's ranch hands, situated a block away, the once brown and drab little home is now one of the street's shining stars. And it doesn't hurt when longtime residents of the neighborhood tell Colette, "It was always a very simple and sad farmhouse and it never looked loved, until now."

OPPOSITE In the back yard a sheltered spot makes the perfect outdoor dining area. Garden chairs painted white and a pair of rattan armchairs flank the long table, built by a friend for Colette's daughter's wedding party. "It makes a great outdoor dining room and is very versatile," Colette says. "It can be styled to fit any occasion from a casual barbecue to a more formal affair."

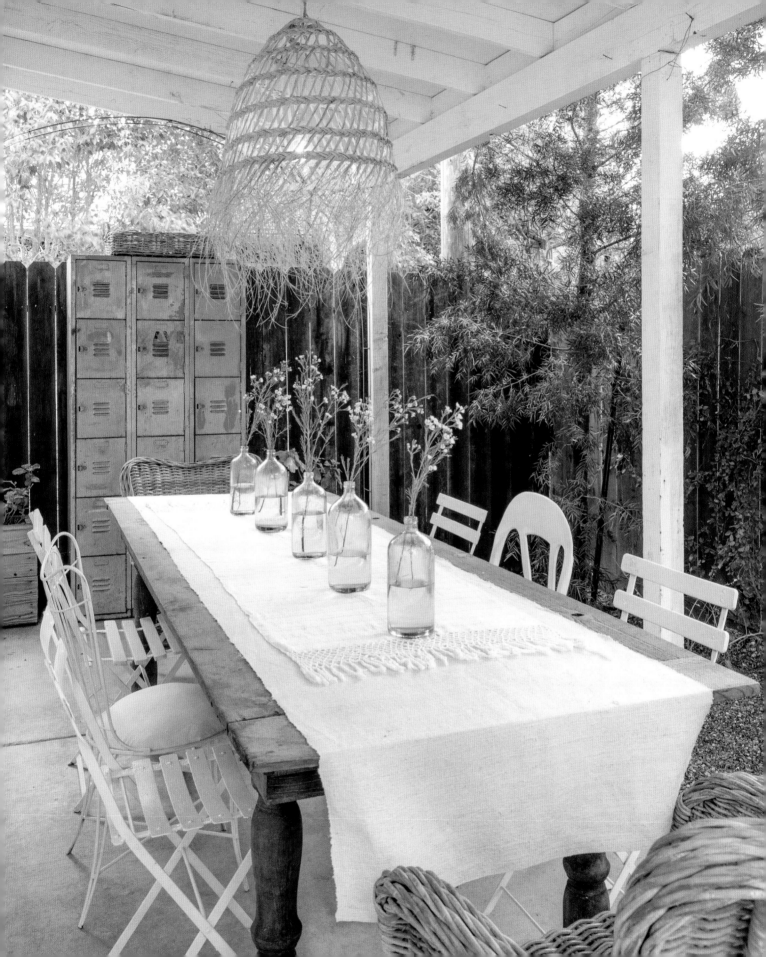

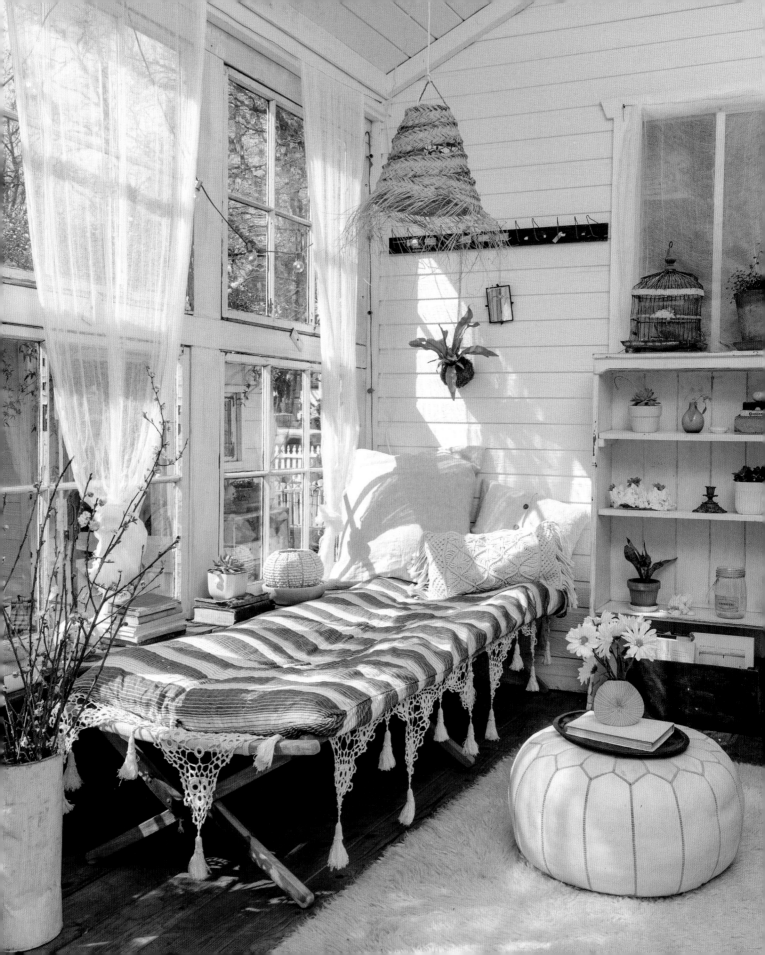

OPPOSITE Colette maximized the cottage's square footage by enclosing the existing back porch off the master bedroom. "We framed the outside wall and put in six windows I found at a flea market years ago. I was thrilled to finally have a spot for them," she explains. The folding camping bed outfitted with a comfy mattress trimmed with a macramé fringe (a souvenir from Colette's daughter's wedding), the rustic handmade rattan pendant, supple Moroccan leather pouf, and gossamer curtains all bring to mind the relaxing and dreamy vibes of a faraway island.

with the promise to buy it at a future date, we couldn't resist." And in 2014 they purchased the sweet home on their dream street.

Built around the 1920s, the original cottage had been poorly remodeled and was in great need of updating throughout. "The very first thing we did was to paint the brown exterior white, replace the front door with a vintage one, and remove the partially enclosed porch," Colette says. Many other big and small changes followed, from trading the small run-of-the-mill front windows for larger salvaged ones, to turning the purple and avocado-green walls into white canvasses.

ABOVE Pillows of varied sizes, hues, and fabrics indulge catnaps and invite quiet reflection.

RIGHT Come spring, a white Lady Banks climbing rose blankets the tin roof of the little garden shed with a profusion of fragrant blossoms adding beauty to the sweet spot.

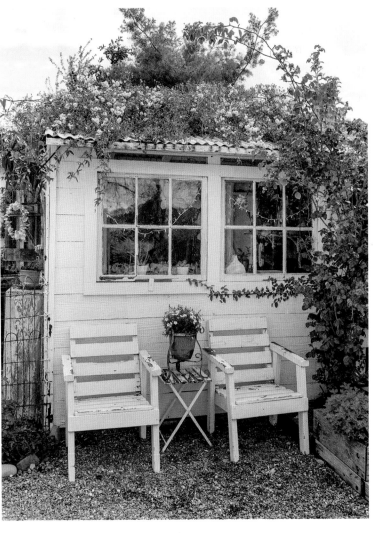

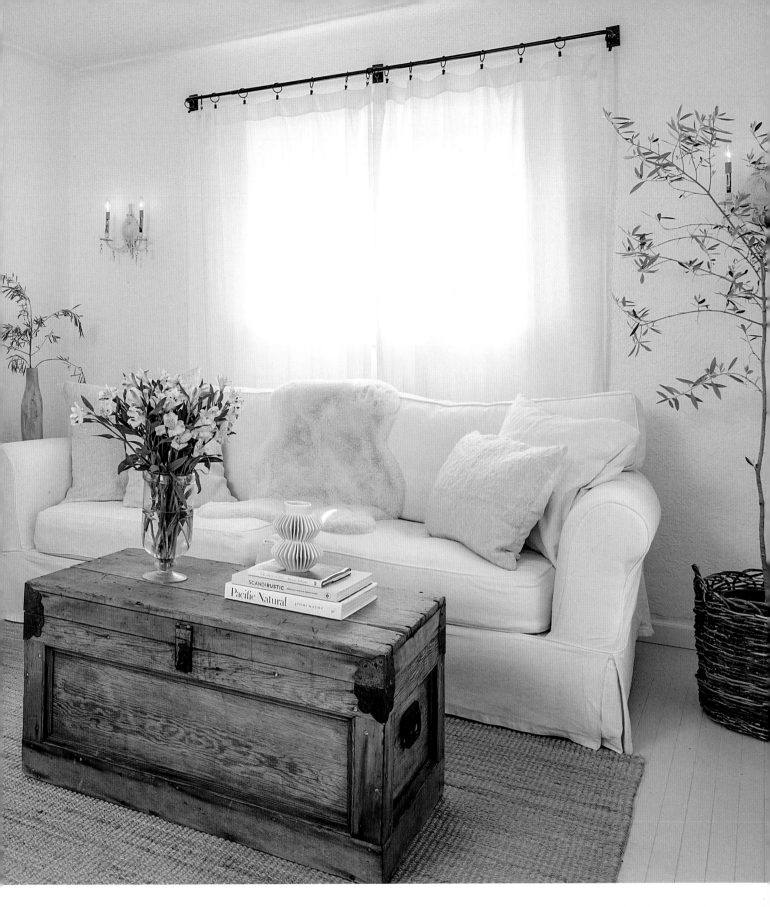

PAGE 46 ABOVE A chalked head stands by fresh and dried greens in an organic vignette.

PAGE 46 BELOW A modern vase adds a contemporary touch to the vintage trunk.

PREVIOUS PAGE Colette values meaningful pieces over those with pedigree. In lieu of a regular coffee table, she chose a trunk her grandfather built. "It stores quilts made by both Randy's and my own grandmother," she says. "My mom stripped its dark finish years ago to reveal the original patina." A yard-sale chair's clean lines spoke to Colette's fondness for simplicity. "I love that its design contributes to the openness of the room." The tall wood table was a lucky find from a yard sale several years ago. "It sat outside our previous home for a long time and got even more weathered," Colette says. "When we moved into the cottage I needed a narrow piece for that wall and this one was perfect. It's rustic and natural wood so, of course, I love it!" For height and textural contrast Colette added an old frame she painted with primer. An oil painting done by her grandmother was a wedding present to Colette's parents in 1959.

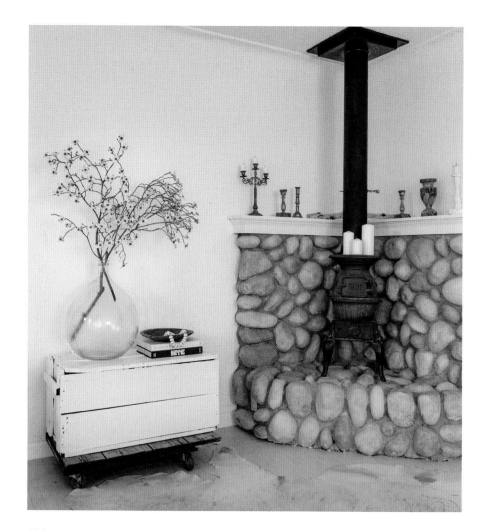

ABOVE The original river-stone wall makes a natural backing for a potbelly stove. Colette counts candlesticks among her various collections. "I have a bit of an obsession with them," she admits. "I like to line them up here and there. They look so pretty, even when they are not lit." The old wooden trunk revived with a coat of white and set on wheels offers movable storage.

OPPOSITE The hallway off the kitchen used to house the refrigerator. Colette and Randy reconfigured it to enlarge the kitchen and relocated the refrigerator, leaving room for a glass cabinet featuring various favorite items.

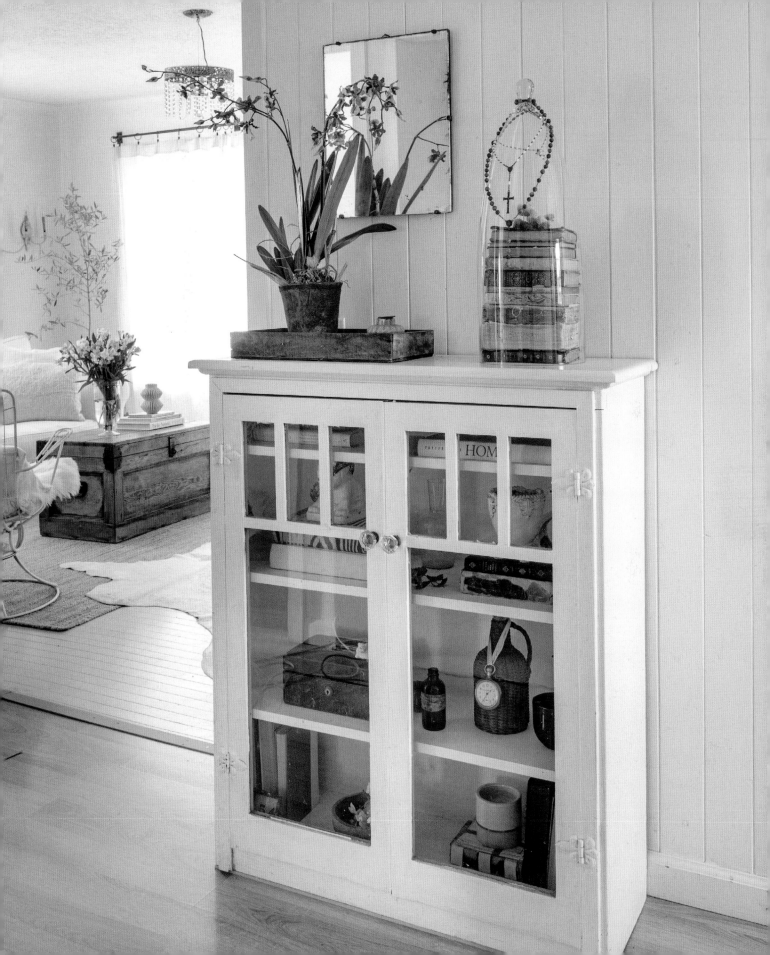

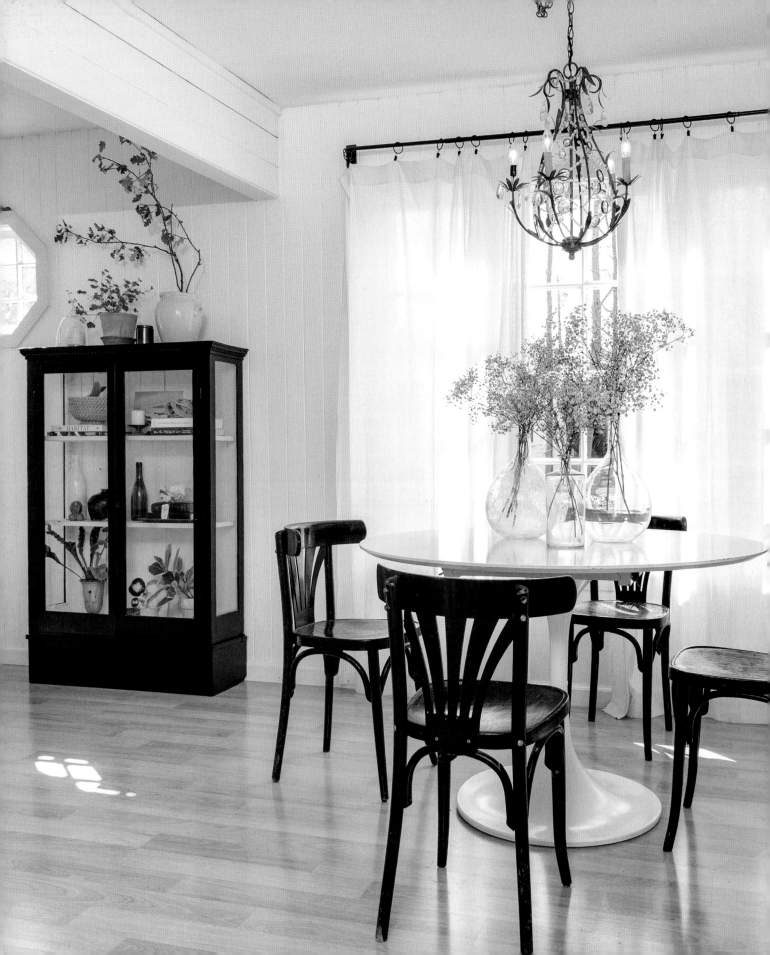

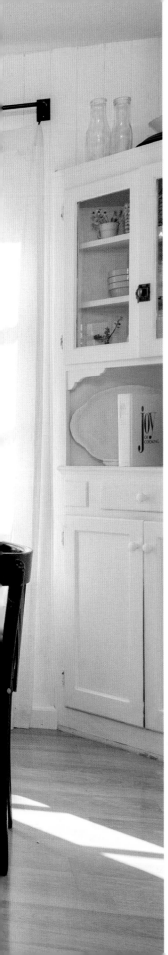

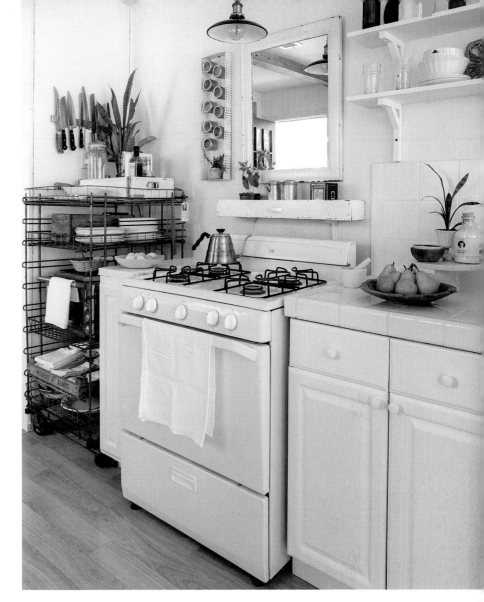

ABOVE Though the kitchen is still a work in progress it has come a long way. "We have not totally remodeled it, but we have definitely moved things around to make it work better," Colette explains. "The old bread rack has so much more storage for plates, cookbooks, towels, and even a toaster oven than the original pantry. I like that it is open and it's a really hard-working piece. Funny note: my girlfriend and I found it in a parking lot of Wonder Bread in the garbage bin!" The new Ikea shelves also add handy storage. To brighten up the small kitchen, Colette came up with the idea of the mirror to reflect and amplify the natural light.

LEFT A white table and black chairs (both from France) and a black cabinet bring the classic color combination to life in the dining room. Though the chairs came in their original paint finish, the cabinet got a complete makeover from Colette. "It was originally a shiny dark brown, to which I gave a quick sanding and dry-brushed on a matte black paint. I also swapped out the glass shelves for natural pine boards." The corner cupboard is original to the house but was gray with blue knobs. Colette brought it up to her standards with her favorite color.

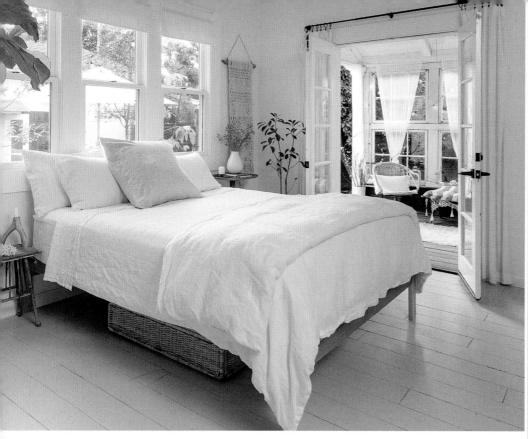

ABOVE Adding a bank of windows and French doors to the master bedroom transformed it from drab and dated to light and airy. The natural light bounces off the white walls and floor, optimizing the calming energy of the minimally furnished but comfy space. The simple platform bed balances style with function by providing storage underneath. Small vintage tables add to the pared-back aesthetic.

Colette understands how several different tactile and visual notes and shapes and hues work together to make a white interior warm and vibrant. "I love mixing in organic textures with lots of wood and plants to give life to the rooms," she says. She cites nature as her biggest inspiration. "I am a forager!" she laughs. "I carry clippers everywhere I go and am always bringing in branches, rocks, pinecones, and wildflowers from camping trips." Instagram is another source for her creativity. "I admire designers who do things that I would be too scared to try, and I aspire to emulate them and be brave enough to experiment with projects in my own home. I try not to worry about what anyone will say. If you like what you have created, that's the only thing that matters!"

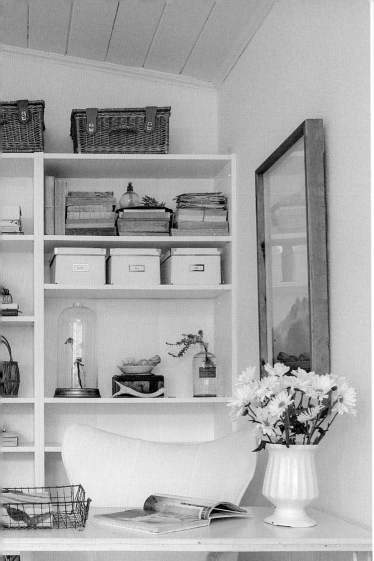

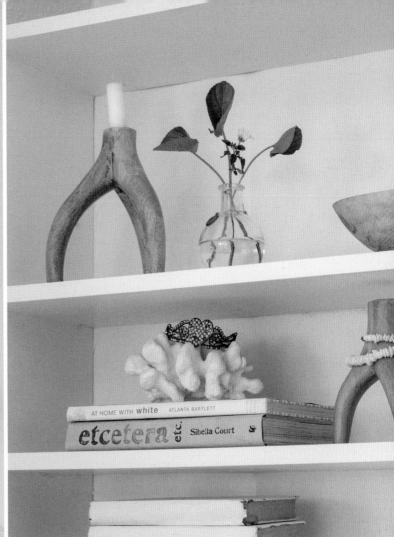

ABOVE Maple candlesticks, a carved wood bowl, and coral keep company with new and old books and a vintage bottle holding garden cuttings. Incorporating loved and appreciated items makes the display feel intentional and organic.

LEFT Colette turned an empty space in the bedroom into her office. "I had these Ikea bookshelves from our previous home and they fit perfectly," she says. "I found the desk and the slipcovered chair at near-by shops that were closing."

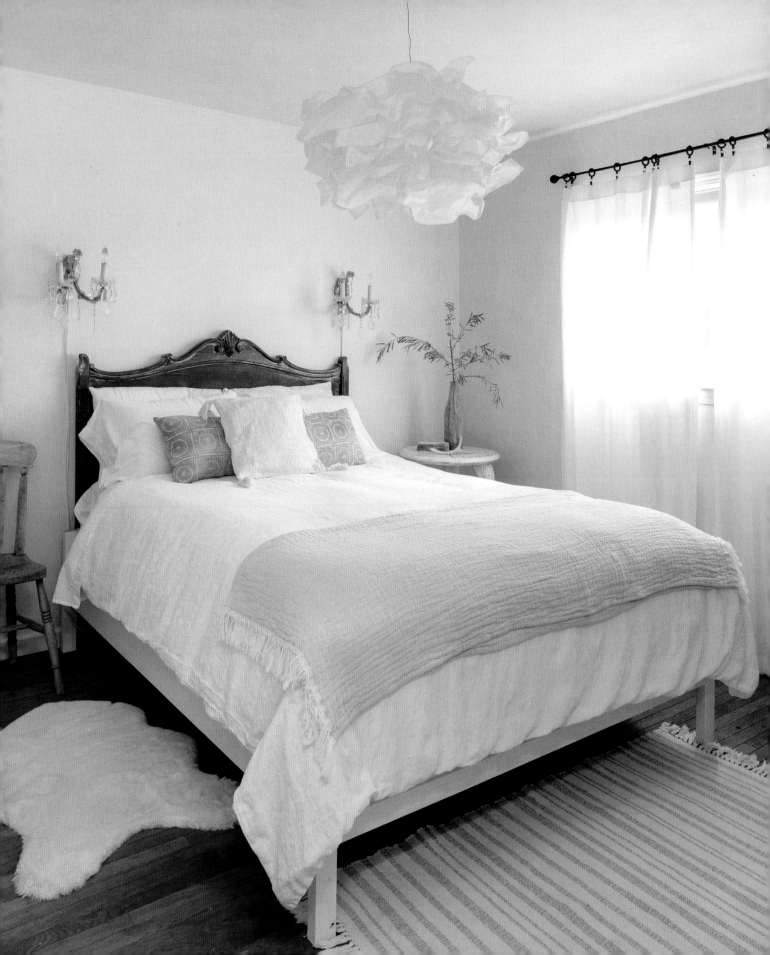

OPPOSITE Colette found the maple headboard in a burn pile at a garage sale. "It had broken pieces that I had to glue back together," she says. She lightened it by brushing steel wool soaked overnight in vinegar onto the wood. Crisp white linens soften the deep-hued headboard while the batik of the lumber pillow brings texture and an organic feel. Colette marries old and new harmoniously with a pair of vintage sconces and a cloud-like ceiling pendant.

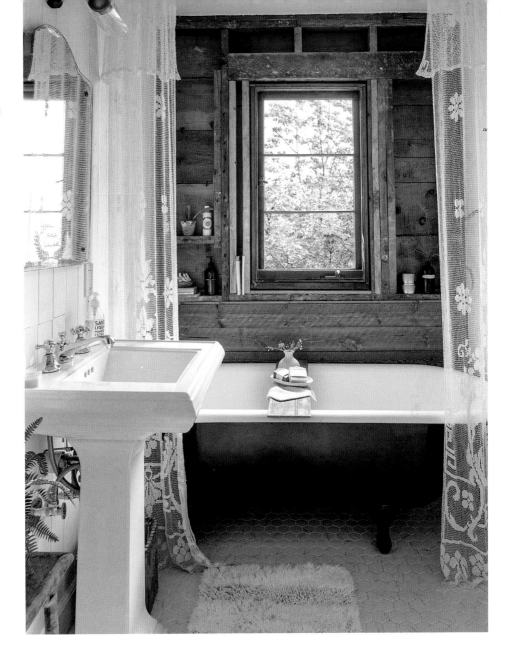

ABOVE RIGHT In the process of removing the old tub to make way for a claw-foot one, the original redwood siding was revealed and it was love at first sight for Colette. "I love the natural wood next to the black-and-white tub." She completed the inviting nook with a pair of lace curtains hung from a wire.

Colette's style is already very much her own, one that doesn't fit neatly in a box. "I gravitate to a lived-in, comfy, not stuffy mix of modern and vintage with lots of soul," she says. "I like that it's a mash up of what I love, not all a particular look like only mid-century or farmhouse. Not all industrial or all modern. It doesn't have to be just one 'look.'"

With a bit of a Scandinavian edge, a touch of curated vintage, and a dollop of that California Boho, Colette has already put her own style in motion, clearly demonstrating that she is well on her way to attaining that fearless decorating approach she aspires to.

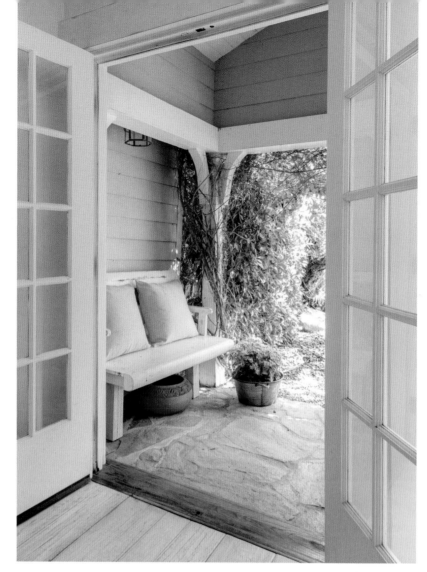

LEFT The cozy little nook is part of the exterior's new and improved design. It was born out of an awkward niche created by a window bump out. Though its movement is limited, the wooden swing brings a classic cottage touch to the setting. Adding French doors and a roof to this spot gave the façade a much better dimension while creating a charming porch.

OPPOSITE Unfettered windows usher in the sunlight and views of the garden, bringing the room to life and blurring the lines between indoor and outdoor living. The alcove is original to the house but was revived with white upholstery, a bench, and new pendants with black shades and a gold finish inside that bathe the setting in a warm, soft glow at nighttime.

COUNTRY CHARM

CAROLE KULBER, HER HUSBAND, DAVID, AND THEIR CHILDREN, LILIE AND LOUIE WERE LIVING IN A BEAUTIFUL OLD SPANISH HOUSE, BUT IT WAS DARK AND CAROLE YEARNED FOR A LIGHT AND AIRY COTTAGE.

"My husband loved the location and didn't want to move unless it was on the same street. Finding a home we would both like wasn't easy," Carole recalls. Until a cottage a few blocks away became available. But it took some convincing on Carole's part to get her husband to agree. "It was ugly on the outside and looked like a cheap apartment building," she explains.

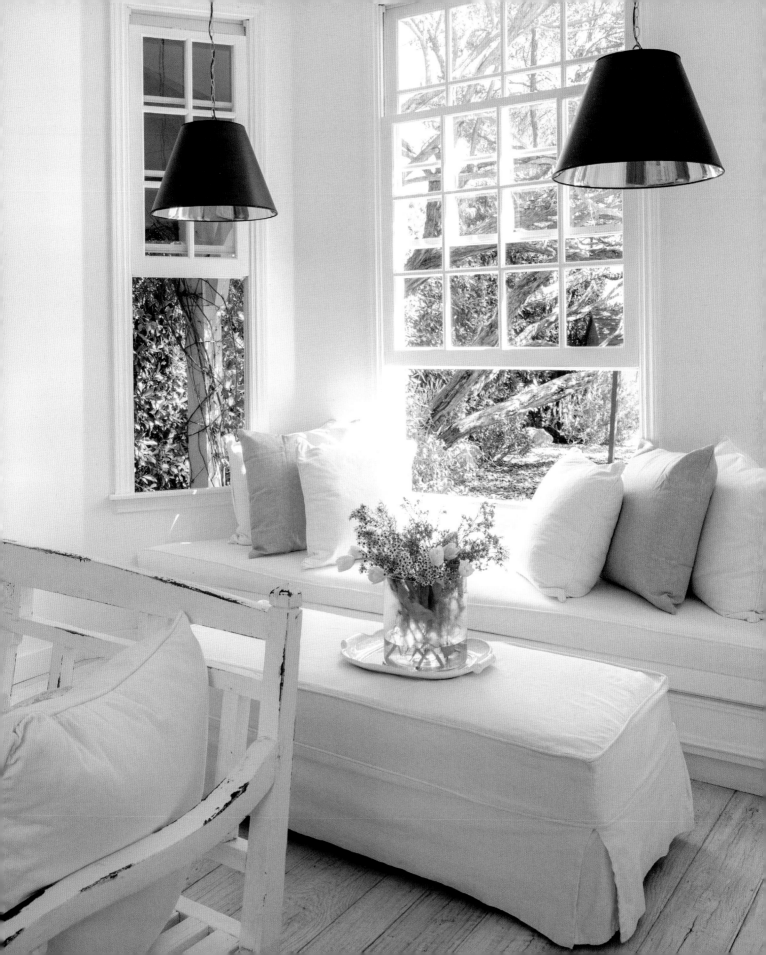

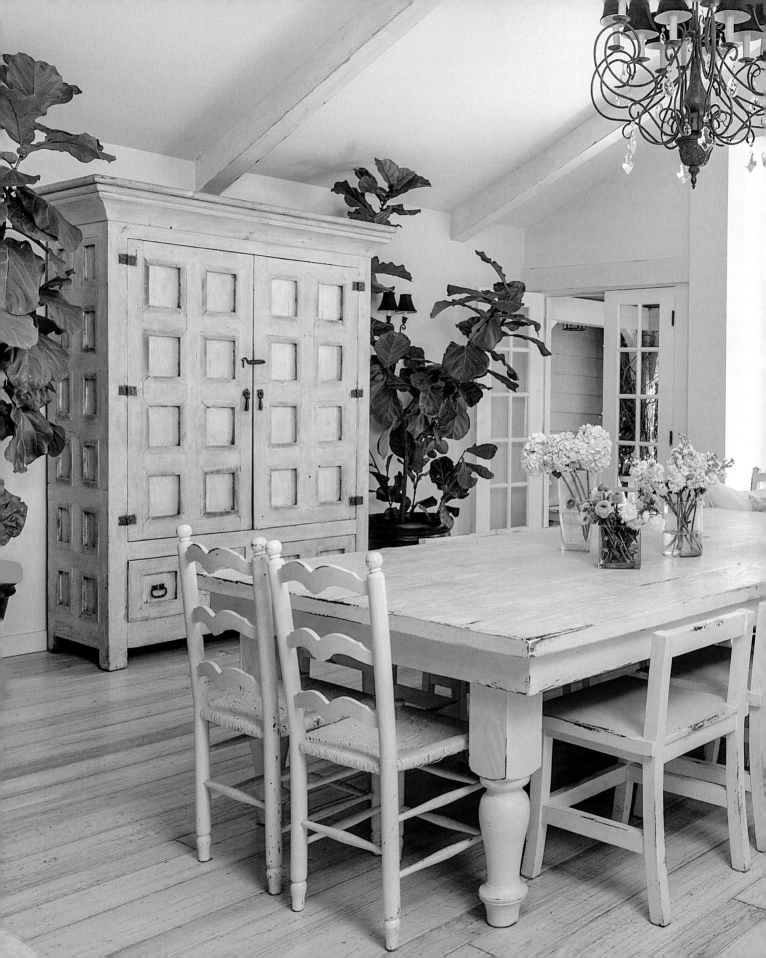

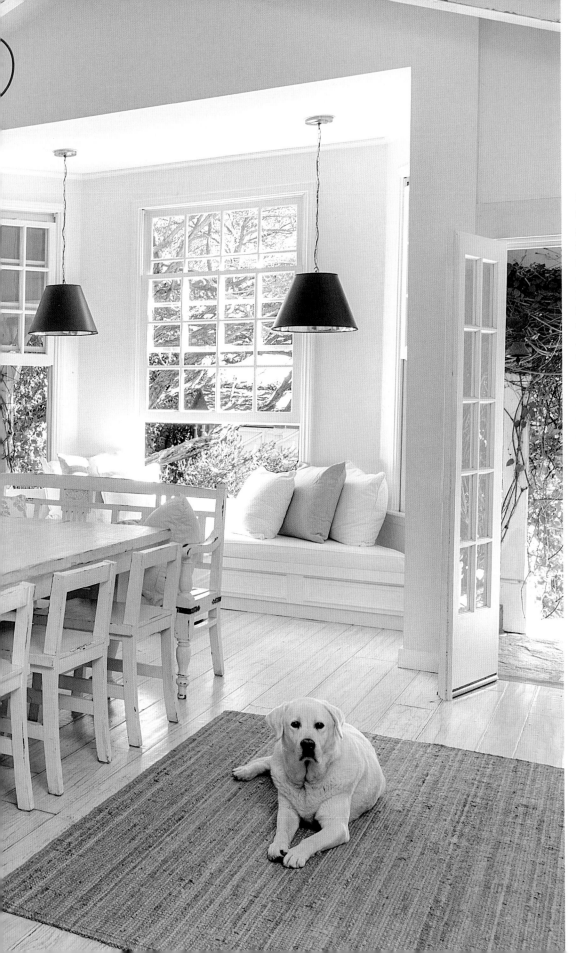

LEFT For the dining room Carole had in mind what she describes as "a fantasy for fabulous dinners with a big chandelier dripping candlewax on the table, like in an old castle!" To make her vision a reality, she designed the sizeable table and chairs that now claim the spotlight. "I asked my friend, designer Lizzie McGraw, to cut the back of the chairs down so they wouldn't obstruct the view to the garden," she says. "Lizzie also did the beautiful paint finish of the table and chairs." Originally a dark green, the armoire was whitewashed. "I wanted it to look like the color of a cloud," Carole says. "I kept the inside edge of each square a little darker to accentuate the different surfaces." Belle, the family Labrador, equally enjoys the interior and the gardens.

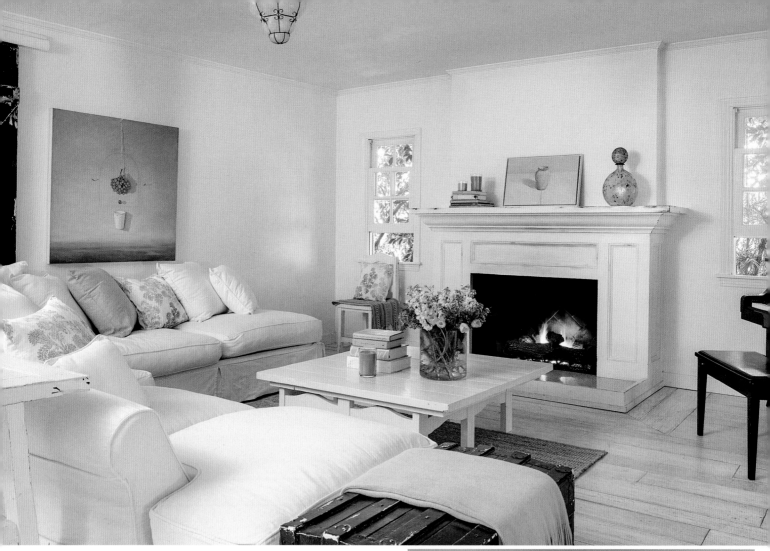

ABOVE The tops of the dining room chairs that had been cut down were used to make the base of the coffee table. Lizzie gave an old trunk from a secondhand shop and a barn door from her own store a black finish to tie in with the dining room buffet. "I really wanted a barn door like the one my grandfather used to have at the entrance of his workshop in France," Carole says. "Lizzie did a wonderful job with the faux finish to make it look vintage." Carole was seduced by the simplicity and peaceful mood of the paintings above the fireplace and the sofa. "They offer a metaphoric 'safe place' for thoughts and eyes to rest."

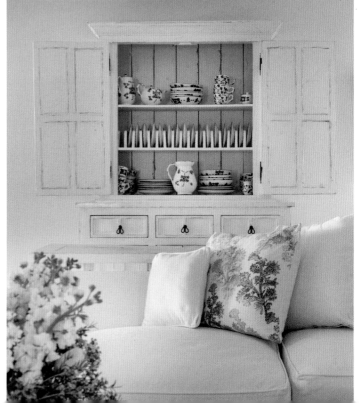

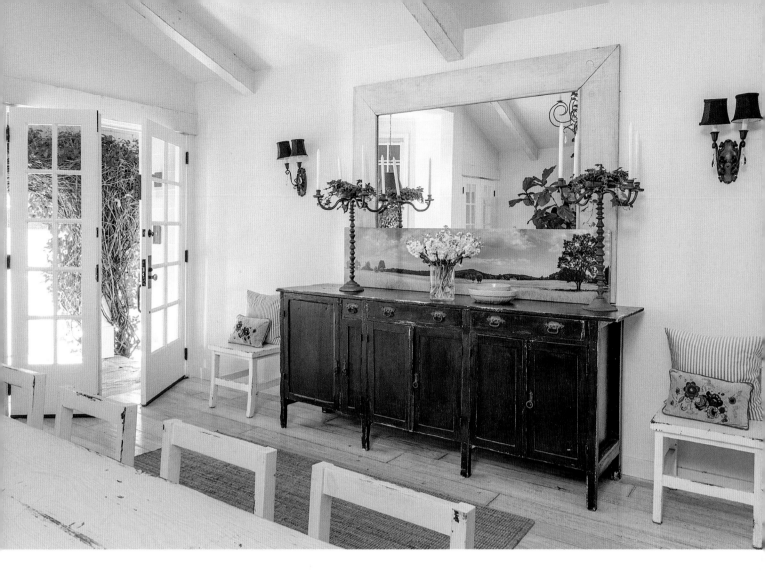

"David didn't even want to go inside." However, Carole knew the façade could be reinvented to look like that of a storybook cottage, reminiscent of the quaint homes in the chic French beach town of Le Touquet, where she grew up. "I asked my husband to trust me. He did and we bought the house," she says.

Carole put the updating in motion, starting with the exterior. The roofline was redefined, new siding and French doors installed, little front porches and a picket fence added, and it wasn't long before the "ugly duckling" morphed into the proverbial swan.

She then focused her attention on the interior transformation. The home was clean but the rooms were painted in dark colors and were in desperate need of more natural light.

OPPOSITE BELOW Carole designed and had the hutch built and painted white. She sanded some areas to let the wood come through to add texture. It showcases dishes from The Ivy, the iconic Los Angeles restaurant. "They look as if they belong to a garden tea party in the English countryside," Carole muses. "It's very romantic."

ABOVE Carole fell in love with this buffet from Santa Fe, New Mexico, but wanted to make it a standout feature. She asked Lizzie to paint it black with faint touches of white to give it a vintage feel.

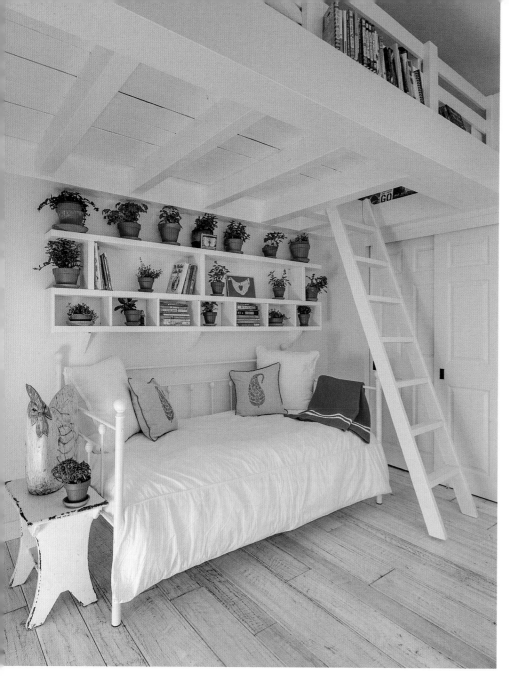

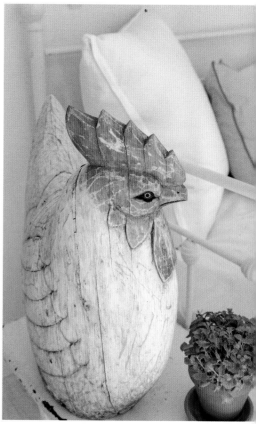

LEFT "Who doesn't dream as a kid of having a tree house?" Carole exclaims. "I couldn't build one for my daughter Lilie, so I created a bedroom loft. A sweet little hiding place just for her." Lilie loves to cook, so Carole also set up shelves lined with pots of herbs that Lilie can easily reach to use in her culinary endeavors.

ABOVE RIGHT Roosters are quintessential elements of Carole's native France. Though she uses them sparingly, they do make an appearance here and there in her home, including on the rooftop, in the kitchen, and this substantial one in Lilie's bedroom.

OPPOSITE "When we moved in, all three bedrooms in the house had windows looking directly into our neighbors," Carole explains. "There was only a low wall separating the two homes. I asked them for permission to make it higher and to plant ivy, which quickly clambered up the wall. Now all you can see is lush greenery." The chairs with the pig cutouts were designed by Carole to add a bit of whimsy.

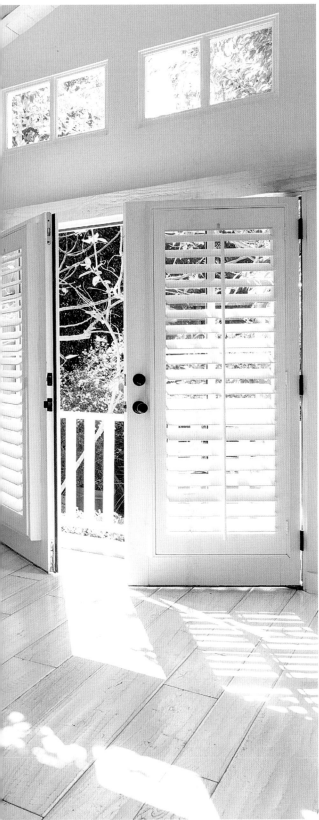

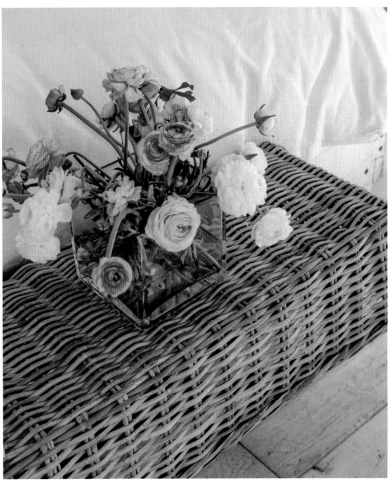

ABOVE A wicker bench destined for the garden finds a home at the foot of the bed, pairing with the floor's driftwood hues.

LEFT Sparsely furnished, the minimalist master bedroom is a luminescent sanctuary. New French doors open up to a small balcony overlooking the garden, while clerestory windows allow a view of the sky. "There is always a bird perched on the branches in front of these little windows," Carole says. The rustic Mexican bed from the couple's former home, nightstands designed by Carole, and a desk found on the curbside have all been reinvented by Lizzie with her signature vintage finish. Wood lamps add contrast and texture to balance the all-white scheme.

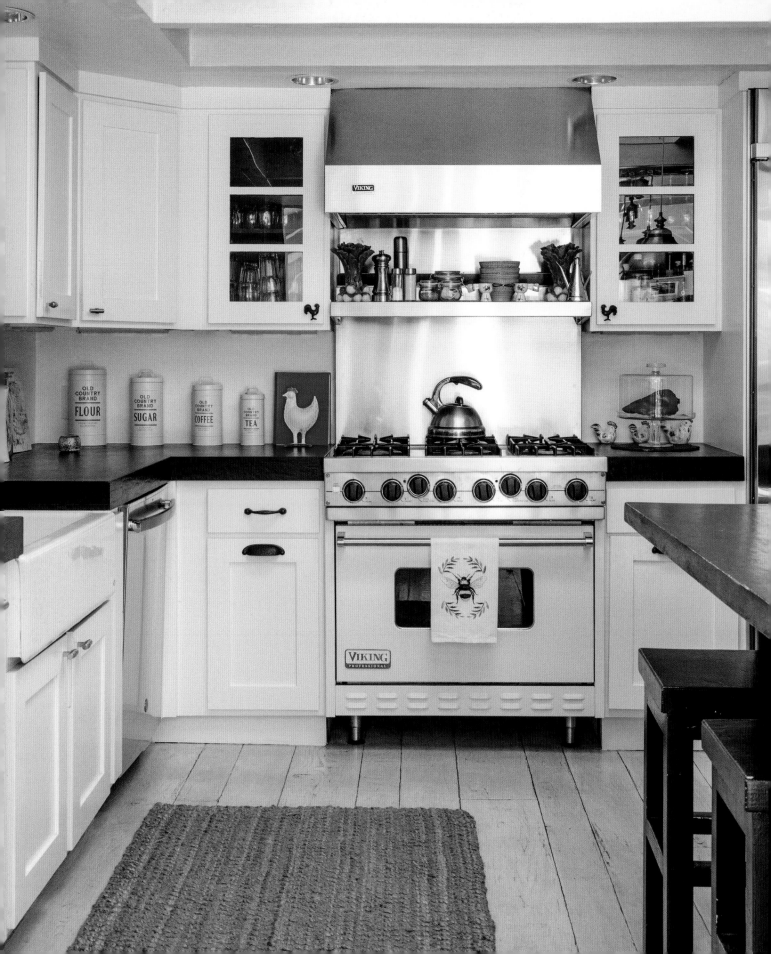

OPPOSITE Carole is not a big fan of stainless steel ranges. "White is so nice, and not just for cabinets," she notes. "It's so easy to add great accents by choosing different kinds of handles for the cabinetry." Here she indulges her Gallic roots with rustic metal rooster handles for the upper cabinets.

RIGHT Bump-out windows enhance the garden view and the farmhouse sink adds both country charm and utility. "Even if you have a garden, keeping a basket of fresh herbs within reach is so convenient," Carole says. "It's also pretty and fragrant," she adds.

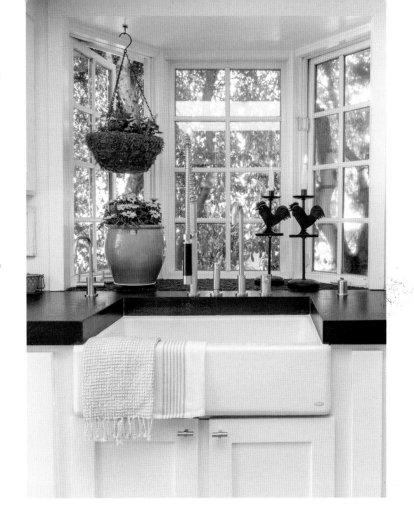

Carol began by painting every wall white, and added vaulted ceilings with skylights wherever possible. "I wanted the house to have a lot of light and feel comfortable," she says. To accent the open, fresh-air feeling she replaced the unappealing parquet floors with custom wide planks with a whitewash finish. "The idea was to recall the plank floors of French cottages," she says. "They changed the whole look of the rooms and are easy to maintain, especially with kids and a dog."

Carole has a lifelong connection with her native France and is especially fond of some of the architectural vernacular of the homes in the Normandy region, specifically those with wood beams. To bring in that beloved feature she incorporated similar timber in the dining room

and master bedroom. To complete the cottage's newfound soothing tranquility, she furnished the rooms with mostly white furniture, a trick she picked up from her days in the fashion business. "The best thing about white is that it's a blank canvas," she states. "If I want to add a touch of color to my palette, I just switch a few pillows and throws and voila! I have a new house. It's like that perfect black dress that you re-accessorize to give it a completely new look."

The once homeliest house on the block is now the prettiest. The simple, white, welcoming rooms offer beauty and function and a quiet charm that will always be in style. And though it is in the middle of Los Angeles, Carole happily says, "It feels as if we are in a cottage in the French countryside."

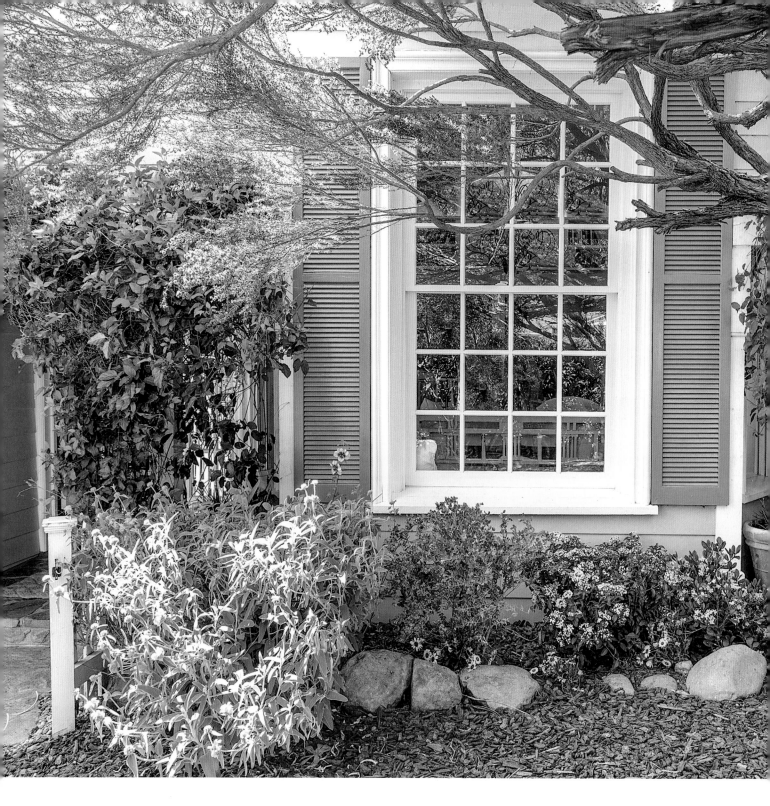

ABOVE With a reconfigured roofline, blue
clapboard, flowerbeds, arbors, and an iconic
picket fence, Carole gave the once drab and dingy
exterior of the cottage its storybook appearance.

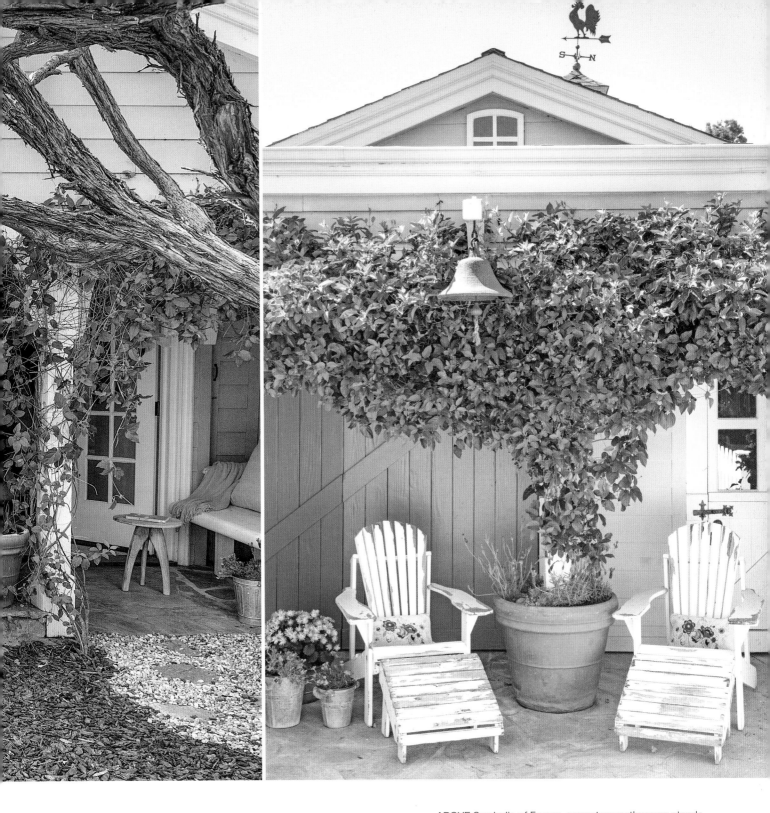

ABOVE Symbolic of France, a rooster weathervane stands
watch over a cozy spot where weathered Adirondack chairs
beckon under a verdant canopy. The big bell reminds Carole
of the school she attended while growing up in France.

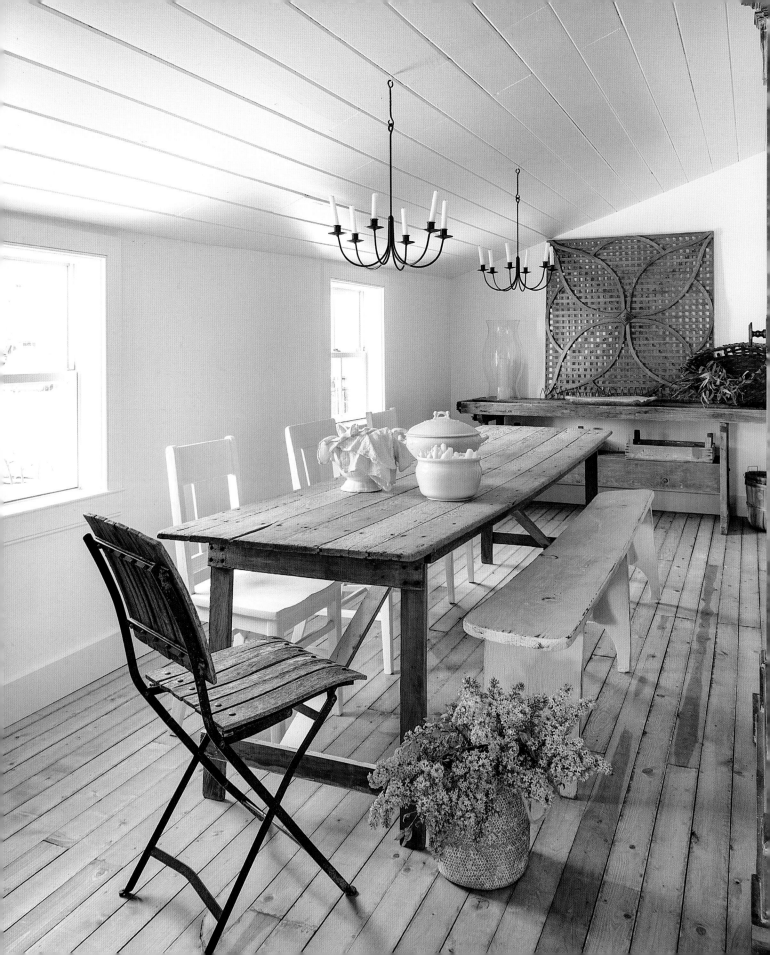

RUSTIC HAVEN

CHILDHOOD SWEETHEARTS SHANNAN AND DREW HAUPT WERE LIVING IN THEIR NATIVE NORTH CAROLINA WHEN DREW WAS OFFERED A CAREER-CHANGING OPPORTUNITY TOO GOOD TO PASS UP.

Shannan has always loved historic houses and aspired to one day live in a period home. As it happened, the town the couple moved to has many beautiful old properties. "The area reminded me of Winston-Salem historical communities where I grew up and the vintage houses that inspired my dream of living in a similar style of house one day," Shannan says. Today, she is living that dream in a farmhouse dating back to 1700—which has the antique charm to prove it.

OPPOSITE The long, narrow dining room called for a table of similar proportions to fit the room's unique shape. A slender harvest table made from pine planks turned out to be the perfect piece. Rudimentary chairs, a vintage bench, and simple chandeliers also help keep the space visually and physically unencumbered.

ABOVE Utilitarian items in varied shades of white and finishes contribute texture and simple beauty while adding to the farmhouse theme.

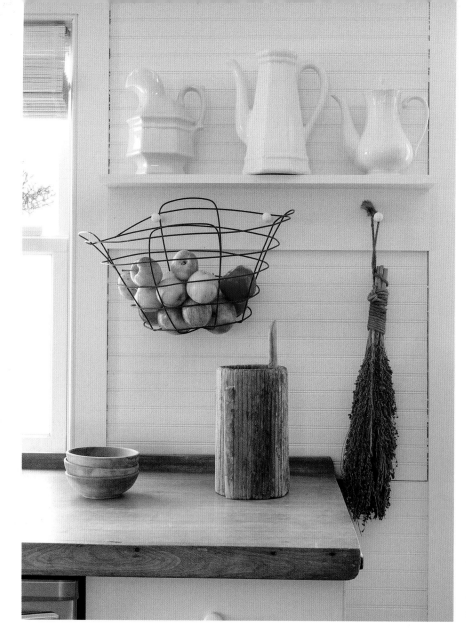

LEFT The upper cabinets were discarded in favor of simple shelving with peg racks that recalls the room's original features.

OPPOSITE When the couple bought the house, the kitchen had been somewhat "modernized" and required special attention. Shannan and Drew have been working tirelessly to take it back to its roots. They installed reclaimed pine wood floor (as well as in the adjacent dining room), originally intended as outside trim for barns. "We used the backside of the product," Shannan explains. "We saw the potential as flooring because it inspired the feel of salvaged wood that has weathered and aged over time." They wrapped the ceilings and walls in bead board to add texture. The light pendant over the sink is a unique vintage explosion-proof factory lamp from Romania, while the one over the island hails from France. "We still have a few other ideas planned for the kitchen," Drew says. "Our hope is to have that room feel as though the elements were inspired by the original interior, as if they have been there all along." The island, an authentic general store counter from England, offers much-needed storage and a working surface and is the kitchen's focal point. The hutch gives Shannan space to display some favorite china pieces, but also a spot to hide functional items.

One step through the front door puts it all on display: exposed beams, pine plank floors, and an imposing fireplace channel centuries-old grace, nostalgia, craftsmanship, and individuality.

But the home was in need of work. The restoration efforts didn't happen overnight and took plenty of physical work on both Shannan and Drew's part. Their goal was to rehabilitate the house's historic features that had previously been obscured by well-intended but irrelevant modern updates.

"We have done everything ourselves," Shannan proudly says. "We learned as we went along and tried to honor the integrity of the home as much as possible."

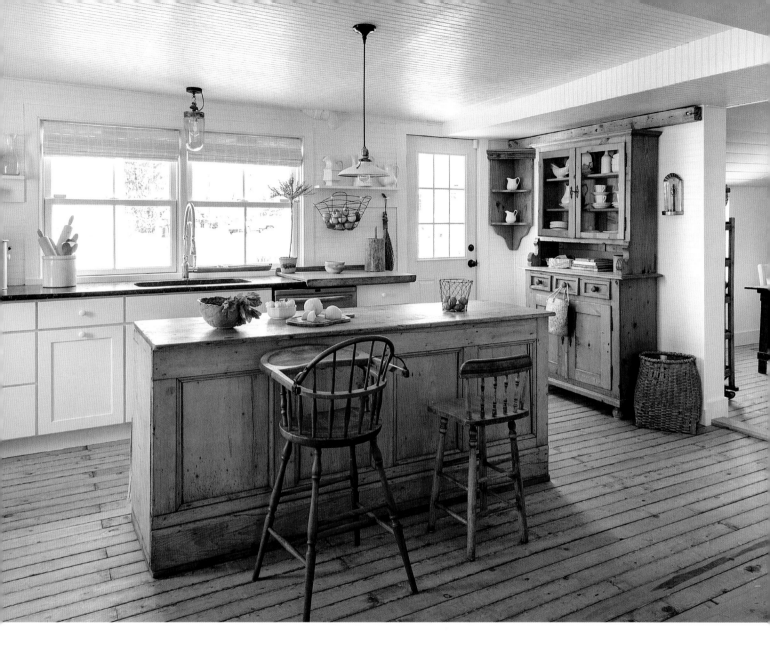

"Though Drew's new position meant relocating to New Jersey, it gave him a chance to move ahead and also allowed us to begin to start our family," Shannan says.

OVERLEAF In recent decades Brazilian cherry stains were trending, so the living room beams had been altered from their natural raw state and darkened with a deep red color. "It proved to be impossible for me to correct and restore them by hand. Professional sand or vapor blasting was required to reverse the stain, which would have compromised the original texture," explains Shannan. "Paints predate stains, so it was the easiest, safest, and more affordable option. Besides, white represents the period more accurately," she adds. The new sofa was selected for its clean lines and durable white linen fabric, which contrast with the floors that have been hand-stripped of their former red stain to expose their natural patina. The shiplap adds texture and a horizontal movement to the wall. The old oak butcher table is always on call for seasonal staging. Though new, the style of the hand-forged iron sconces corresponds to the metalwork and hardware on the doors throughout the home.

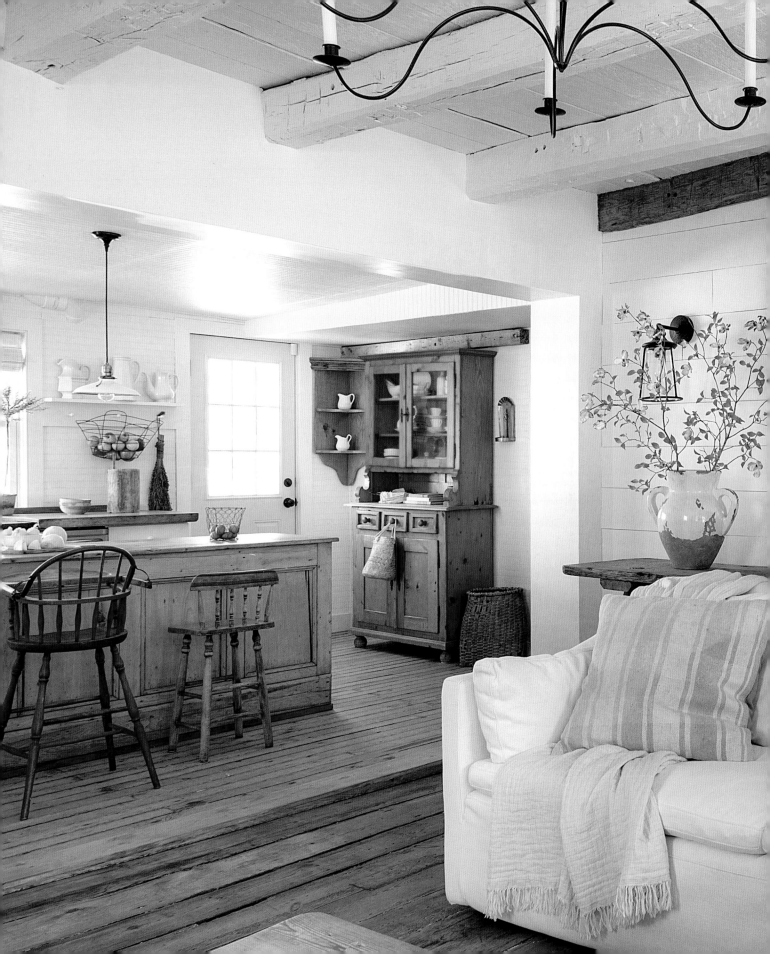

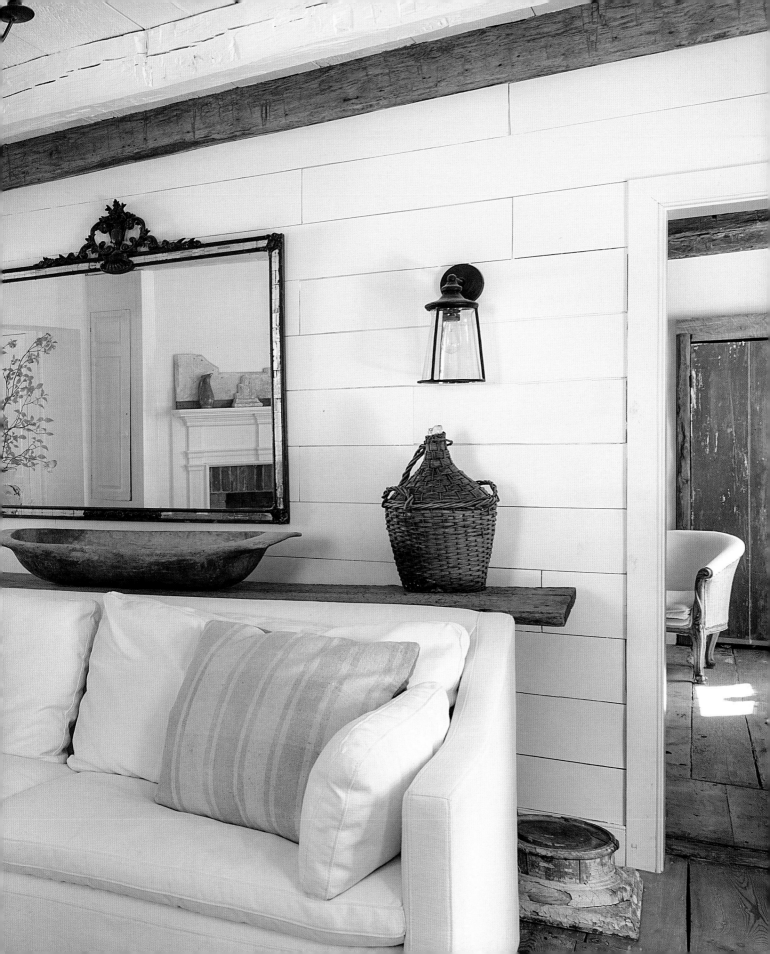

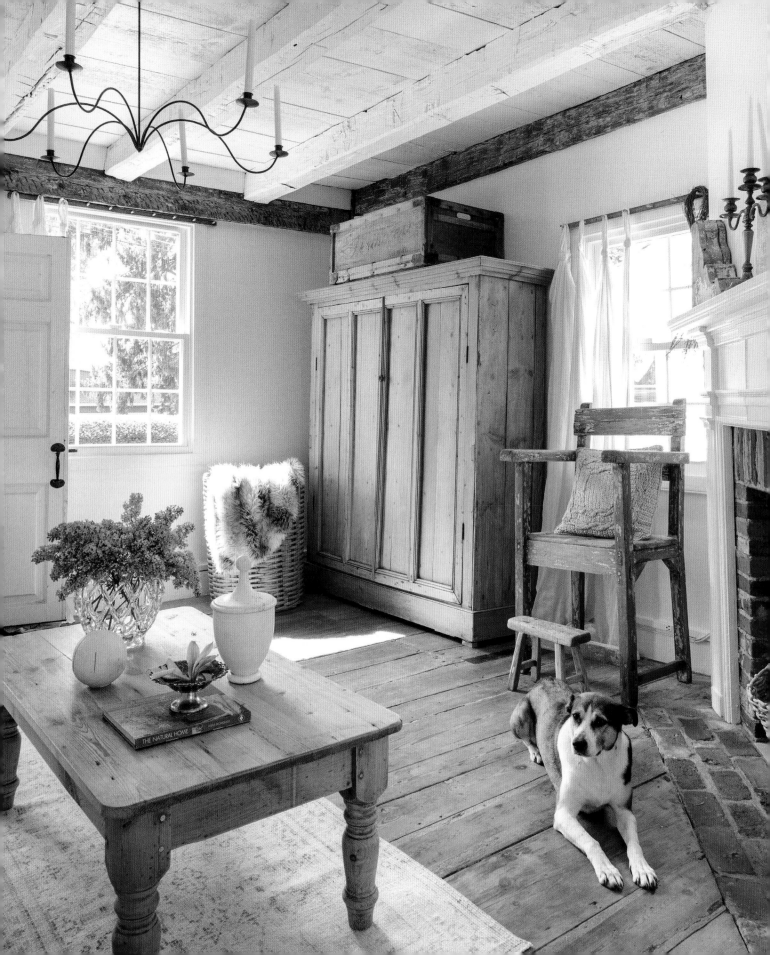

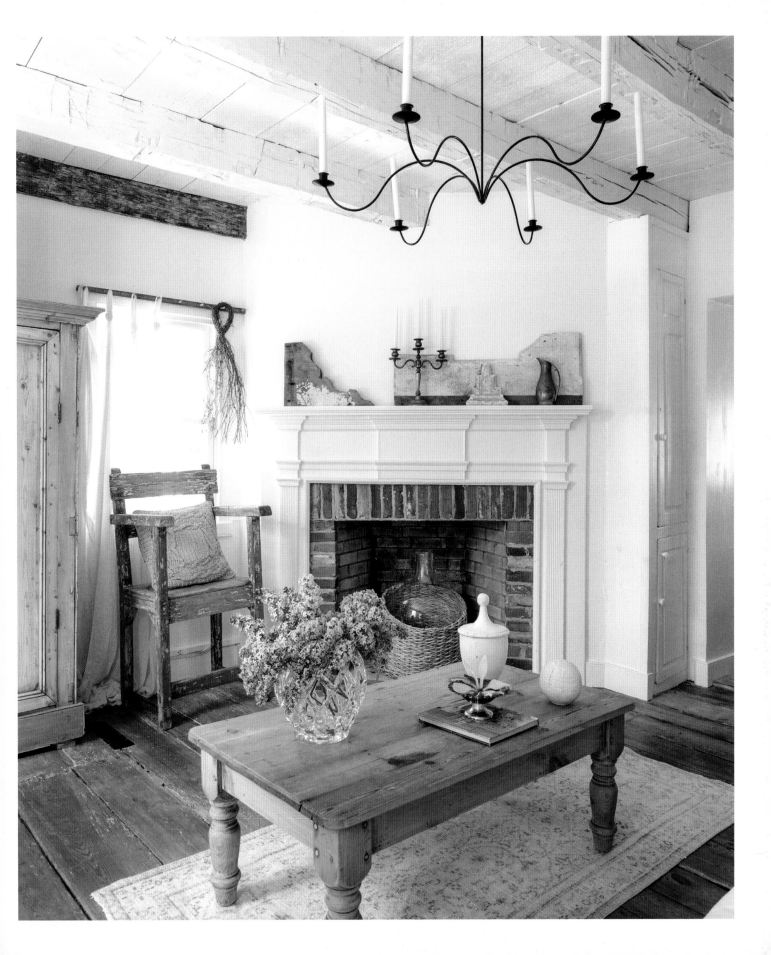

PAGE 76 The pine armoire conceals the television and affords stylish storage for modern components. Layla, the family rescue pup, is much loved by all. "She is the sweetest dog ever. She loves the children and we couldn't ask for a gentler pet," Shannan says.

PREVIOUS PAGE The vintage tapered candle chandelier adds authenticity to the space. "The wired sconces are the main source of lighting," Shannan says. The pine coffee table has been cut down to better suit the size of the space. The unique tall chair is an old porch chair found in an antique store. "I never saw another one like it," Shannan notes.

LEFT A wooden rack hangs from salvaged fencing wrapping around the wall of a passageway. "It is a great place to display seasonal decor, blankets, and baskets," says Shannan, whose love of slouchy, organic panniers prevails throughout her home.

BELOW An old tobacco basket from North Carolina is a nod to Shannan's southern roots. Its lattice design recalls the webbing straps of the deconstructed sofa. "I always wanted to try to deconstruct a sofa, and love the exposed open form in this room. Since this isn't our main living room, it was a great piece with which to experiment." Weathered salvaged doors were used to craft the coffee table.

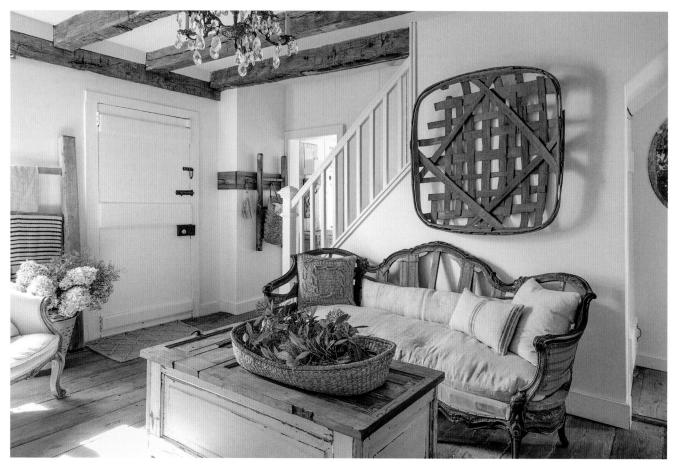

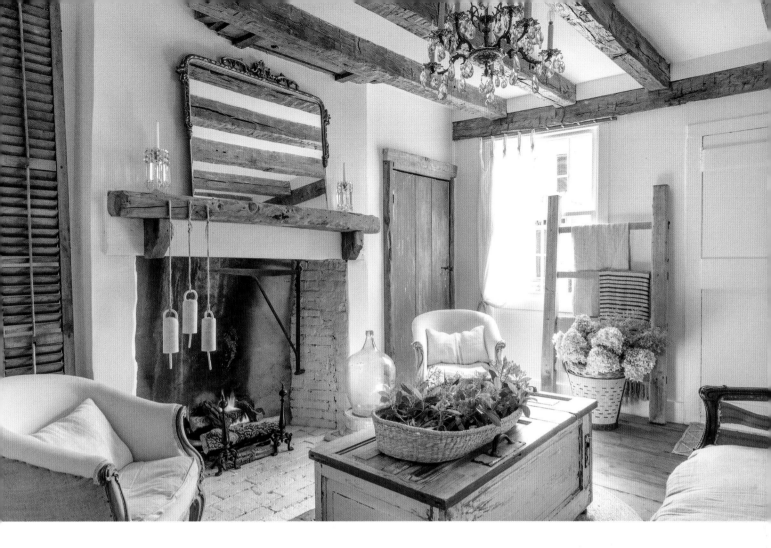

Shannan believes that when you invest in a historic home you become its caretaker, and that as such it is incumbent on you to respect and nurture it. Hers and Drew's formative years prepared them for the tasks at hand. "My parents raised me to work hard," she explains. "I get my love for projects from them, which shaped my passion for design, restoration, and curating our home. Drew grew up learning woodworking and home building skills from his grandfather, and went into the construction industry."

Though they have accomplished much in a few short years Shannan says the home is still a work in process, specifically the kitchen. "We have already made many improvements, but we have many more planned for it," she notes. However, with most of the projects already completed, Shannan has been enjoying the rewarding task of furnishing and decorating. "A white backdrop brings me calm and peace," she says.

ABOVE Shannan's collected and organic style marries elegant elements with raw materials in a timeless and rustic way. "I've learned to surround myself only with things that I truly love," she says. "I stay free of trends. Having meaningful pieces around which build our home story and create lasting memories for our children is all that matters." The keeping room is her favorite room. "It is a space that is entirely mine and remains mostly undisturbed in the course of our daily routines. It is the place where I can regroup peacefully," she says.

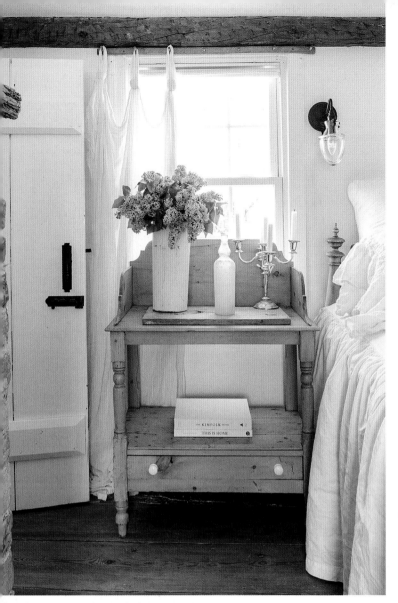

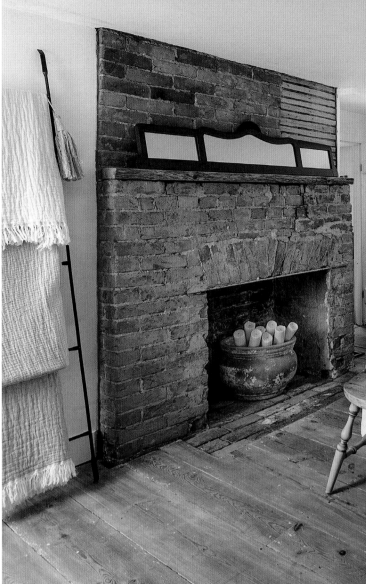

ABOVE LEFT The finish of the antique pine washstand has been scrubbed to pair up with the bed and the smaller nightstand. Gauzy linen curtains hang from peg rods made from tobacco sticks once used to hang the plants from barns' rafters to cure.

LEFT A bucket painted white, an old cloudy bottle, and a silver candelabrum are united in a romantic vignette.

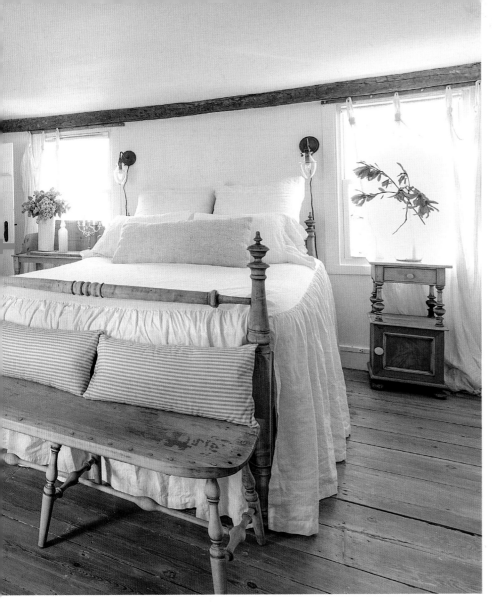

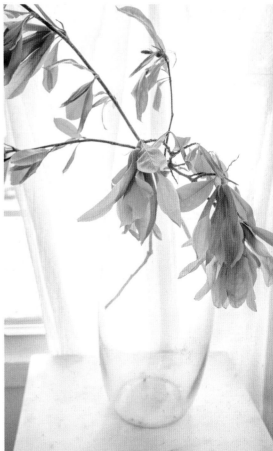

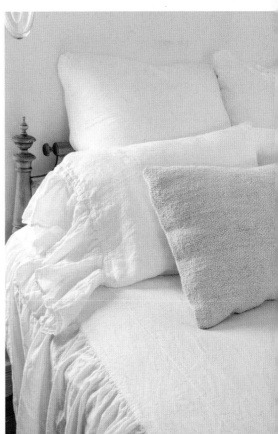

ABOVE The fusion of crisp white finishes with honeyed timber brings a light and airy atmosphere to the master bedroom. The brick fireplace is original to the home but had been plastered over. Drew removed the horsehair plaster to expose and restore the authentic brick design. "It made such a difference," Shannan says. "It brought back warmth and life to the room, as did the hand-scrubbed three-hundred-year-old pine planks." The antique pine bed and the nightstand were sanded down to the raw wood for a softer finish. The bench is a broken roadside find that Shannan pieced back together.

ABOVE RIGHT A clear bottle holding a flowering branch makes a simple but elegant statement. The graceful blossoms add a discreet spot of color and a natural touch.

RIGHT Custom-made bedding in a European linen blend brings softness, texture, and comfort to the inviting bed.

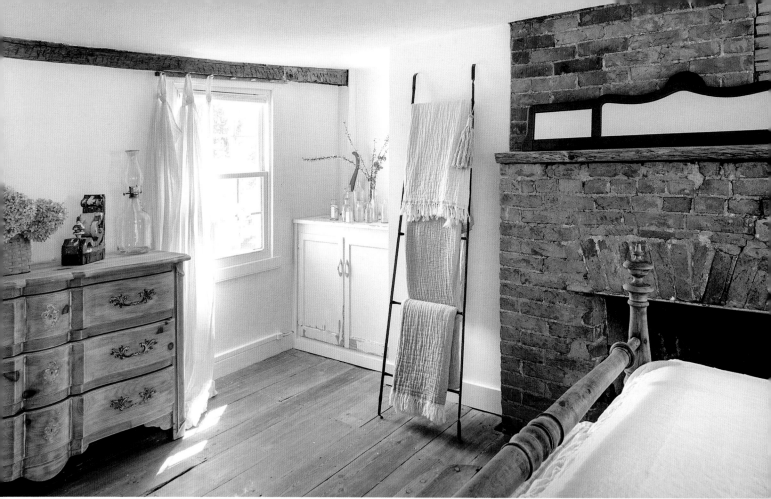

ABOVE For visual and atmospheric consistency, Shannan refinished the newer dresser using the same technique she applied on the other pine pieces. The vintage iron rack holds throws as was its original purpose.

RIGHT When Shannan and Drew got married, they had twenty of these large candles as centerpieces on the guests' tables. They gave some to family members as keepsakes but kept the others for their meaningful significance. Shannon uses them throughout the year as decorative elements.

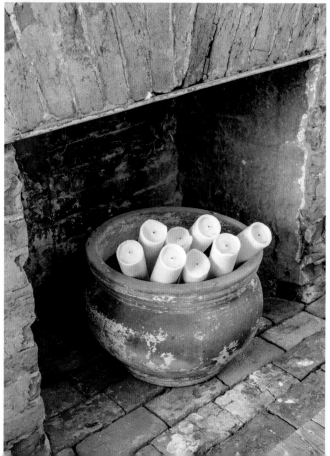

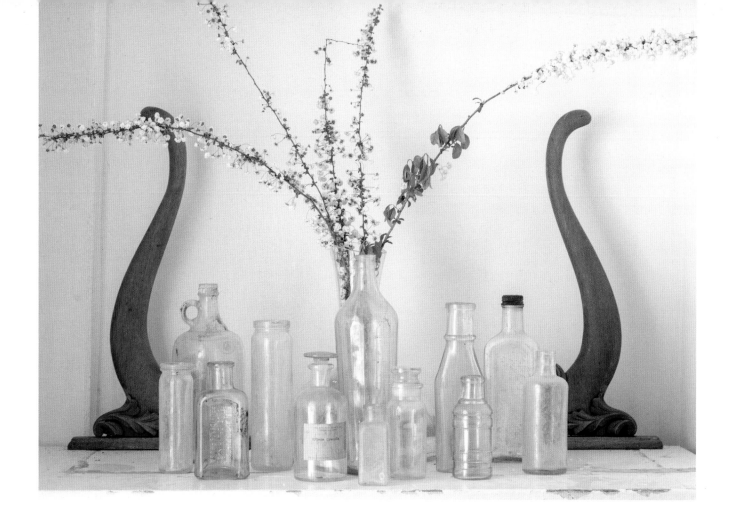

"We chose a clean, pure white palette that is historical in feel and not sterile. The natural toffee tones of the wood provide warmth and the combination is something that I never tire of," she adds. As for shopping, Shannan admits being a thrifter at heart: "I love secondhand shops, antique stores, and seasonal markets. I also search online marketplaces like Etsy and eBay, and I have been known to pick up pieces from the side of the road!"

Shannan and Drew have already achieved the two goals they had in mind when they moved from North Carolina: not only did they give their home back its soul, but they also managed to fulfill their desire to start a family, which now includes three little boys: Hunter, five; Beau, three; and baby Aaro, just five months old. It is clear that from the rebirth of their home to the addition of their little ones, everything Shannan and Drew have done has been a true labor of love.

ABOVE "The neutral backdrop allows me to easily switch items throughout the seasons," Shannan says. Here a collection of mostly white bottles evokes a calm and fresh summer day.

VINTAGE VIBES

WHEN RENÉ COGAR, A NATIVE OF CAPE TOWN, SOUTH AFRICA, CAME TO VISIT HER SISTER AND HER FAMILY IN SEATTLE, WASHINGTON, SHE ENDED UP MEETING HER HUSBAND, RANDY, WHO HAILS FROM WEST VIRGINIA. IN 2011, WHILE LOOKING FOR A HOUSE CLOSE TO RENÉ'S SISTER, THE COUPLE CAME ACROSS THEIR PRESENT HOME.

René has always had an affinity for antiques and vintage pieces and for restoring those in need. "My love of creativity and all things home decor has opened up so many doors for me and given me experiences I never would have had otherwise," she notes. "The most enjoyable and sometimes frustrating project has been redoing our home and garden. It's still a work in progress. It truly has been a labor of love and it is amazing to look back and see how far we have come."

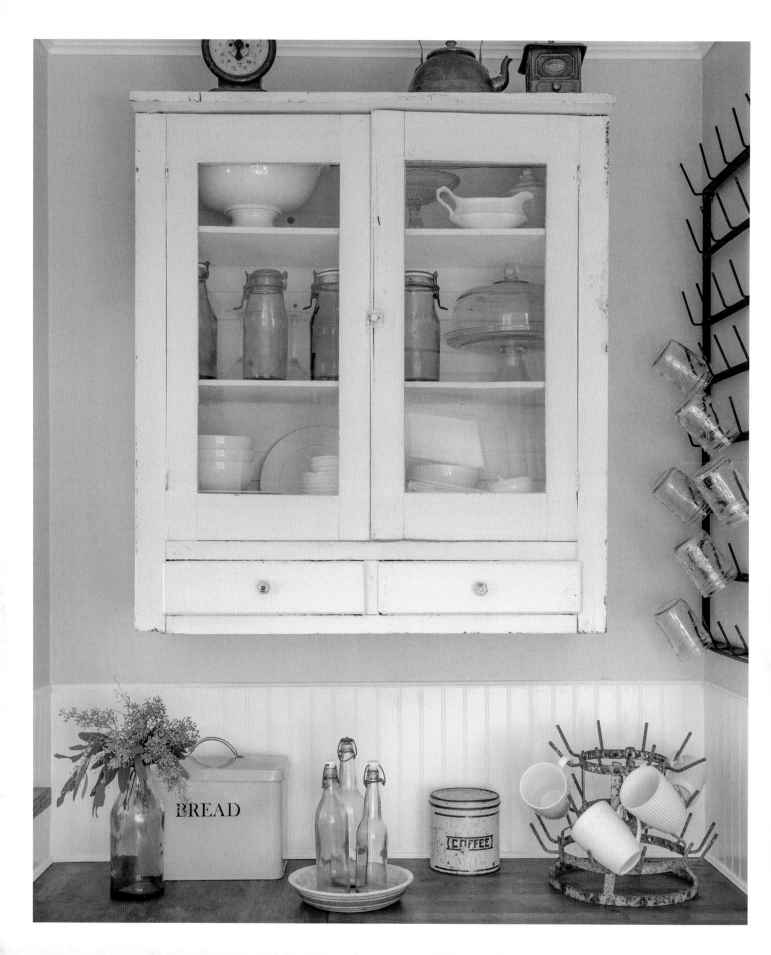

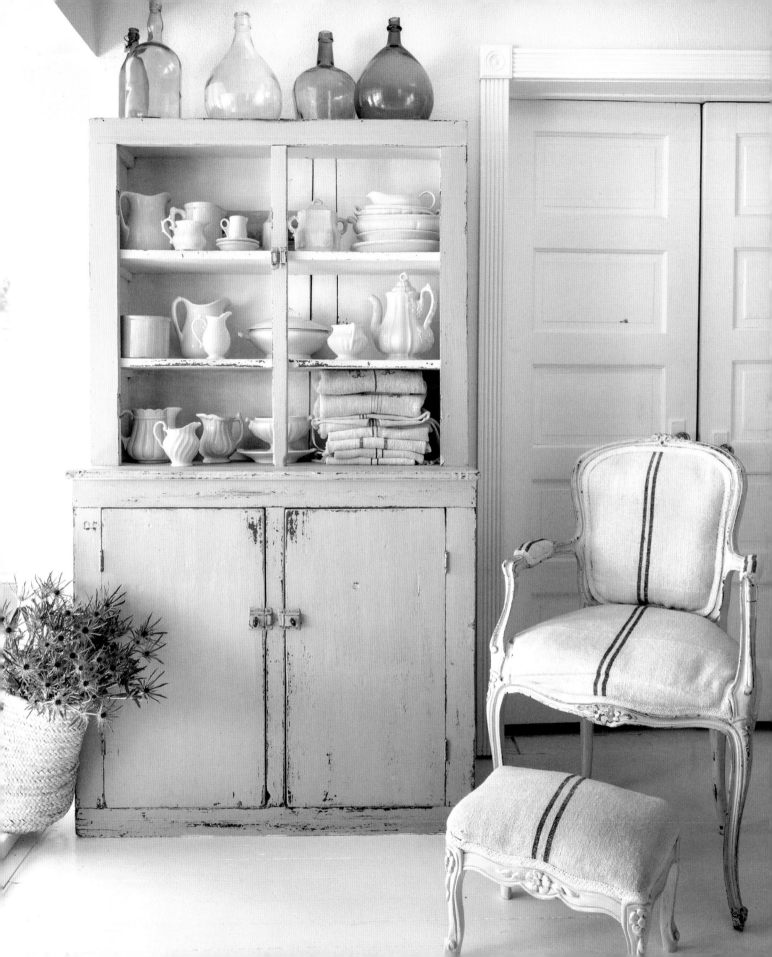

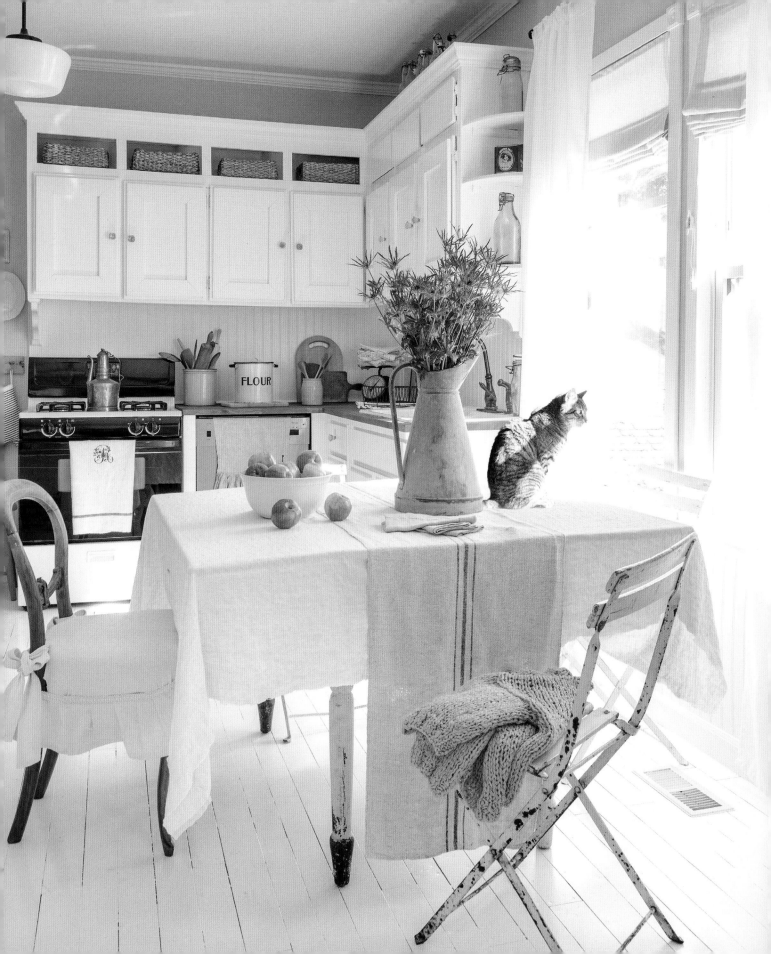

PAGE 86 The cupboard was exactly what René had envisioned for this space. "I believe it was the top half of an old hutch," she says. "It was originally yellow and it was a feat for my husband and myself to attach it to the wall." The drying rack makes a graphic statement, provides extra storage for keeping jars and mugs handy, and accents the room's French mood.

PAGE 87 René made the most of the space off of the entryway facing the living room. "It's been a hard space to define but we just refer to it as the sunroom since it's surrounded by windows," she explains. "The hutch was red when I bought it. I painted it with milk paint to achieve the weathered look that I love. I gave the chair the same treatment and reupholstered it with an antique grain sack."

OPPOSITE One of the first things René did when she moved into the home was to paint the original cupboards white and give the floor several coats of regular porch and floor paint, finishing them with polyurethane. "We added the bead board to the walls and replaced the countertops with butcher blocks. I stained them, and then sealed them with hemp oil and beeswax. My goal was to instill an old French country feel," she explains. And with the addition of the farm table and disparate chairs she succeeded in establishing the look she aimed for.

René concedes that her own style is a mix of several of her favorites: Cottage, French Country, Romantic, and English Country. "I am also inspired by so many of the talented people on Instagram. It has been a great tool in helping me define my own style." René set out to create a feeling of calm by pulling hues from a narrow range of hushed tones of white and gray. The end result is a home that feels good, flows well, and aligns with her sensibilities. But it took time to get there. "For me, the hardest part about decorating is being patient," she confesses.

"As most of my choices are antiques, it can take a while to complete a space."

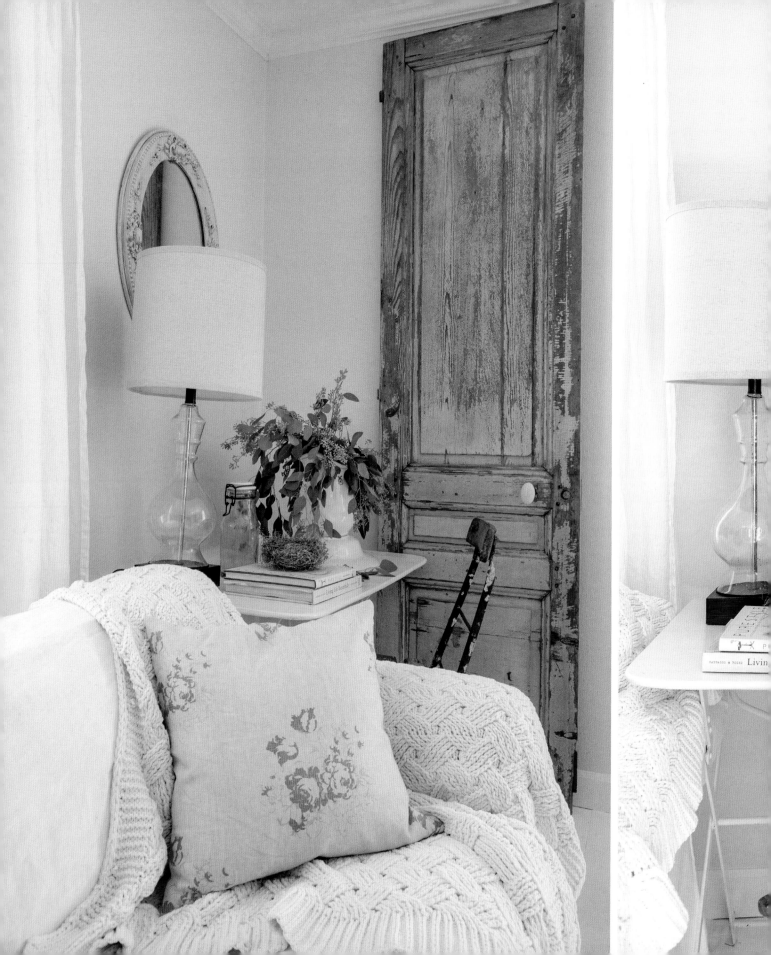

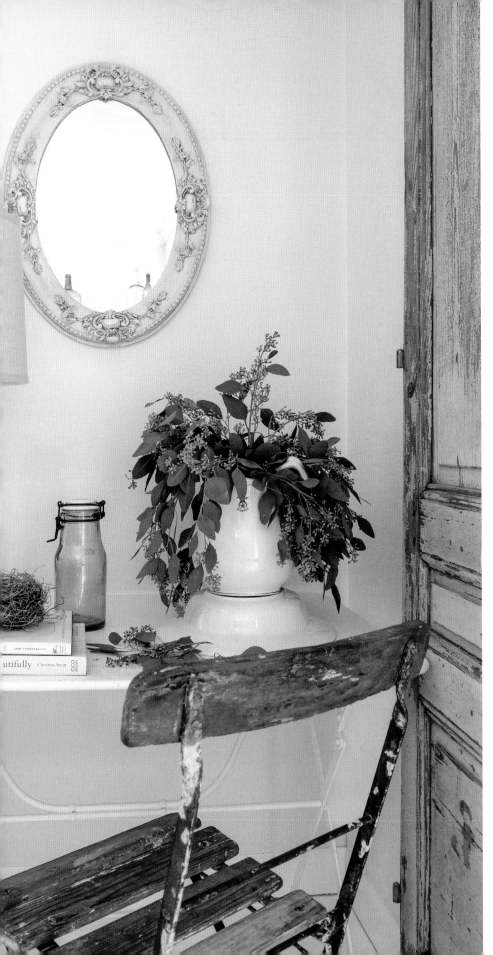

OPPOSITE An antique French door brings the eye upward while its light coffee hue gives warmth and texture to the little corner. A knitted throw and a floral Hatley Cerise pillow, from famed Cabbages & Roses, cozy up the newer sofa.

LEFT The metal French bistro table was shipped to René from England. Together with the garden chair, René gave it a new purpose as a desk. She painted the mirror with chalk paint, distressed it, and finished it with a dark wax to highlight its vintage feel.

RIGHT "I am all about light and bright. It's calming, happy, and welcoming," René says. Case in point, the living room is a luminous backdrop of pearly whites. "It's the perfect foil for the antiques I love, like the Napoleon III armchair dressed in a slipcover made from a French hemp sheet." A diminutive chandelier contributes a discreet romantic touch and contrasts with the rustic trunk. A small wooden bench and an old little stool double as side tables. René is partial to the stool. "I fell in love with it the moment I saw it," she recalls.

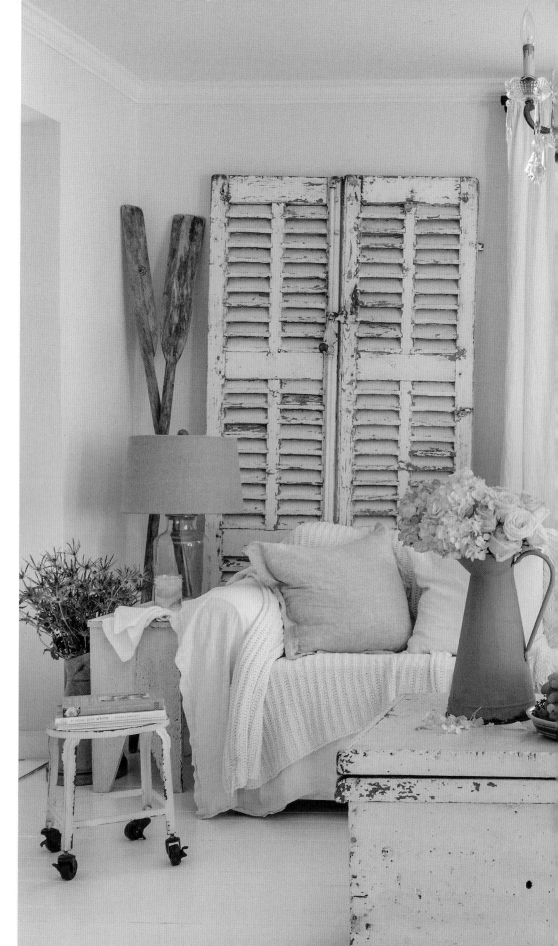

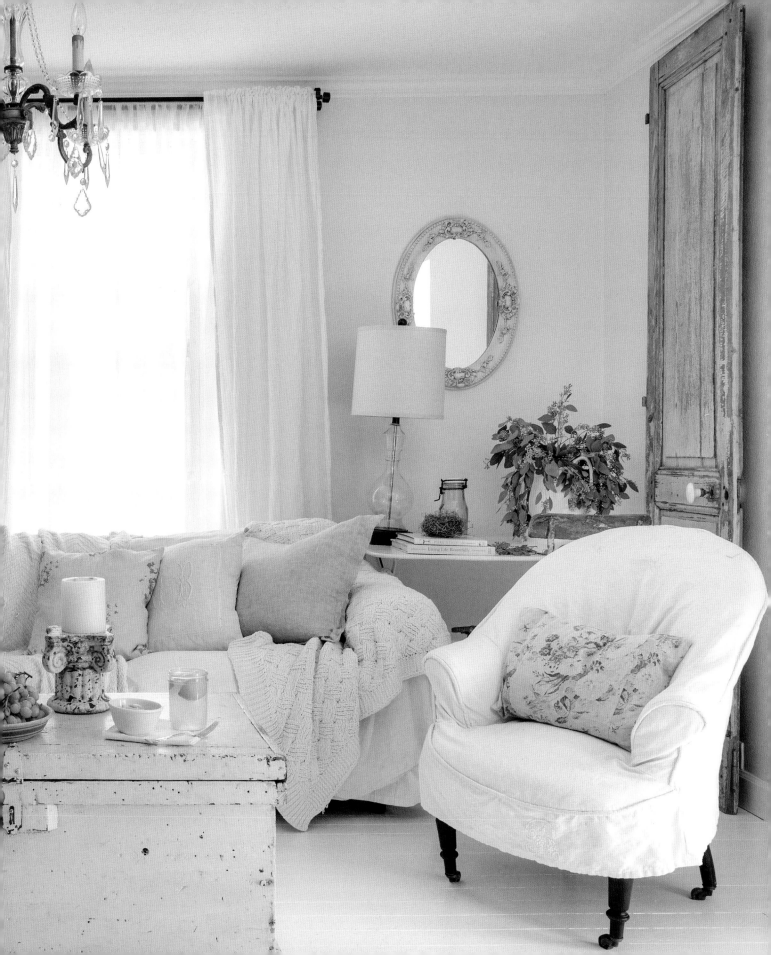

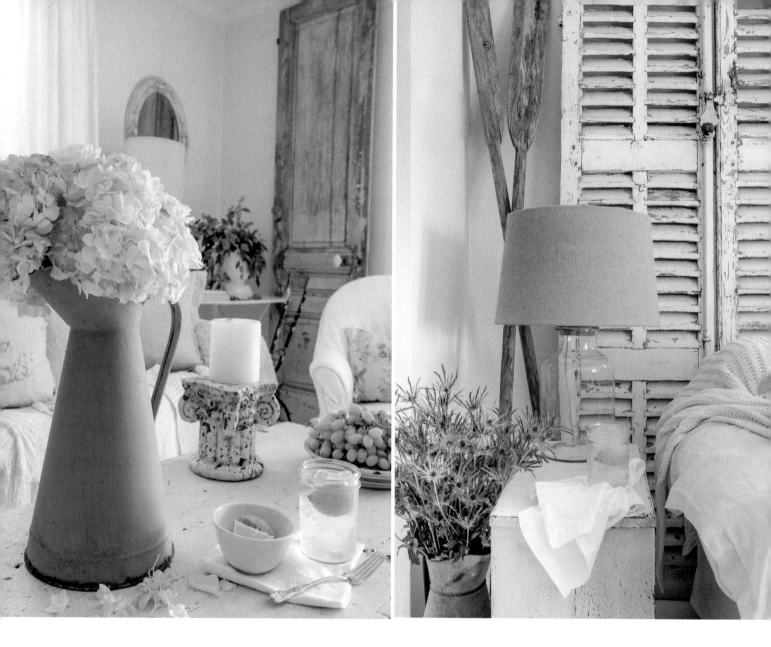

ABOVE A blue zinc pitcher filled with fading hydrangeas injects a bright note and a country accent.

ABOVE "The shutters were a birthday gift from my husband," René says. "He knows the way to my heart!" The oars were also a gift, from one of the couple's neighbors.

"For me, the hardest part about decorating is being patient."

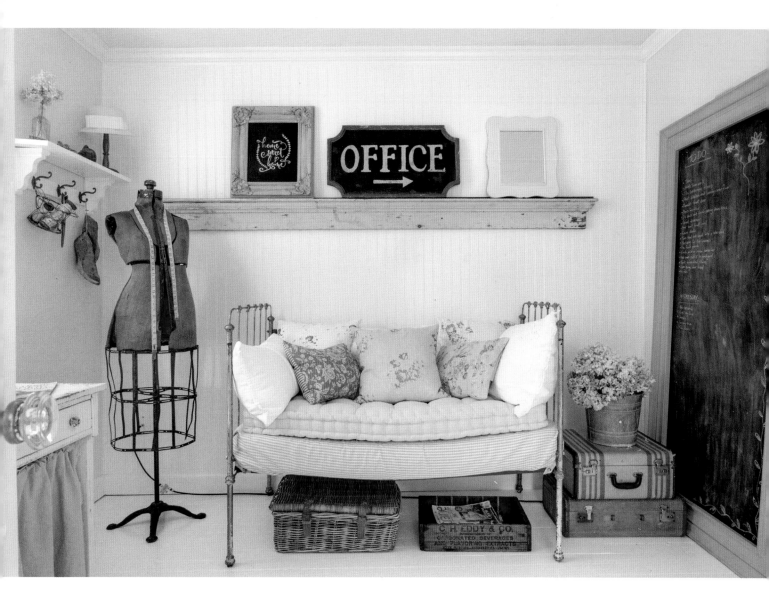

ABOVE "I believe when the house was first built this space was a bedroom," René states. She now uses it as an office/craft room. "I do sew, although I'm not very good! I make pillow covers, curtains, and other basic things." With its size and style, an old child's crib is a perfect fit for the small area. The dress form hints at René's stitchery endeavors. The blackboard plays dual roles as a statement piece and for making lists.

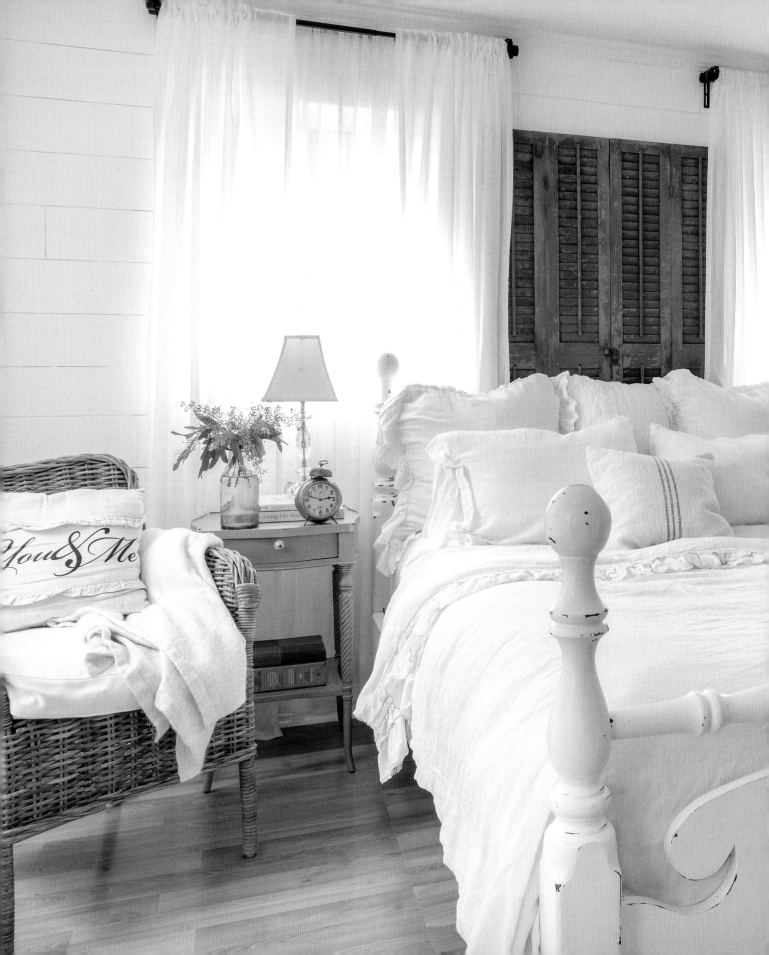

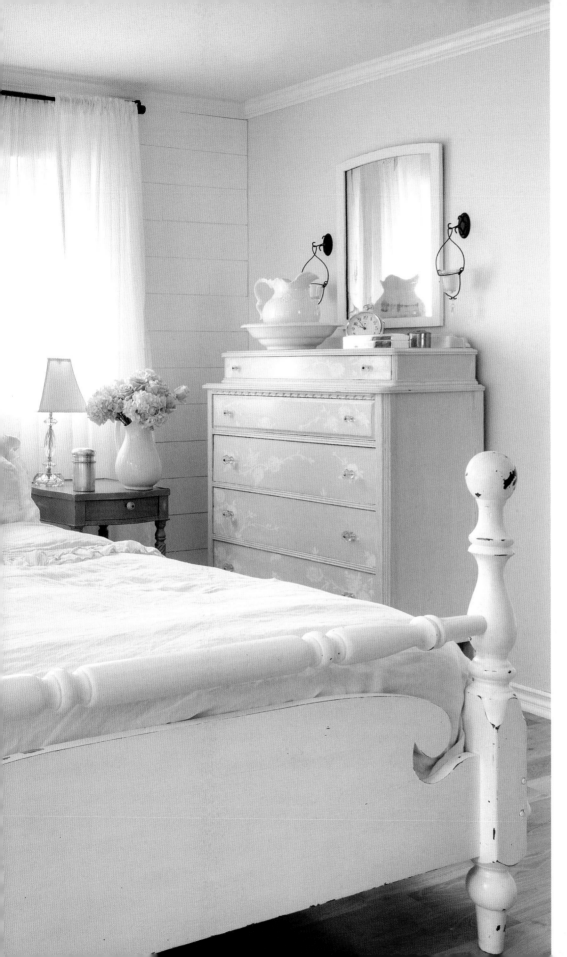

LEFT Randy installed shiplap to give the bedroom its cottage appeal. René selected a vintage bed, which she topped with new bedding for a cozy feel and ease of upkeep, and a grain-sack pillow for a timeless touch. She chose the wicker armchair for its texture and comfort and the shutters to add character.

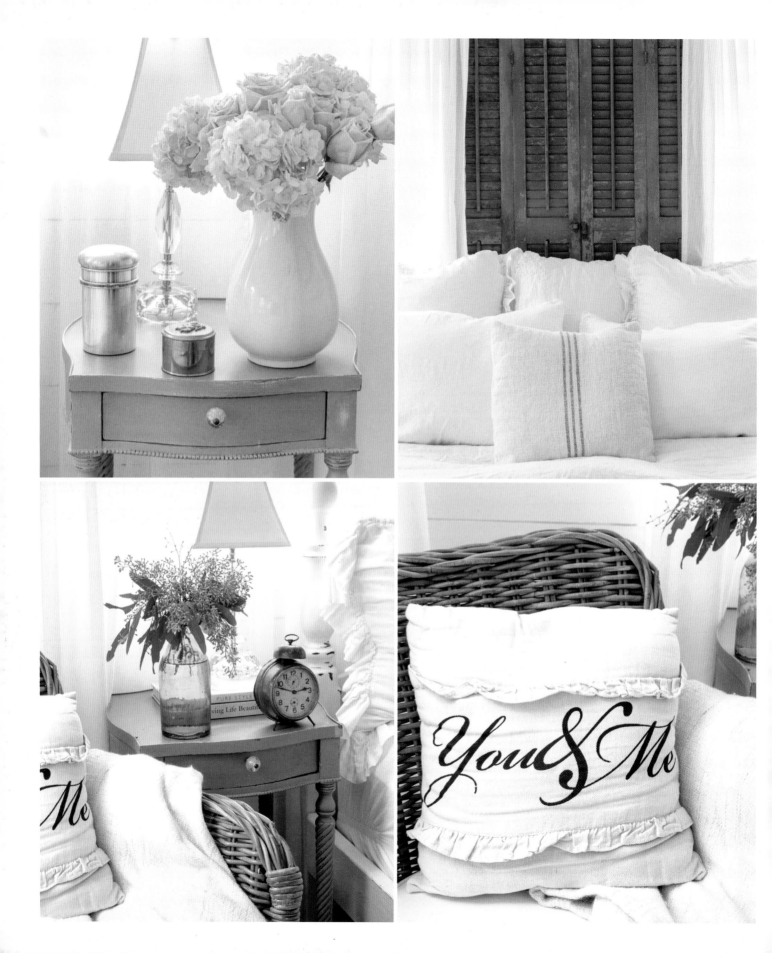

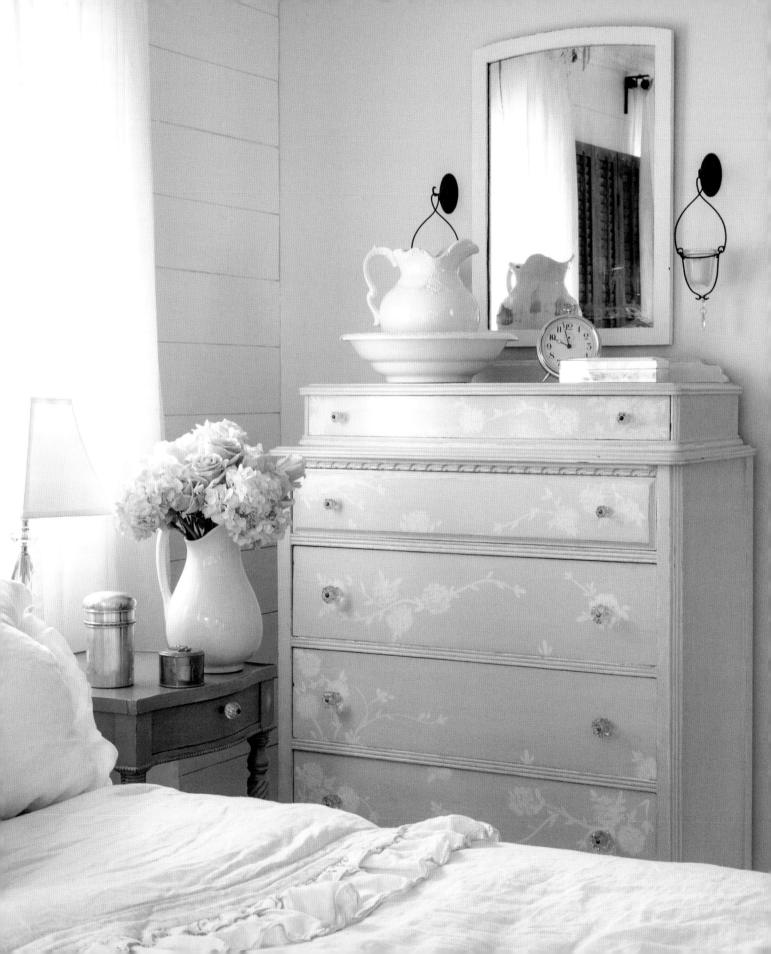

"We had been living in a tiny one-bedroom apartment, and moving into this 1,200-square-foot home was a huge improvement," René says. "I have loved living here ever since."

PAGE 98 ABOVE AND BELOW LEFT A pair of vintage nightstands was revamped with chalk paint and glass knobs to fit the decor.

PAGE 98 ABOVE RIGHT The tall, narrow shutters add definition and depth to the bedroom, but their aged finish also conveys a sense of history.

PAGE 98 BELOW RIGHT A readymade pillow spells out the couple's affection for each other.

PREVIOUS PAGE René worked her magic on this old dresser, giving it a glamorous finish with Miss Mustard Seed's paint in a silvery sheen, and painted the garland of flowers freehand with white paint.

OPPOSITE The bathroom wood vanity came with the house, but René painted it to suit her color scheme, and added the vintage glass knobs and the black-and-white backsplash and fretwork.

"Once I have the design of my space in my head, I then need to find all the elements to put it together. But that search can also be the most fun and the most rewarding part. As most of my choices are antiques, it can take a while to complete a space. I like to think of my home decor as something evolving over time." As René says, "it's a work in progress," and so she is always exploring antiques shops and fairs and roaming online outlets like Craigslist, Offer Up, Facebook Market Place, and Etsy for the next perfect piece. Right now, the search is on for a vintage stove: "I think it would be the icing on the cake and truly give my kitchen that Old World look and feel I want it to have."

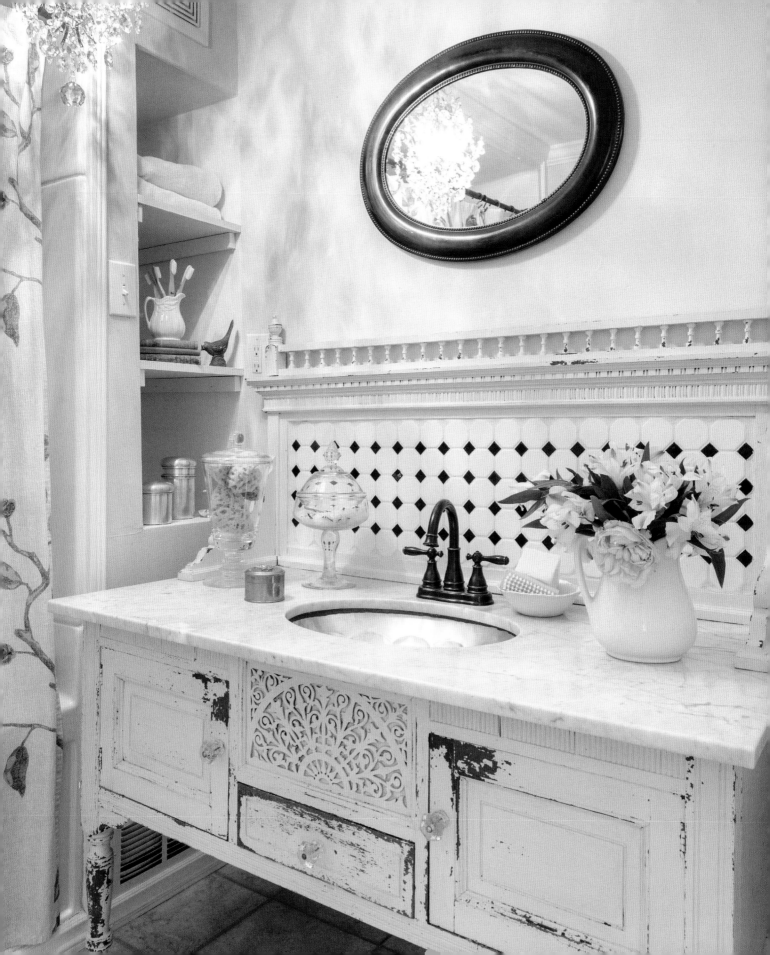

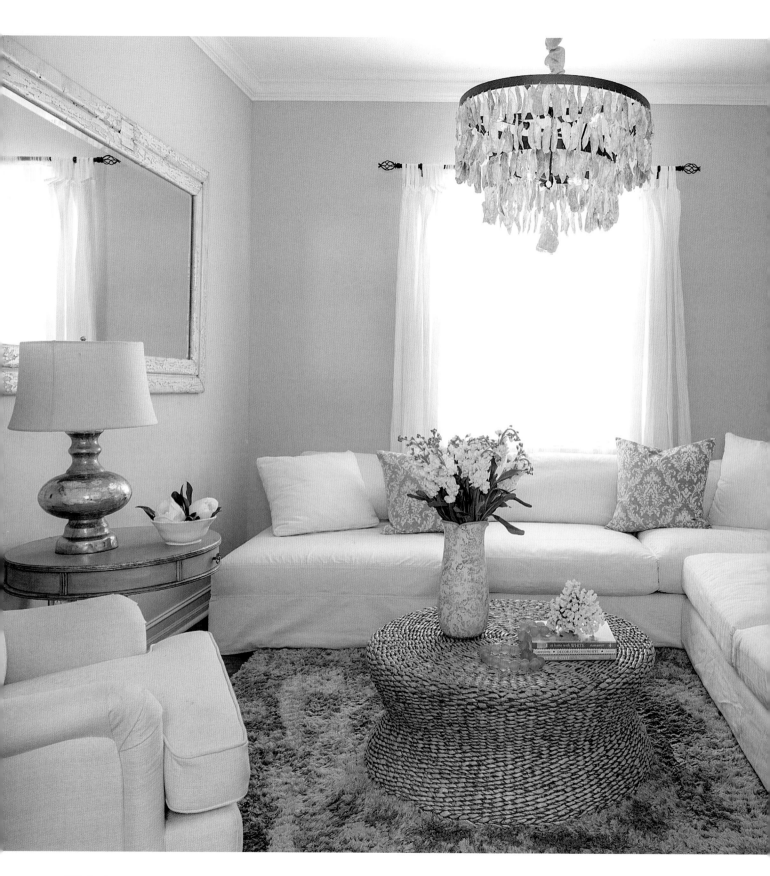

LEFT A one-of-a-kind set of old French doors came from a 1920s Mediterranean home belonging to one of Susie's clients who was ready to part with them. "We always knew we wanted to add character and charm to our home, and those turned out to be just what we were looking for." Thanks to his carpentry skills, Mark was able to install them.

CELESTIAL ROMANCE

IT CAN BE SAID THAT SUSIE HOLT KNOWS A THING OR TWO ABOUT CREATING DREAMY INTERIORS.

Susie's knack for designing beautiful spaces started very early on. "Honestly, I believe my decorating career began the day I was born," she says. "My parents would go to work and by the time they came home I would have rearranged all the furniture!"

LEFT With its two layers of oyster shells and a large crystal rock hanging from its center, the unique chandelier is the focal point of the inviting den. "I knew its organic feel was perfect for our home," Susie says. An old French window was fitted with some of the couple's favorite photos. The size, shape, and color of the wicker coffee table and the flaking patina of the mirror harmonize with the room's subdued hues.

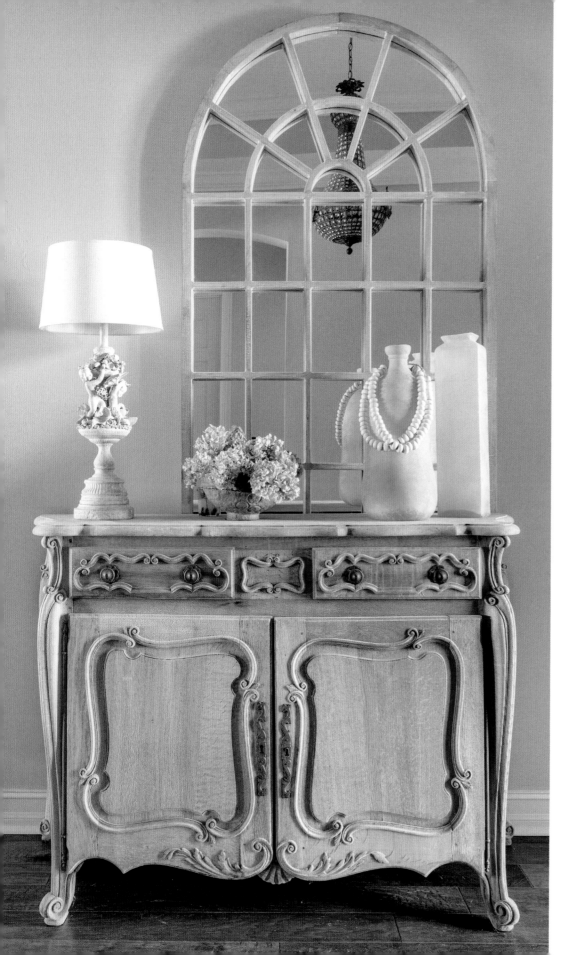

LEFT The dark hand-scraped wooden floor sets a contrasting foundation for the light oak of the early 1900s French buffet. The mirrored window reflects the Empire chandelier. Though the composition evokes the past, the modern bottles feel right at home and together with their color foretell the home's blend of decorating influences.

OPPOSITE ABOVE LEFT A large piece of coral becomes a three-dimensional art form when displayed as a freestanding object.

OPPOSITE ABOVE RIGHT In the hallway leading to the living room, Susie gave a pine sideboard pride of place because of its sentimental value. "It was in my parents' home for over thirty years and is very meaningful to me," she says. The same friend that constructed the one in the living room made the barn wood mirror.

OPPOSITE BELOW A linen upholstered French chair keeps company with the buffet of the same provenance. The seagull painting pays homage to the littoral.

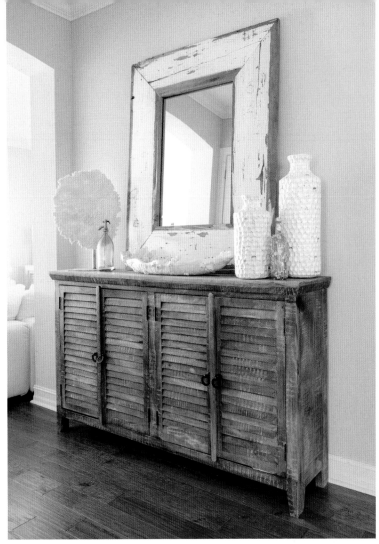

By the age of eighteen, Susie was styling windows for department stores. Her dream of owning her own shop and pursuing her passion for interior design came to fruition when she and her husband, Mark, opened Posh, a beach-chic boutique on the island of Venice, Florida. Twenty-two years later, Posh and the numerous homes Susie designed for clients are proof of her enduring love affair with pristine decor and exquisite interiors.

Susie is quick to credit her mom and dad as being her greatest influence: "They have always encouraged me and my siblings to do what we love. They were my biggest cheerleaders, along with Mark, who has so much confidence in everything I do. With that kind of support, you cannot fail."

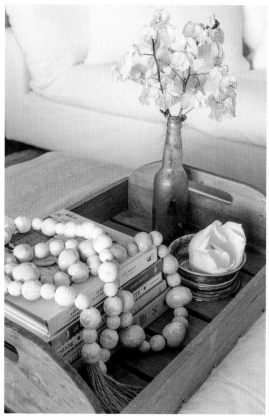

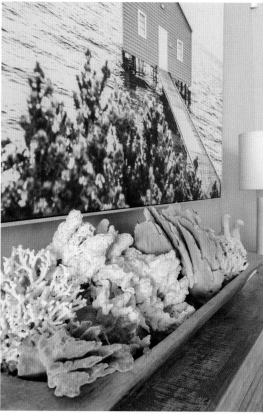

ABOVE A rustic tray holds painted beads in hues that mimic the changing colors of the nearby Gulf of Mexico. A tarnished silver bowl cradling a fragrant magnolia blossom and a vintage bottle with stems of white bougainvillea impart a sense of time and place.

ABOVE Nature's sea sculptures never fail to captivate. White and grayish-blue coral fragments are a fitting match for the painting's watery theme and colors.

Two years ago, while looking for a larger house, the couple decided to build their own. Prior to this recent move they had always lived in smaller cottages, so the biggest decorating challenge was to find the elements that would set the tone for the Zen retreat they envisioned. "We were not used to 3,200 square feet of space and extra-high ceilings, so it took a while to find just the right pieces to create the serene spa-like atmosphere we craved," Susie recalls. But the effort was worth it. "An empty home is like a blank sheet of paper on which you can live out your creativity," she notes. By focusing on the gentleness of soft tones, interesting shapes, and organic materials, her deliberate design choices weave an ephemeral cocoon through the rooms where coastal references echo the waterside location.

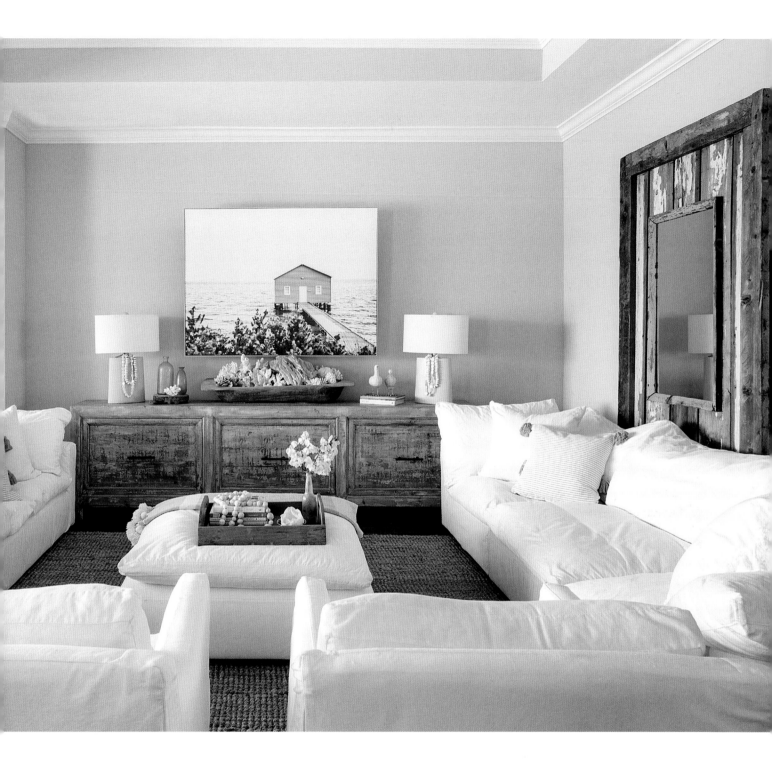

ABOVE Far from a stuffy seating area, the living room is proof that form and function can beautifully align. In a space intended to spark and kindle conversation, twin down-filled sofas and chairs slipcovered in white canvas encourage guests to lean in, sink down, and relax. The buffet appealed to Susie for its size, origin, and faded French blue color, as it reminded her of furnishings she saw while on a trip to Europe with her parents when she was sixteen years old. "I never forgot. It made a huge impact and has influenced my style for our store and our home." The boathouse painting was a lucky find not only for its color and subject but also because it easily and perfectly conceals the television. A pair of lamps with matte bases and linen shades diffuses soft lighting and adds symmetry. By layering muted hues, soothing fabrics, and textural finishes the room combines the elements that define effortlessly stylish and contemporary nesting.

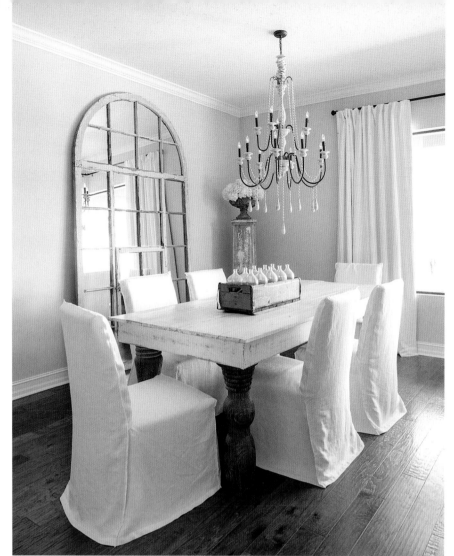

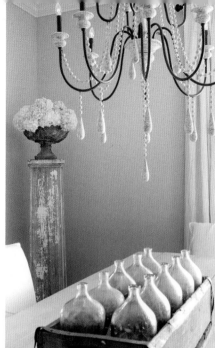

ABOVE In the dining room, vintage elements lend an air of artisanal charm. Parson chairs slipcovered in Belgium linen flank a 9-foot by 4-foot farmhouse table that Mark built from old wood and porch posts found on a trip to Texas. "We wanted a contrast between the driftwood legs and the white tabletop," Susie explains. The 10-foot-high arched French mirrored window is the room's pièce de résistance. "It is what was needed to ground the space," Susie says. The curvy black iron French country chandelier with white wooden beads and pendants crowns the room.

ABOVE RIGHT An antique French crate in a distressed blue finish accommodates a collection of old seltzer bottles in a display that is as visually lovely as it is becoming to the room. The column adds another level of character and dimension to the mix.

OPPOSITE Classic white Shaker-style cabinetry, a wavy glazed Italian subway-tile backsplash, a quartz-topped island, and linen slipcovered stools contribute style and function to the kitchen's chic modernity. Though fitted with clear and sizeable shades and large bulbs, the light pendants feel weightless and do not compete with or hamper the view of the dining room's chandelier.

ABOVE A grouping of utilitarian items reveals Susie's flair for creating a pretty and organic vignette.

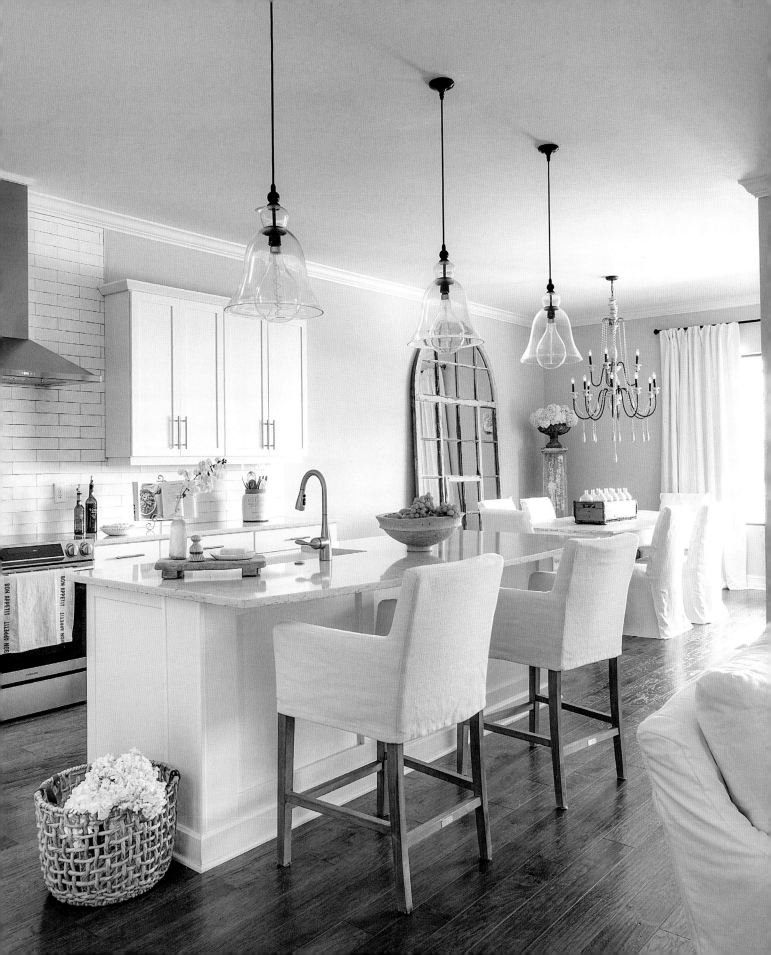

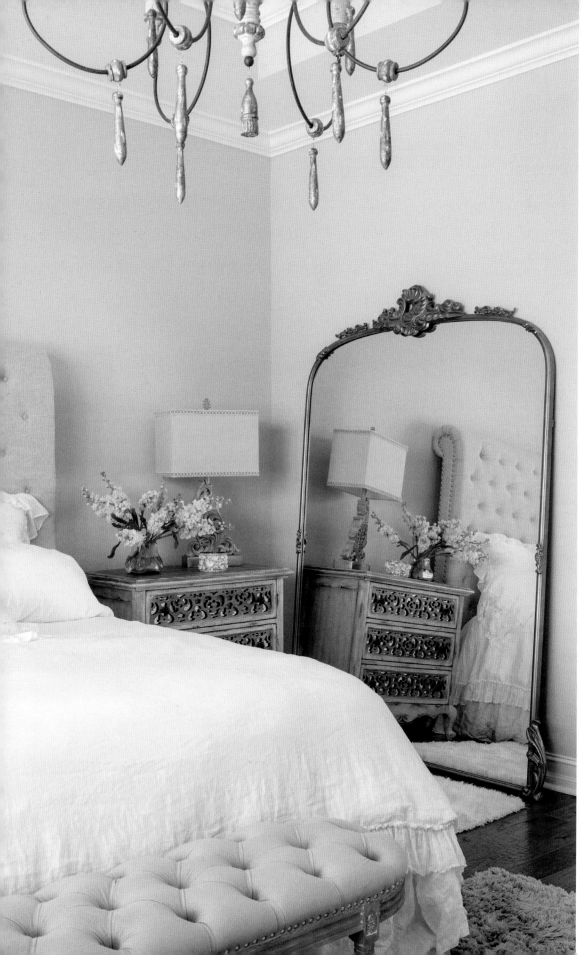

LEFT Aptly named "Grand Amelie," the imposing mirror commands attention, adds dimension and a touch of glamour, and amplifies the natural light while heightening the textural quotient by reflecting the dresser and the headboard.

OPPOSITE In keeping with her quiet, mellow palette and French country influences, Susie chose a kingsize bed with a tufted high rolled headboard upholstered in a sandy-hued linen. Luxurious linens are aesthetically at rest here. "As with the guest room, I didn't want a lot of furniture, but texture was important," Susie explains. Soft shaggy rugs, a velvet-clad bench, and a pair of dressers with an aged finish, fretwork, and mercury details bring in the tactile elements she wanted to impart.

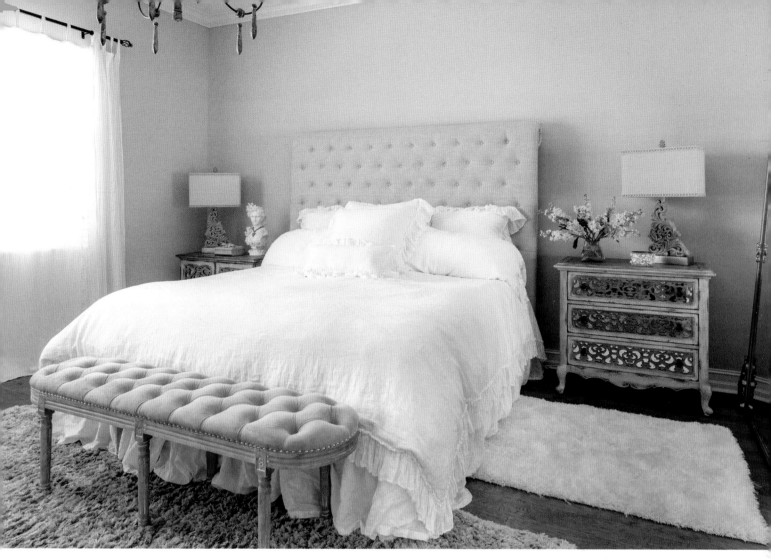

RIGHT With its taupe linen shade and iron base painted with a gray wash, the lamp keeps pace with the subtle color scheme and the room's French-inspired theme.

FAR RIGHT The dresser's weathered surface and fretwork imply age and history. The small shell-encrusted box connects it to the other treasured oceanic items evident throughout the home.

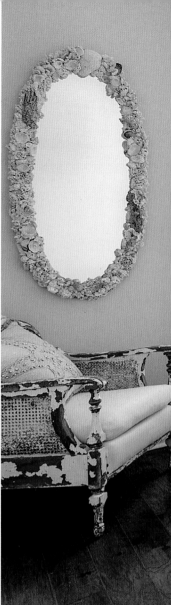
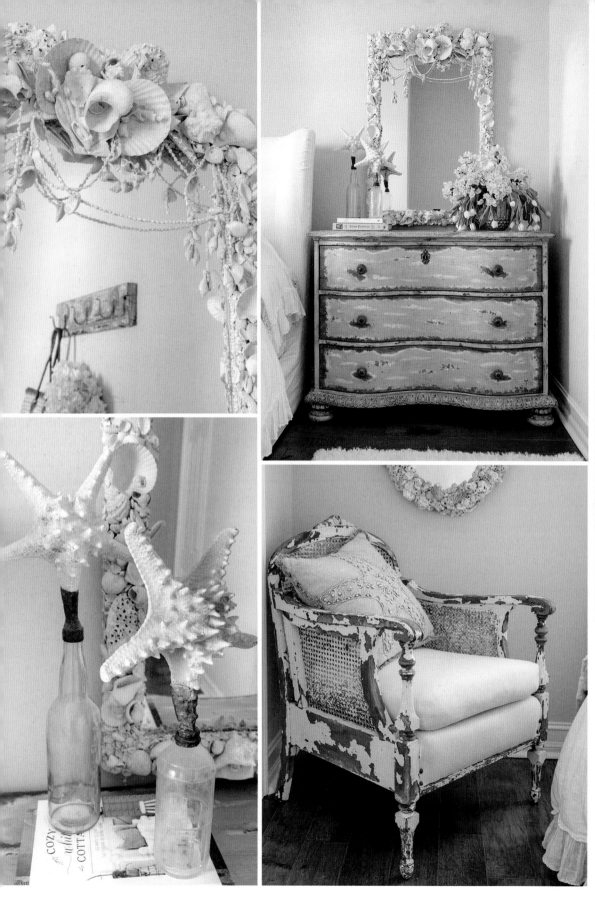

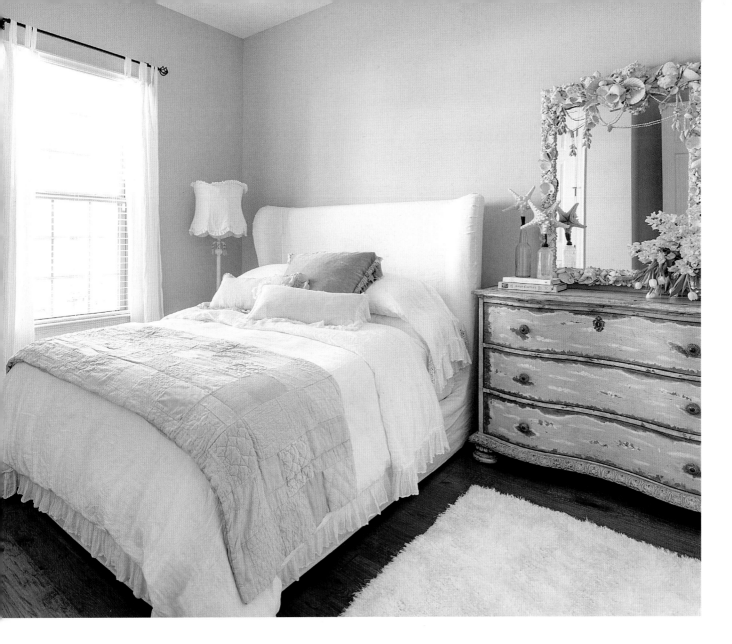

OPPOSITE ABOVE LEFT To create such an intricate and exquisite frame involves hours of collecting just the right sizes of shells, designing a pattern, setting them, and an eye for proportions and shapes, not to mention infinite patience.

OPPOSITE ABOVE RIGHT When you live by the sea, incorporating shells into home decor is natural. Susie commissioned this exquisite mirror especially for her home from a local artist. "I love beautiful, organic pieces," she says.

OPPOSITE BELOW LEFT Starfish welded to old bottles make fanciful finials.

OPPOSITE BELOW RIGHT "The French cane chair is one of those rare pieces with the perfect patina of age," Susie notes. She paired it with the mirror to create a cozy, chic corner that's both relaxed and refined.

ABOVE "I had been searching for a slipcovered curved wing bed for a long time and finally came across this one," Susie explains. "I didn't want an overdone guest room, just a couple of statement pieces, and this fit with the European Coastal look I was aiming for." But her quest for another perfect piece went on until the dresser revealed itself. Its sinuous shape, glorious color, and gently worn finish proved irresistible. "I wanted the room to feel welcoming yet light and airy," Susie says. Mission accomplished!

OPPOSITE "I am inspired by nature," Susie says. "Watching the sun glisten on the water and the crisp blue sky takes away any worries and makes you understand the value of simple things. Waking up to sunshine somehow sets your mood for the day!"

Susie also manages to strike a balance between new pieces of furniture with which to build out her space, while mixing in vintage finds to make it feel cozier and more personal. Though her love of white is undeniable, she likes to include a touch of romance and softness with hints of pale blue hues, especially French blue. "I have always loved white," she says. "In fact, I have decorated with white for over thirty years. The serenity and purity of it make me feel calm and peaceful the moment I walk through the door."

The nuanced color ways offer boundless possibilities. "You can learn so much about a home through the synergy of its shared space. It has to flow seamlessly," she says, pointing to the open floor plan of the main living area. Looking at the sustained crisp and tranquil ambiance that pervades, it's clear that Susie achieved the spa-like mood she wanted to instill. In spite of their designated functions, all rooms signal serenity from every angle.

Organic yet tailored, casual yet polished, Mark and Susie created a timeless home to cherish now and forever. "It truly is our haven. It's like being on vacation every day of our life!"

It is, indeed, a heavenly retreat from a chaotic world.

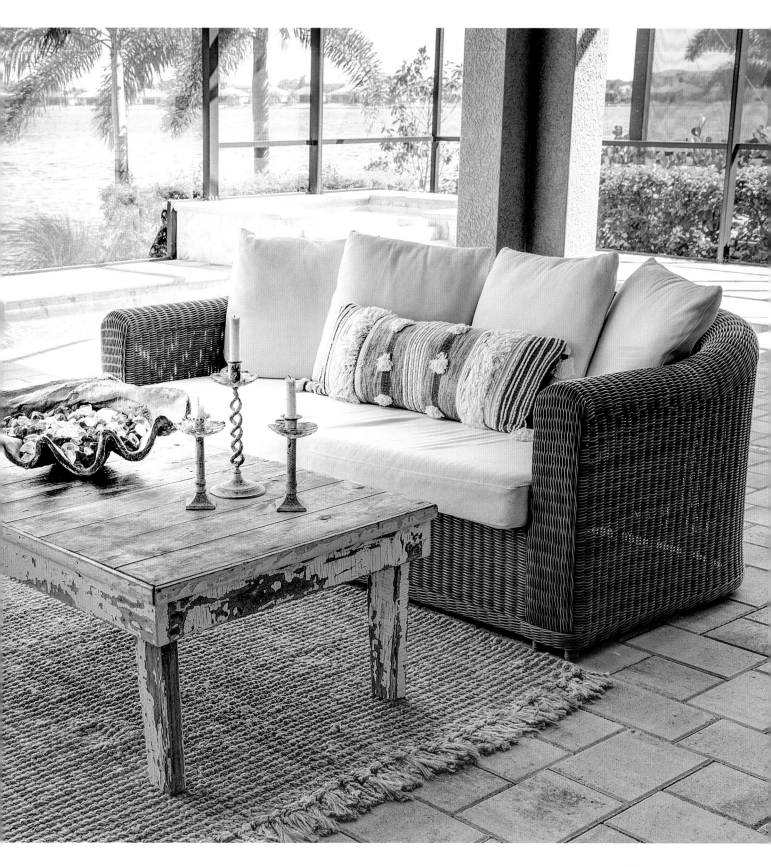

ZEN ELEMENTS

JODI AND JOHNNY GOLDBERG'S SPRAWLING CALIFORNIA PROPERTY EXUDES A POWERFUL SENSE OF TRANQUILITY. BUT NEITHER THE RANCH-STYLE HOME NOR THE SURROUNDING GARDENS WERE ALWAYS THIS IDYLLIC.

After losing their longtime family home to the catastrophic Montecito mudslide of 2018, the couple moved to their present Santa Barbara residence, where Jodi applied her magical makeover formula to transform the interior and tame the wild grounds. "I was grateful to have this project to focus on. It helped us to heal from the loss of everything we knew and loved," says Jodi, who owns Jodi G Designs, an interior and landscape design firm in Santa Barbara.

ABOVE Lush and verdant plants, vines, and trees cloak this enclave in privacy. Oversized chairs work well for this space and create a comfortable spot to read, listen to birds sing, or watch the sky at dusk.

OPPOSITE Jodi made a lot of changes to the landscaping to make it her own. "I added olive trees for privacy, potted plants, fountains, and, of course, Buddha. I made sure to create a drought-tolerant garden that's easy to maintain."

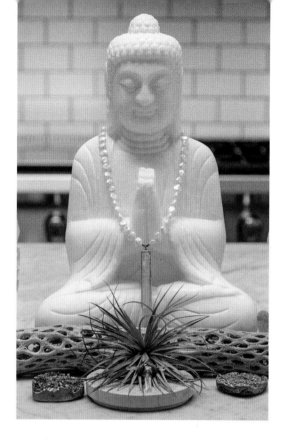

ABOVE "This marble Buddha was a special house-warming gift from a friend to bless the house," Jodi says. "His necklace is made of irregular pearls with a selenite crystal pendant. Selenite is believed to have cleansing qualities and dispels negative energy, hence bringing calm and protecting the home." The two gold crystal hearts that lay in front of the Buddha were also a gift to Jodi from a friend because of their meaning. "She says I remind her of love and hearts symbolize this sentiment."

RIGHT The home has been designed to encourage engagement with the outdoors. The living room opens to a terrace complete with a comfortable seating area surrounding a fireplace, overlooking the garden below. "We love to sit out here to work, relax, dine, watch the sunset, and take in the ocean views," Jodi says.

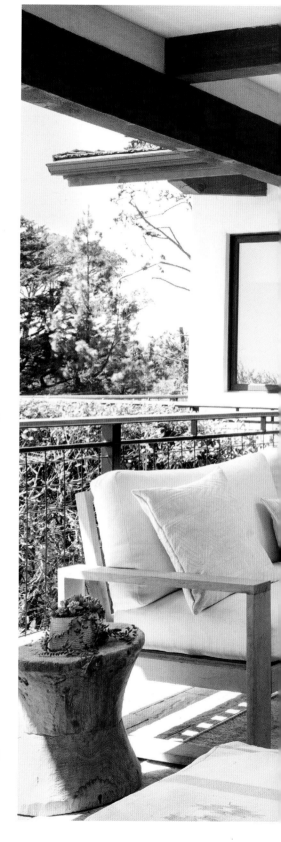

Jodi has always been sensitive to space and light and how they impact one's emotional and environmental wellness. "I wanted to create an organic, light-filled sanctuary," she says, adding, "The key points of spaces designed with a holistic approach are functionality and energy flow. For me the process is very intuitive." And that feeling of wellbeing is exactly what was achieved with her soothing palette of whites and creams, layered with natural textures and finishes, brought to life with collected and meaningful art and textiles.

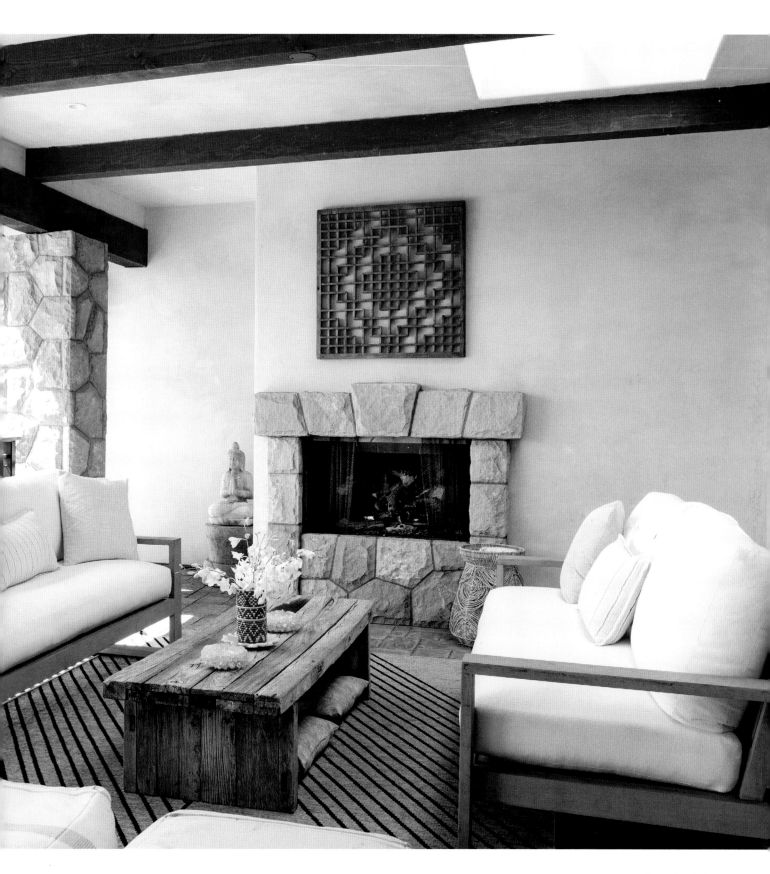

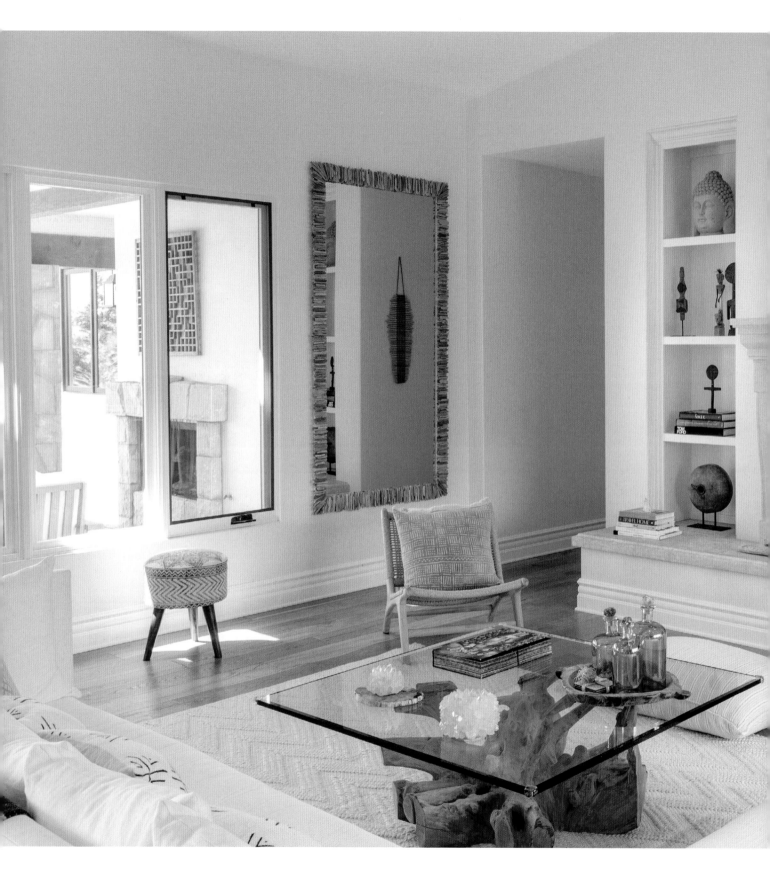

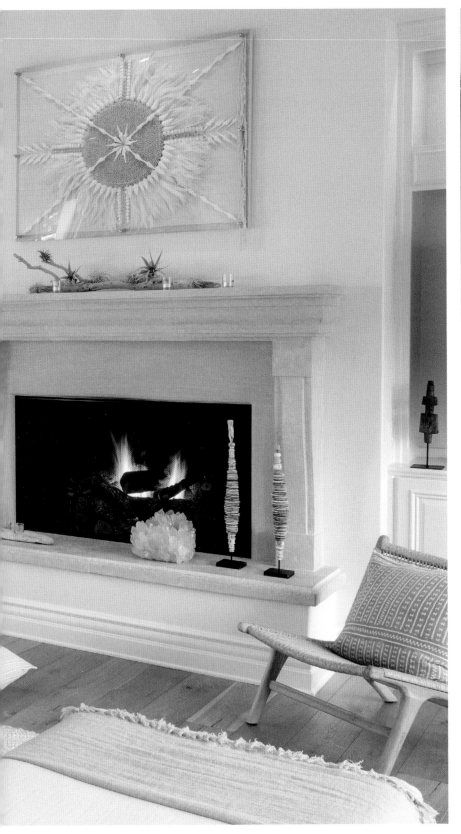

LEFT Above the original fireplace a piece by San Francisco-based artist Trudy Lynn Elliott features vintage ivory African mud cloth with cowrie shells, white rooster feathers, and white spindle shells. Jodi commissioned the mirror from a local artist who collects driftwood from Santa Barbara and near-by beaches. Floor pillows and a pair of low chairs add to the relaxed feel and tie in with the various natural elements of the space.

ABOVE Jodi found these two stacked bone pieces from Africa through a curator in Los Angeles.

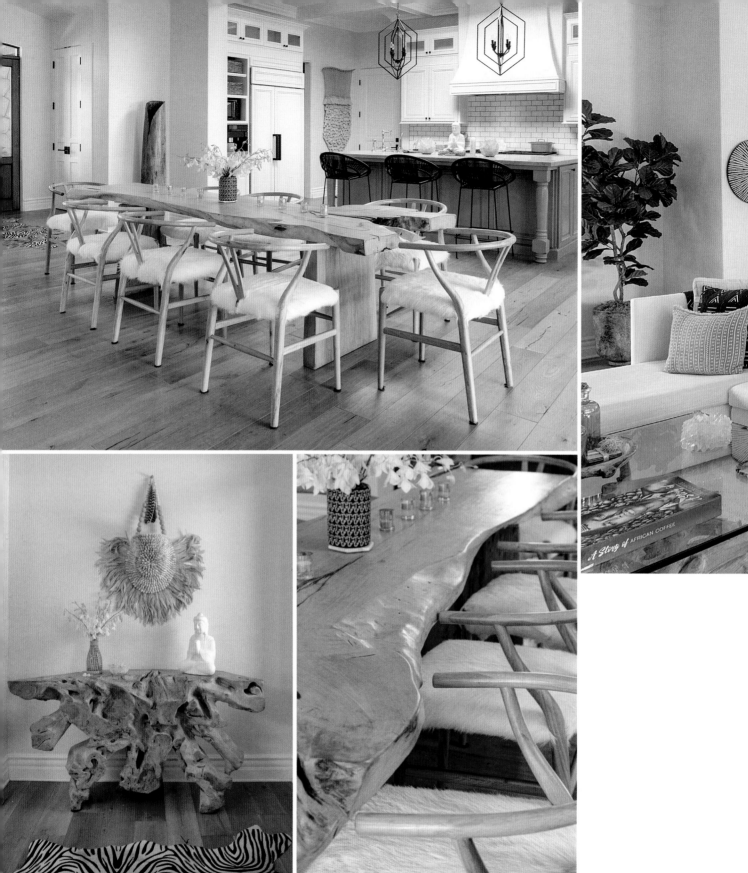

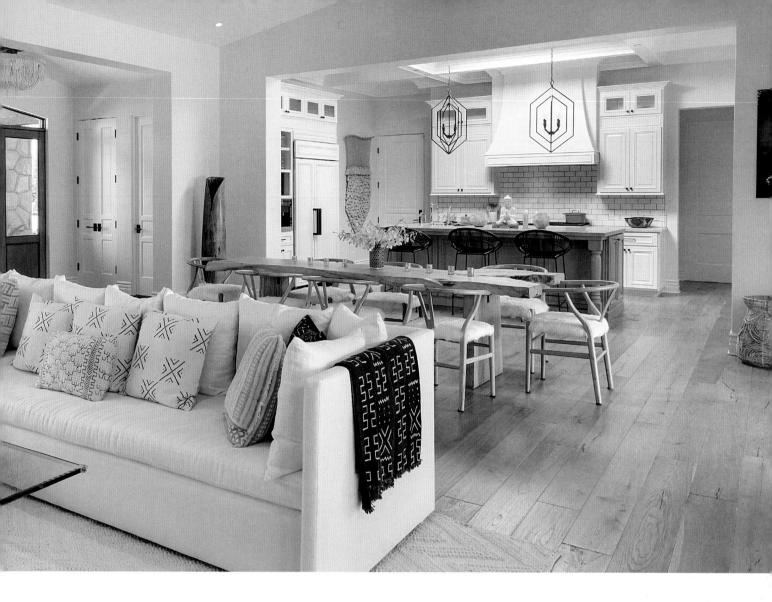

OPPOSITE ABOVE "The dining-room area called for a massive piece," says Jodi, who selected a live-edge organic Suar table from Indonesia. "The movement and aesthetic of the table captured my attention," she adds. In the background a stripped and stained palm-tree trunk from Bali makes an exotic sculptural statement. "I was drawn to the piece because of the color and size. It adds a unique grounding element," Jodi says.

OPPOSITE BELOW LEFT A sculptural teak-root console displays sacred items collected by Jodi from her travels. The wall hanging by artist Trudy Lynn Elliott is made with ethically sourced shells and feathers. A faux zebra hide accents the foyer's inviting and spiritual mood.

OPPOSITE BELOW RIGHT "I love how when someone opens the front door, they are greeted by the beautiful table and ivory faux-fur chairs. This dining scene helps set the tone for the entire house," Jodi explains.

ABOVE The wide-open main living space facilitates an uninterrupted flow from one room to the next and to the outdoors. "It was designed for entertaining family and friends," Jodi says. "My husband, Johnny, and I wanted a beautiful space that we could live and play in. We envisioned an organic living area with a seamless connection from inside to out." Jodi is careful not to over-complicate the space, relying instead on natural elements that come together in layers of texture and neutral hues.

"The large sofa was the perfect addition to the open living room," she notes. "I love a sofa with a chaise to comfortably curl up and watch a movie." For contrast and texture, she chose African mud cloth for the pillows. "It has been a favorite go-to textile in my design practice for the past twenty years," she points out. A wool rug offsets the sleek glass of the coffee table and helps warm up the expansive space. "It's also soft and comfortable on bare feet—a must!" Jodi adds.

RIGHT Jodi updated the kitchen with the black accents from the lighting, hardware, and barstools. The wall hanging holds a special meaning. "An Australian woman founded a company to help sustain the lives of the women of the African village where it was made," she explains.

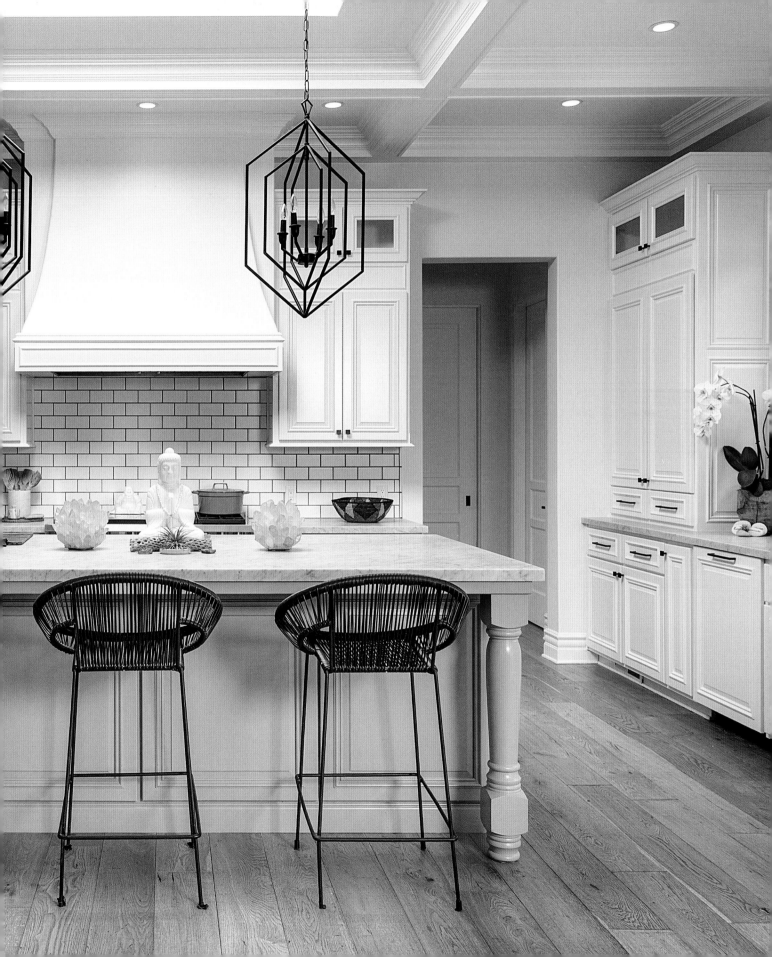

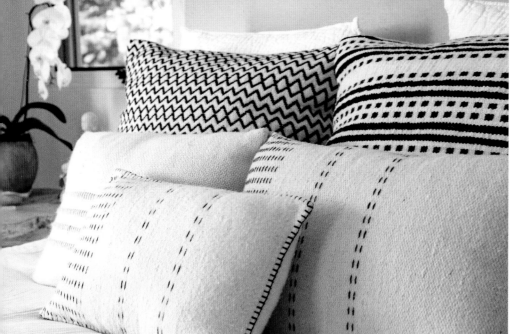

ABOVE Set against the linen-upholstered headboard, pillows in Jodi's signature African mud cloth add gentle ethnic touches to the neutral room.

RIGHT Cherished gifts from friends and family as well as pieces collected from faraway lands, including some crystals, sit close by on a simple bedside table. "I have always been drawn to crystals because of the energy they give off and the calming presence they provide," Jodi says. "When I travel I can't help but collect new ones."

FAR RIGHT The leanly furnished master bedroom takes on a Zen persona with its simplicity and meditative elements that reflect Jodi's mindful approach to living. Large windows draw nature inward, enhancing the peaceful and stress-free feeling. The quiet decor is intentional and the room includes eco-friendly materials like the custom hand-carved bench made by Jodi's favorite Santa Barbara woodworker.

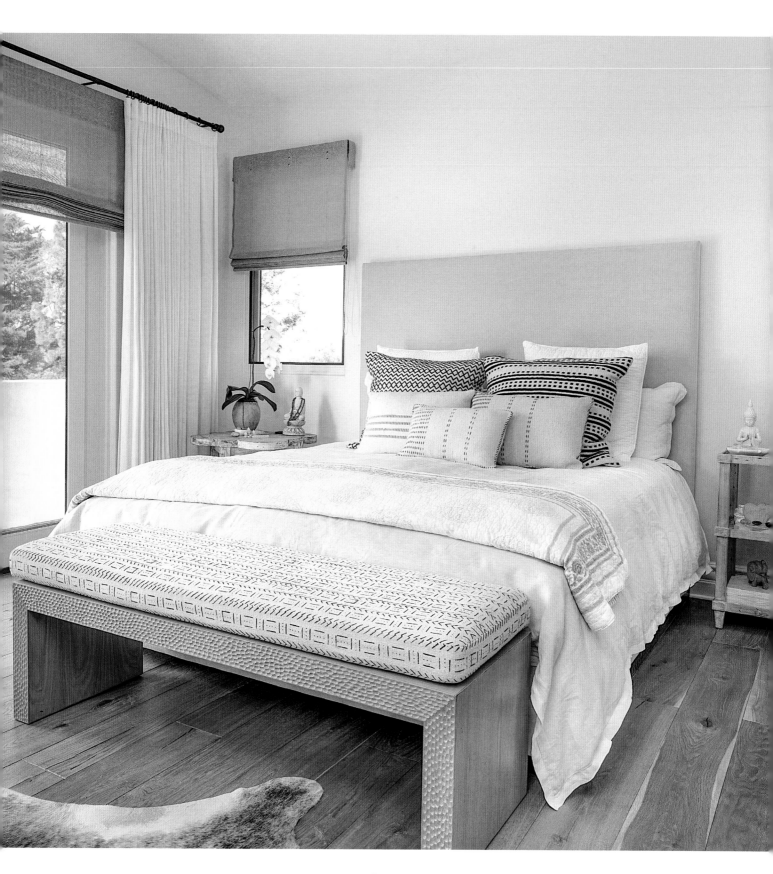

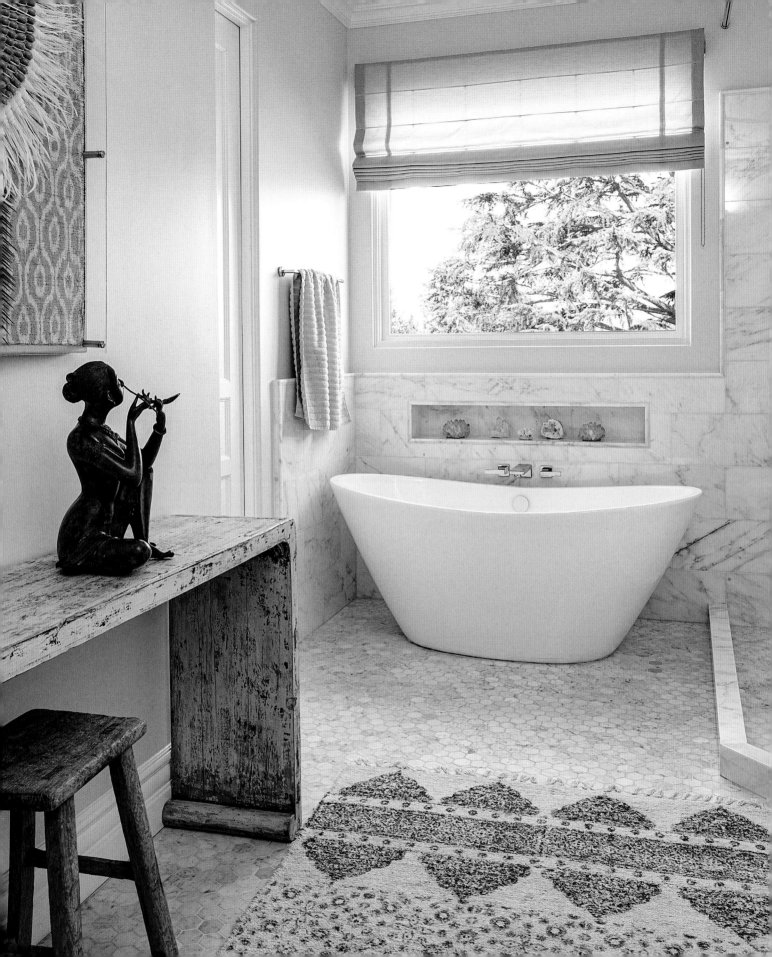

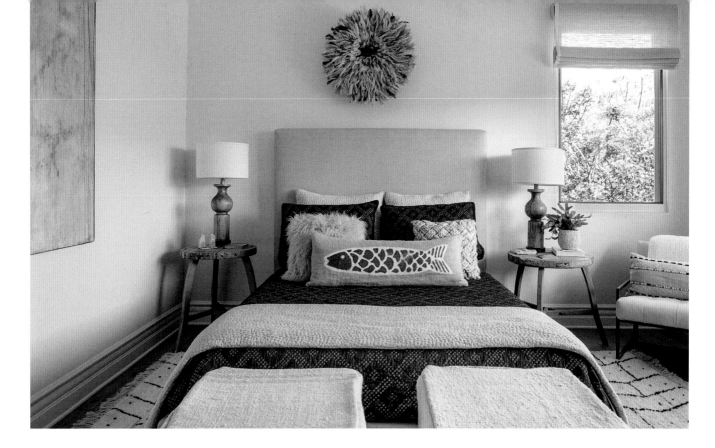

OPPOSITE A spa-worthy freestanding soaking tub is the focal point of the bathroom. An antique console balances the modernity of the space. The delicate sculpture of a woman is very dear to Jodi, as it was a gift from her mother, who has since passed. The tribal feather and beaded artwork establishes a connection to the rug.

ABOVE "In the past, I never really included blues in my designs. But recently I've really enjoyed bringing the color into spaces," Jodi says. "One of my favorite ways to incorporate a pop of blue is through indigo fabrics, like the pillows and throw in this room." Above the bed a traditional tribal African juju hat symbolizes prosperity. "I love integrating these hats into my designs to bring texture, culture, and personality to a room," Jodi says. Though the nightstands are made with reclaimed wood and the lamps are new, the colors and shapes work harmoniously together.

The main open-plan living area includes a spacious living room, dining room, and kitchen, each opening onto a terrace overlooking the gardens and the ocean beyond. Having the inside flowing seamlessly into the outdoors was important to Jodi, who cherishes the connection to nature.

Both Jodi and Johnny, who is known professionally as Johnny G and invented fitness programs Spinning, Kranking, and In-Trinity, often work from home, so Jodi made it a priority to design inviting spaces where they could let their creativity flow.

Throughout the house, raw materials, patterns of light, and furnishings with straightforward lines lend a sense of aesthetic calm. Jodi casts aside clutter yet keeps rooms highly personal with meaningful pieces that reflect the couple's philosophy of peaceful living.

Visually balanced, gently contemplative, and thoughtfully furnished, Jodi and Johnny's home is a study in serenity where nature, culture, and harmony are purposefully and skillfully united. "It's our Zen retreat," Jodi says.

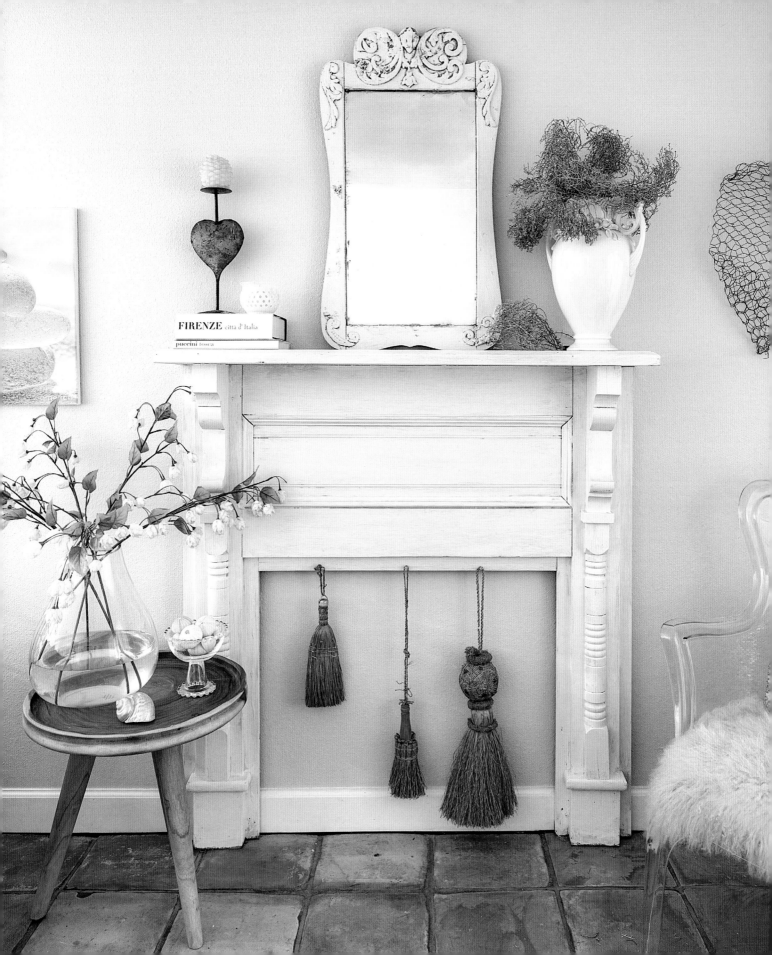

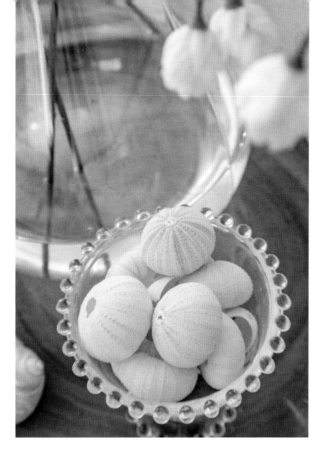

OPPOSITE The mirror is one that has stayed with me through every move. I made the chicken-wire heart a long time ago and it has seen various colors over the years, but whatever hue it takes on, its symbolism remains the same.

LEFT Beachcombed finds, like these tiny sun-bleached urchins, are a reccurring theme of the decor.

FANCIFUL CHIC

WHEN I MOVED TO CONNECTICUT IN 2020 I SOLD MY FLORIDA COTTAGE FURNISHED EXCEPT FOR A FEW PIECES THAT WERE DEAR TO ME. I FOUND A WONDERFUL HOME TO RENT AND PROCEEDED TO FURNISH IT. BUT AS FATE WOULD HAVE IT THE PANDEMIC HIT, AND AFTER A YEAR IN NEW ENGLAND I DECIDED TO COME HOME TO ROOST, SO TO SPEAK.

I loved the northeast, but the circumstances made it impossible for me to stay there. It was an adventure, one that gave me a chance to reevaluate many things, including the need to reinvent myself. And with that came the desire to create a new home environment.

OVERLEAF I have always loved having a fireplace in a living room, even if it's just a mantel. To me it says "home," and it's a perfect stage for seasonal decorations. This one came unpainted and I tried to keep it in its natural condition, but deep down I knew it would end up white. I opted for the wicker coffee table for its texture, shape, and organic material, and to ground the room. As for artwork, it has to either reflect my love of books or be a soothing scene.

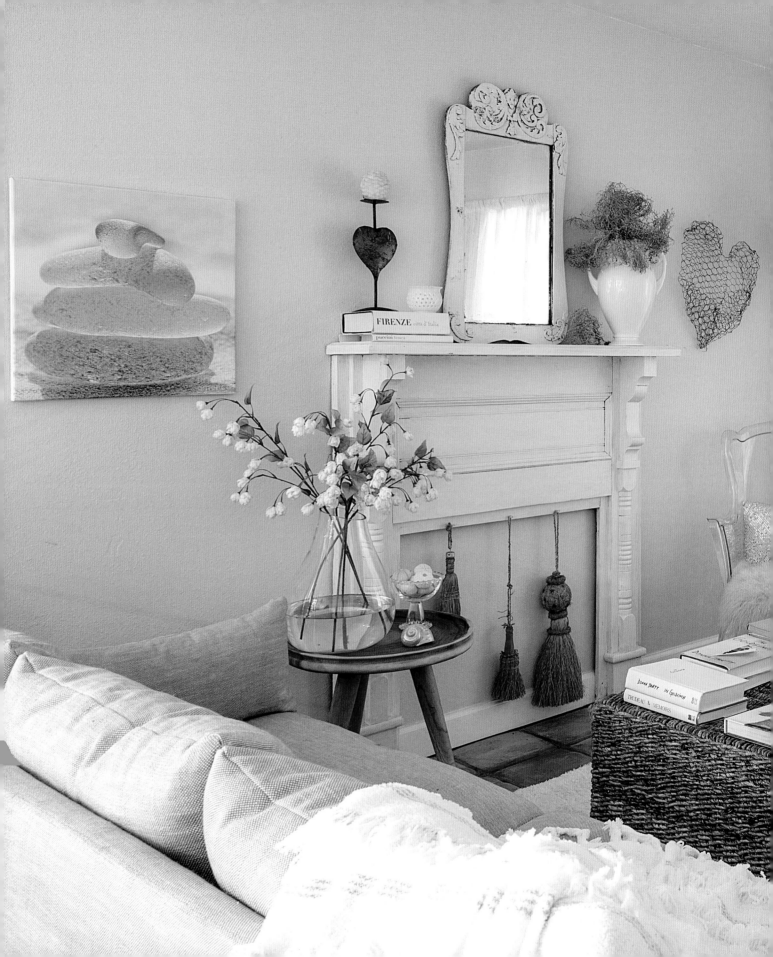

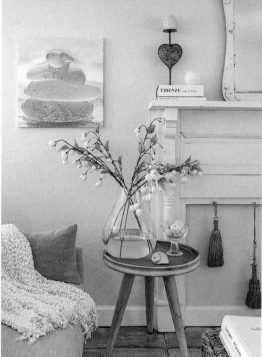

Moving back meant renting, as the real-estate market had exploded. However, landlords don't favor someone with three cats. But I got very lucky. A friend happened to have completely remodeled a home she wanted to rent and, better yet, she happens to be a cat lover! I actually decided to rent the house without even seeing it before driving back to Florida. It's a sweet home nestled among mature trees in a very quiet neighborhood. It's not large, but it's spacious enough for my kitties and me.

I wanted the rooms to feel ever so calm and soothing and the freshly painted walls provided the perfect backdrop. The hue is hard to define, as it changes with the natural light, morphing from the faintest gray to a barely-there blue.

When you move into a new home it takes time to figure out how to best utilize the space, but I knew I wanted it to have a quiet energy, serenity, and comfort.

One of the nicest features is the main living space that bridges the kitchen, dining room, and living room, which opens onto the porch that allows the sunlight to flood the whole length of the linear space. But the most challenging aspect of that design was to configure each area so they would flow seamlessly yet have their own identity.

ABOVE LEFT Snow-white buds nodding from graceful stems deliver delicate notes.

ABOVE CENTER Textural accents from the side table, brushes, and a nubby throw contribute warm touches.

ABOVE RIGHT Being surrounded by books never fails to make me feel home and settled. There is something reassuring about their presence, like that of old friends. Instead of occupying a bookshelf, they take center stage on the coffee and side tables, which they often share with fragrant candles or fresh flowers, or just get piled on the floor.

OPPOSITE As much as I enjoy a comfy sofa, there is nothing I like better than a cozy reading spot with a roomy chair. I love the ample Lucite armchair's light and airy style. The blush fur pillow feels sumptuous to the touch and the sequin one adds comfort and a hint of glamour. The Ikea pendant provides not only great reading light but also a whimsical touch. The book canvas is another piece I have had for over twenty years. It adds a graphic impact, but by bringing the eye upward it also creates an illusion of more vertical dimension.

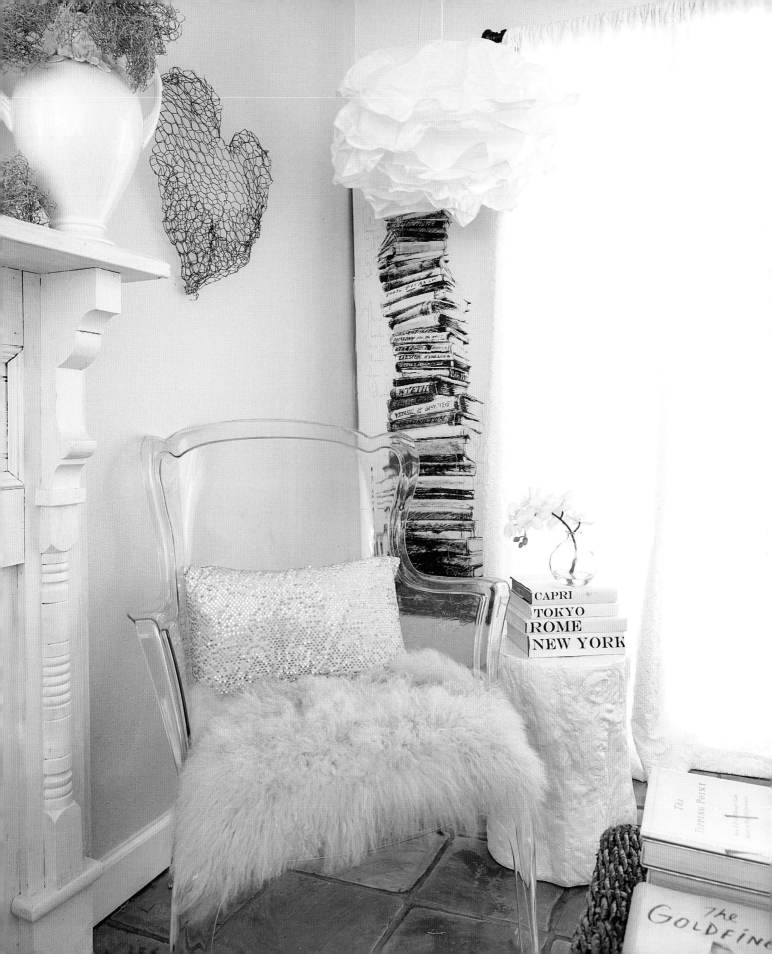

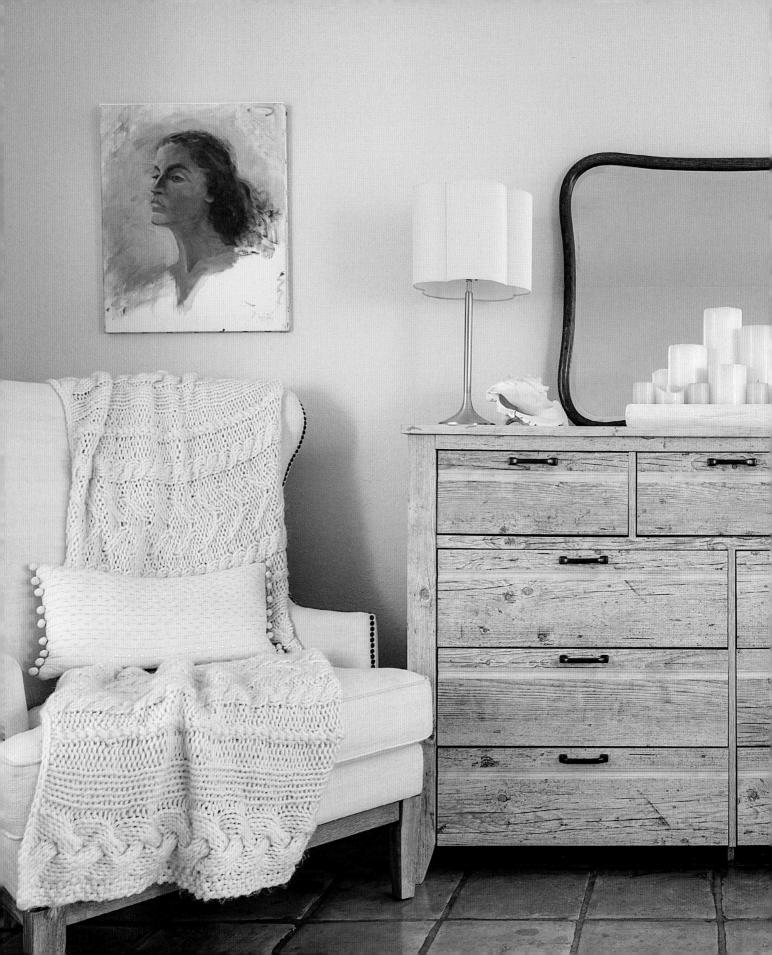

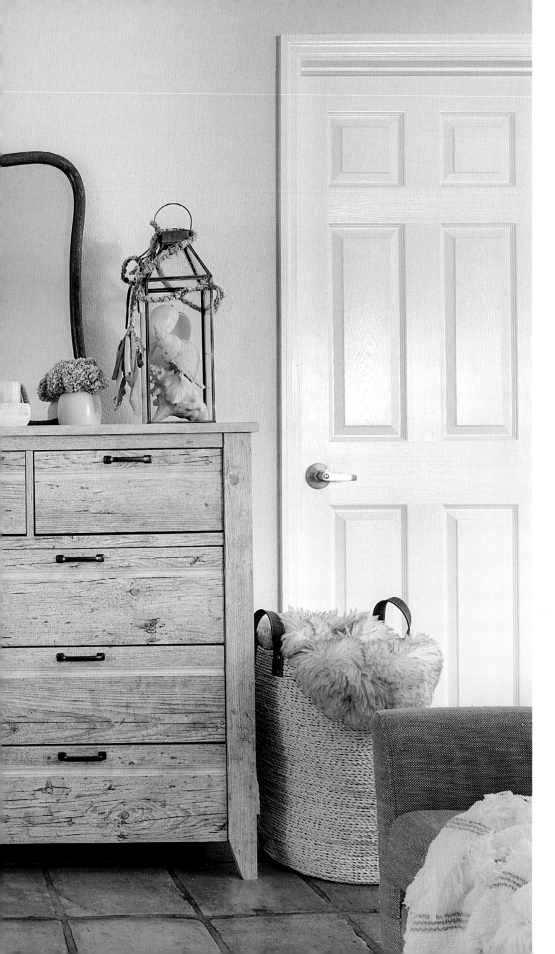

LEFT The sun-bleached wood
of the dresser recalls the
washed hues of driftwood
found on near-by beaches.
Shells gathered in the lantern
tie in with the local setting.

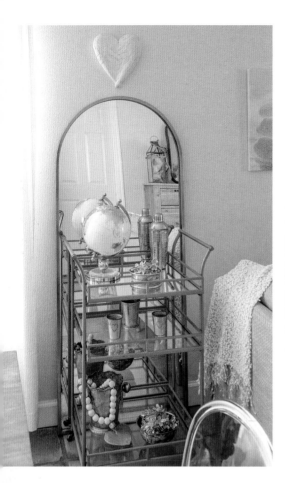

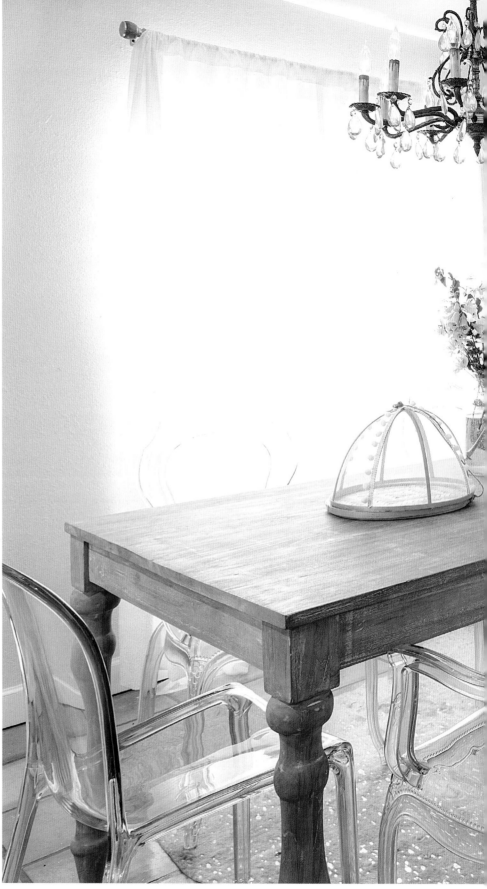

ABOVE A floor mirror brings height and depth to the bar trolley. When not used for its intended purpose, the cart makes a movable stage for displaying meaningful items like pieces from my silver collection and gifts from friends. I have a thing for globes because they make me feel I have the world at my fingertips.

RIGHT The classic design of the acrylic chairs pairs harmoniously with the traditional chandelier and the farmhouse table while allowing them to be the focus of the dining room and keeping the view of the adjacent living room unobstructed. A faux hide defines the space and tempers the coolness of the Mexican tiles. The sofa helps transition to the living room while setting a subtle boundary between both spaces.

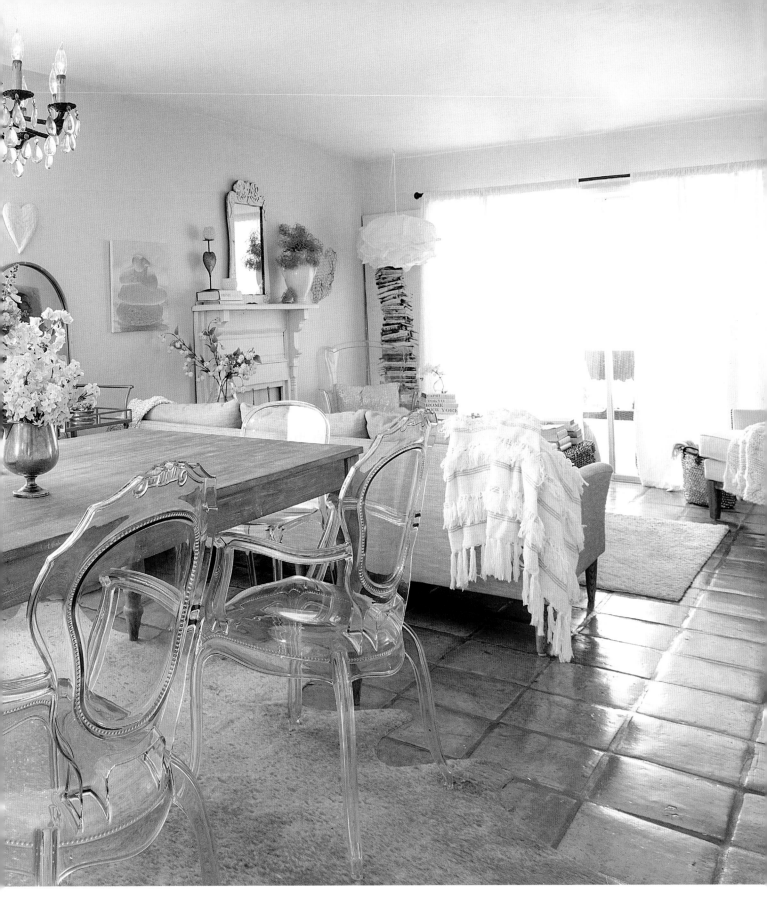

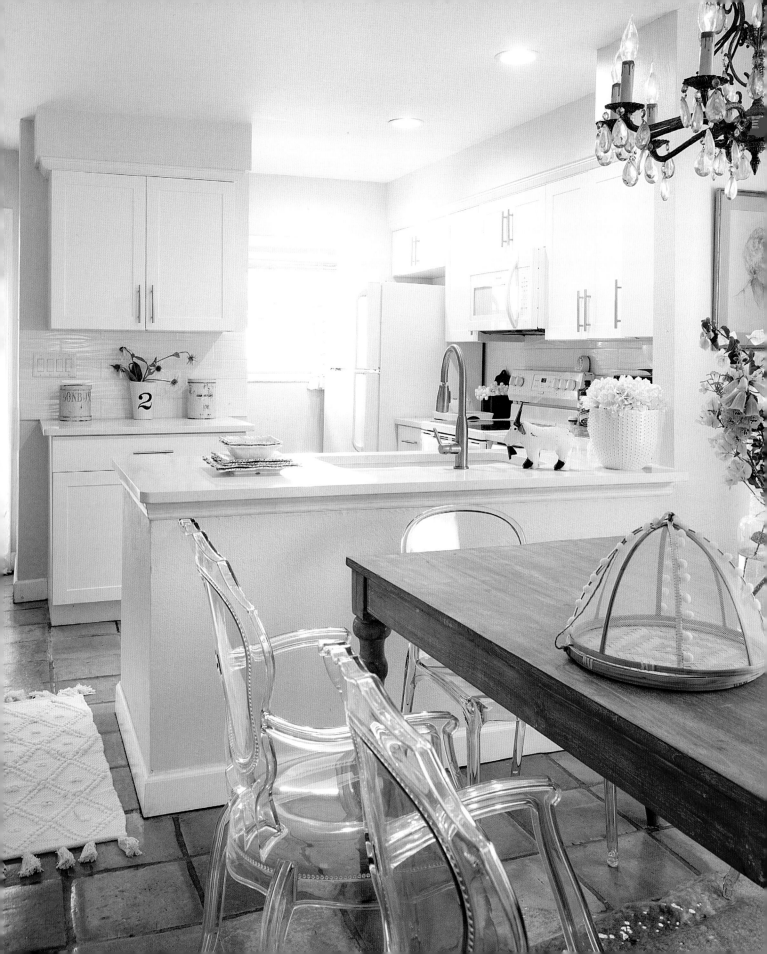

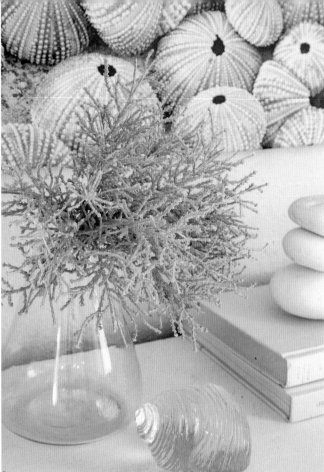

Since I had already bought furnishings while in Connecticut, those pieces had to fit into this new scheme without making the spaces feel crowded. But, as the saying goes, "necessity is the mother of invention!" The main problem was the size of the dining-room table that I had acquired for the Connecticut cottage's large dining room. I love that table and didn't want to have to part with it. I first set it in the width of the dining room, but that placement was competing with the sofa, which I had placed alongside the adjacent living-room wall. The solution was to divide the all-in-one space in a way that would delineate the two rooms without obstructing the view from one to the other. Moving the sofa to face the porch and the dining table lengthwise turned out to be an easy and quick fix, plus it freed the wall, which afforded me the possibility to include a favorite feature: a fireplace. Every other piece found its own sweet spot.

OPPOSITE The kitchen's simple Shaker-style cabinets and openness to the dining room create a clean transition and an uninterrupted visual flow between the spaces.

ABOVE LEFT A small foyer welcomes with a simple cupboard that provides storage, which in a small home is always in short supply. The urchin canvas was made using a photo from a home Mark Lohman and I photographed many years ago. Their hue and texture add depth to the pale palette.

ABOVE RIGHT The stack of rocks (called a cairn) is a gentle reminder of the need to create balance in every aspect of life. It's a practice that has carried spiritual meaning across cultures for centuries. The seagrass and the translucent shell nod to the coastal location.

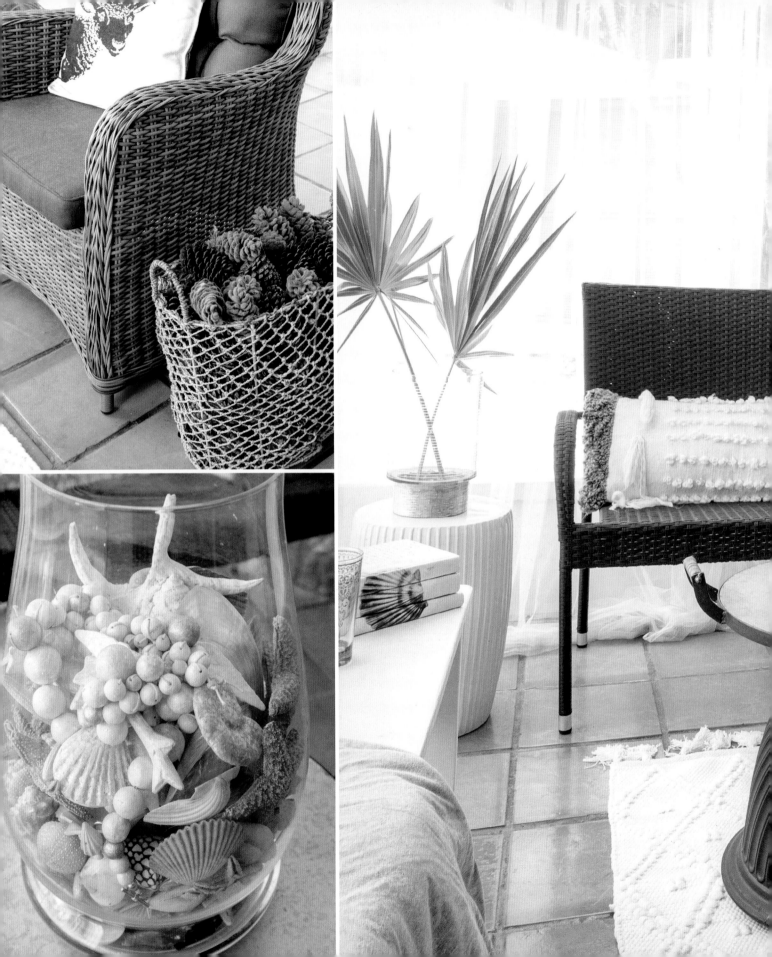

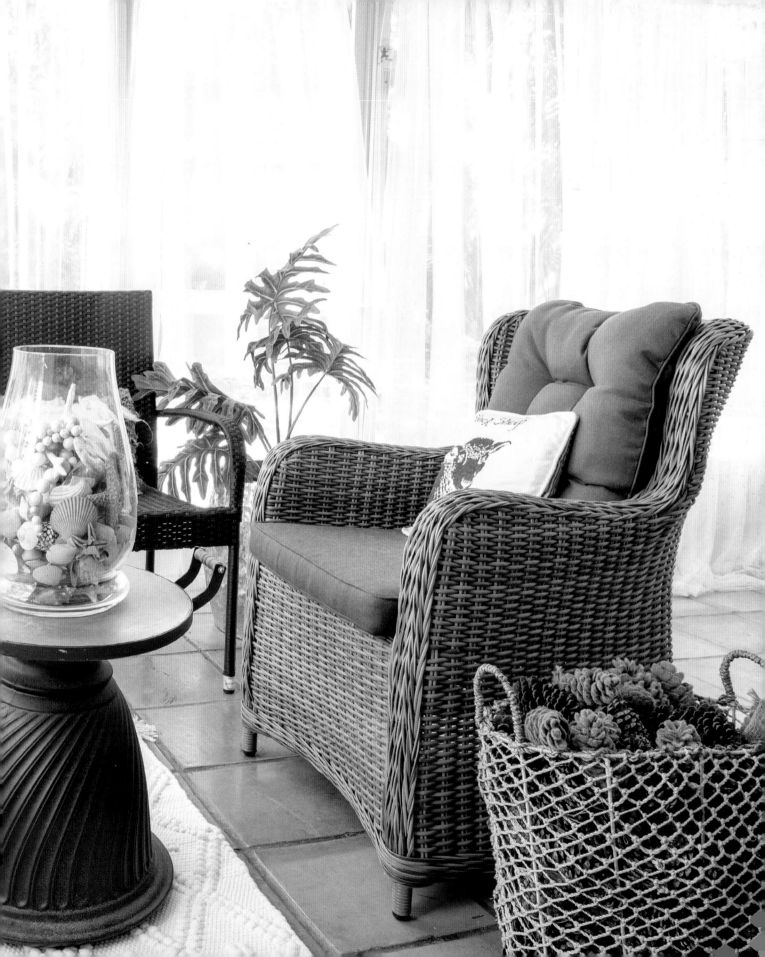

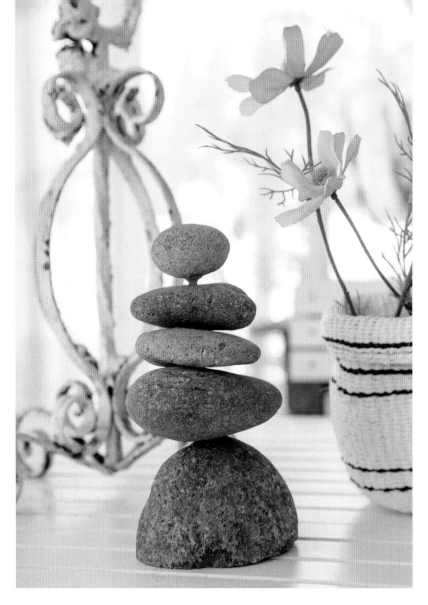

PAGES 142 & 143 The living room opens to a screened-in porch perfect for Florida's balmy weather. Because the summer days come with high humidity, all-weather furnishings are a must. Simple but comfortable plasticized black wicker pieces make a striking statement against sheer curtains.

When it comes to shopping, I am a stalwart supporter of looking for deals from discount stores, secondhand shops, and yard sales, and even discarded items waiting for a new life on the side of the road. Truly, furnishing and decorating a home doesn't have to be costly!

As for style, well, that's a different story because I like so many. I love to layer old, new, and oddities, and to use traditional elements in a way that makes them feel more modern. I lean toward feminine touches and tactile richness. My goal was to create a serene interior reminiscent of a Parisian apartment, but one that felt current and organic with accessories like shells and artwork that fuse my French roots with the Florida lifestyle. After a few short months it all came together, just the way I had imagined. No doubt the house will keep evolving, but I am content with its serene aura, for now!

ABOVE An iron candelabrum, stones, and a small woven basket come together to form a textural vignette.

OPPOSITE Gossamer curtains bestow an ethereal cocoon-like atmosphere conducive to peaceful morning coffee and intimate tête à têtes to share a glass of wine at the end of the day.

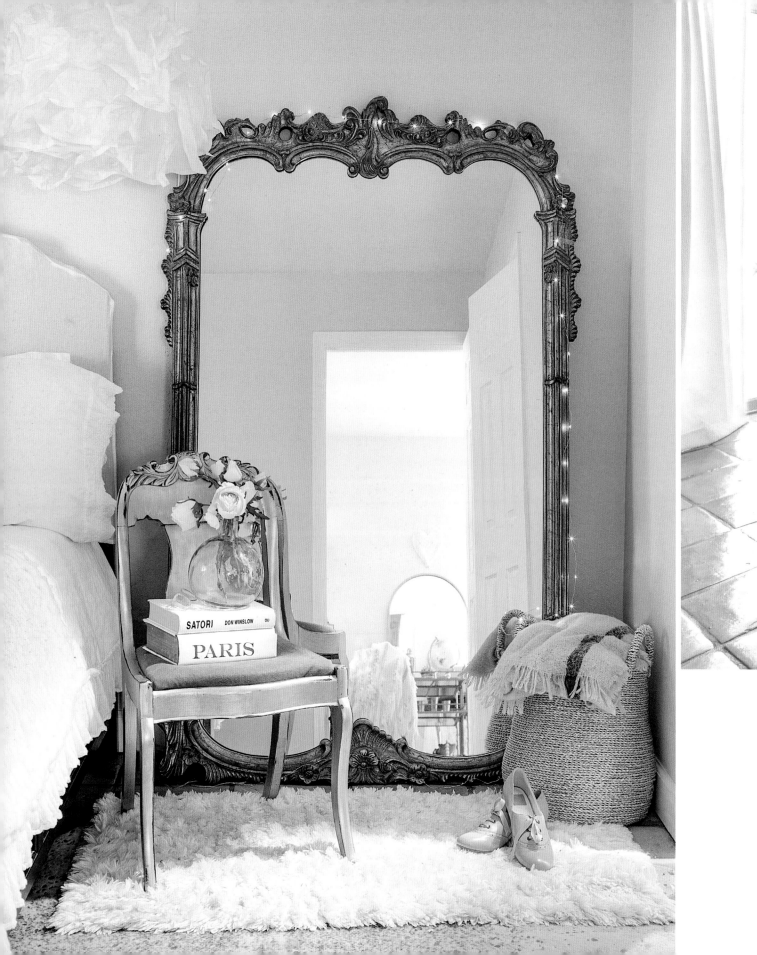

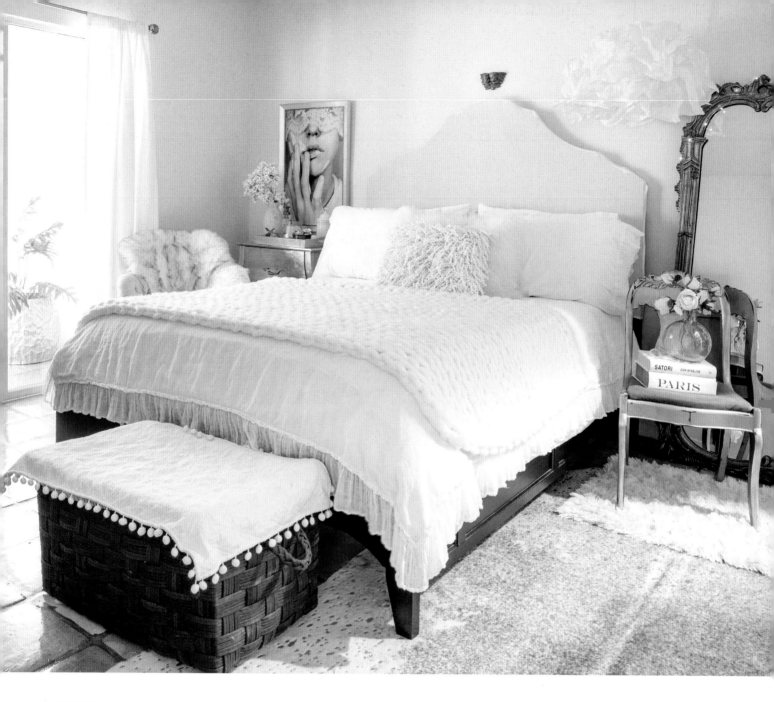

OPPOSITE I had wanted a sizeable floor mirror for a very long time but could never find one that didn't cost a small fortune. But, sometimes, fate smiles upon you, as happened when on a whim I decided to stop by a junk shop where in the past I never found anything worthwhile. And there was this 3½-foot by 6½-foot treasure set in a tarnished gold wood frame. I cringed when I asked the price and couldn't believe my

ears when I was told it was only $100. But, not one to question my lucky star, I grabbed it. It gives the bedroom that romantic Parisian boudoir flair I was aiming for. I had never mixed gold and silver together before, but the chair and basket proved to be good companions for the mirror. With its cloud-like paper-thin layers, the light pendant almost disappears, yet provides all the light that is needed.

ABOVE I purchased the bed at a time when I was in a black-and-white phase, but for this house I wanted white only, at least for the headboard. I didn't really want to paint it because it has a medium gloss finish, so instead I had a slipcover made and it did the trick. I actually like the bit of black from the side of the bed and the trunk, as it adds depth to the room.

RIGHT The quaint front porch sets the scene for Peg's charming cottage interior. French ticking fabric and a pillow and bolster echo the daybed's vintage pedigree. To provide privacy but still let the light in, Peg hung sheer curtains using plumbing pipes as rods. "It's so pretty when they blow in the breeze," she says. A former coal bucket sits on a rustic stool she found in her neighborhood with a "free" sign on it. When the need arises, the original plank floors are refreshed with a new coat of paint. Eight-year-old Moose and six-month-old Margot, Peg's Boston Terriers (and favorite companions), are fans of cottage comforts and love lounging on the porch.

COTTAGE CLASSIC

FOR PEG SHRADER THE SAN FRANCISCO BAY AREA IS FAMILIAR TERRITORY. "I GREW UP ABOUT AN HOUR SOUTH OF MARIN COUNTY. THE BEACH IS ONLY THIRTY MINUTES WEST AND SAN FRANCISCO TWENTY-FIVE MINUTES TO THE SOUTH. IT'S BEAUTIFUL AND I LOVE IT HERE," SHE SAYS.

Peg wasn't planning on moving from her former home, but when a cottage only two blocks away came up for sale she couldn't resist. "It had just been restored by a woman I knew, and it was in great shape," she recalls. "She was buying old homes in the area and fixing them up. I loved her work because she always kept as many original features as possible and maintained the character of the home." Not having to make structural changes allowed Peg to focus on decorating the cottage. "I have been cutting photos from magazines for years, the kind that make my heart go 'pitter-patter,'" she says.

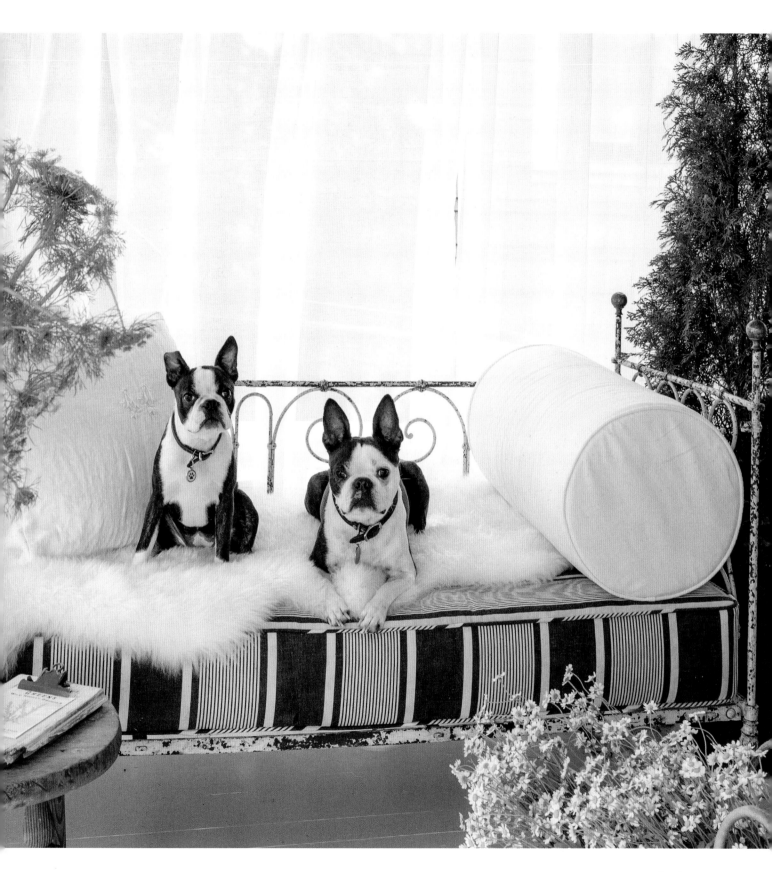

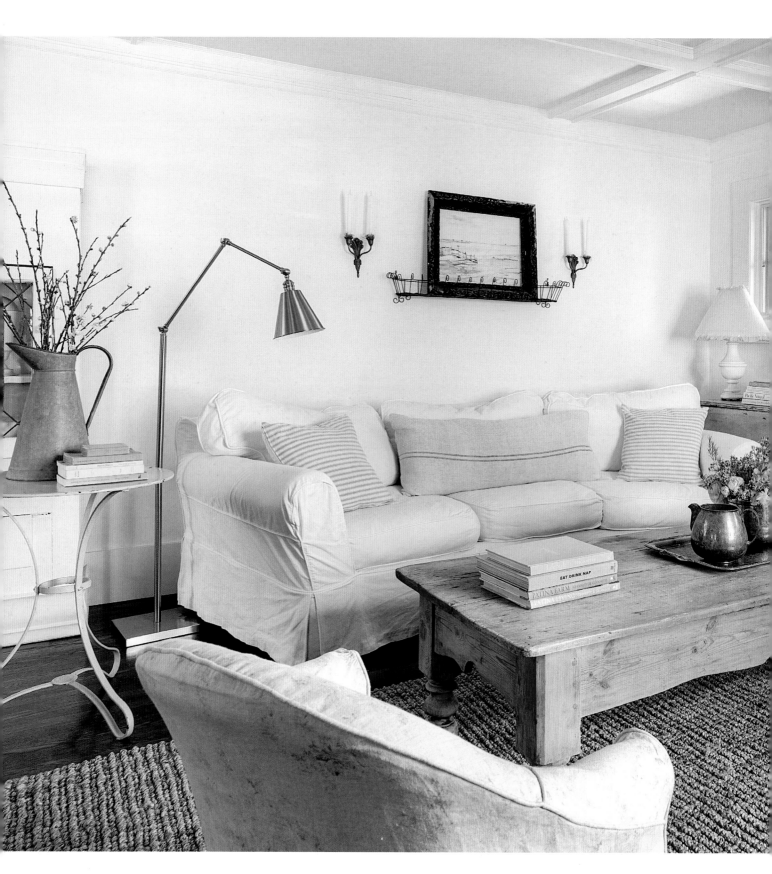

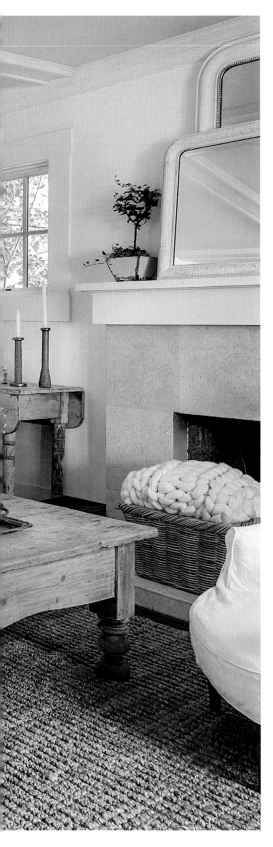

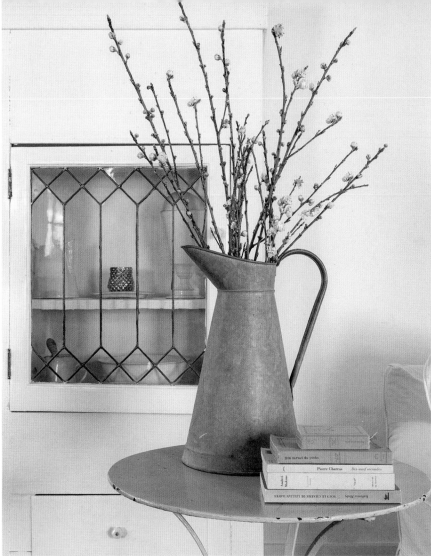

LEFT The box-beam ceiling, floor, and fireplace were already in place when Peg bought the house, but the leaded-glass cupboard was a recent purchase. "I knew that it matched the dining room's built-ins," she says. "It was made using old separate pieces." With her doggies in mind, Peg had three sets of white slipcovers made for the big and cozy deep couch. "So far I've only used one. I wash it with bleach once a month or so," she says. Pillows of similar provenance and colors heighten the comfort level. Not one to go for matching pieces, Peg selected a drop-leaf table for one side of the sofa and a bistro one for the other side. Set in a wire shelf above the sofa is an original watercolor, by artist Margot Rampton, which depicts the Camargue region of France. Peg has an affinity for old silver, which she prefers tarnished like the trio displayed on the hefty Irish pine coffee table. A pair of slipcovered chairs rounds up the inviting seating arrangement. Though quite a departure from the Louis Philippe mirrors on the fireplace mantel and the vintage furnishings, an industrial-style floor lamp confers a sleek note yet fits the decor. "I find lamps challenging," Peg says. "I like to add a newer piece to my mostly vintage ones here and there."

ABOVE Peg bought the bistro table for its color. "It's my favorite shade of blue and it's the original color," she says. "Plus, it's yet another way to bring the outdoors in."

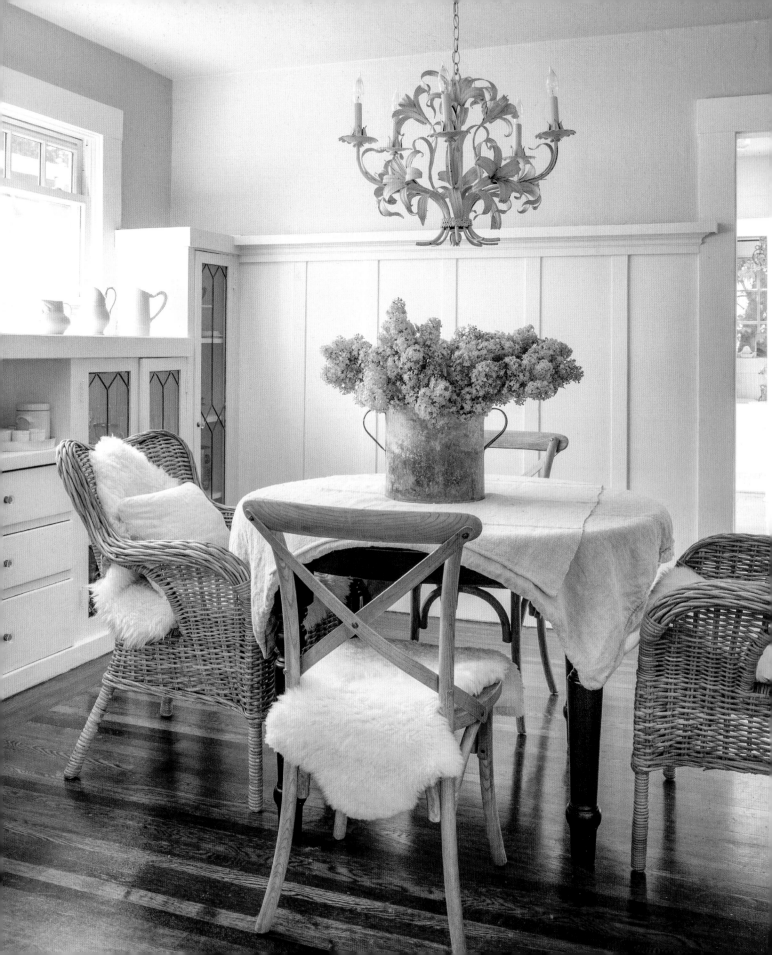

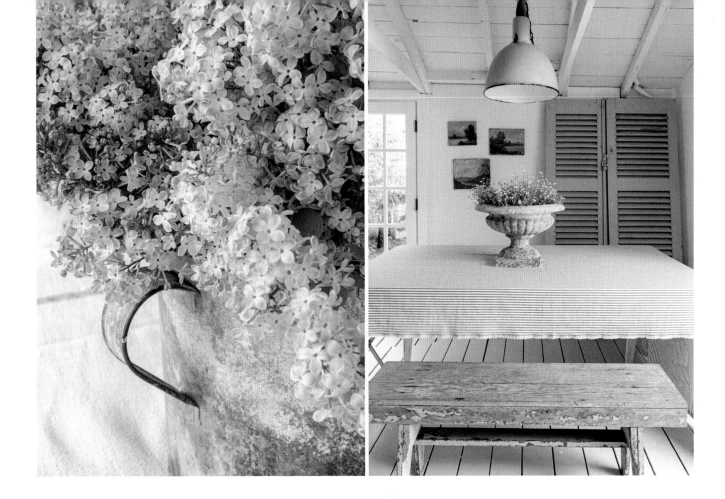

OPPOSITE The dining room's original built-in leaded-glass cabinets, oak floor, and board-and-batten walls are some of the features that attracted Peg to the cottage. "I love that they contribute authenticity and history," she says. She is especially fond of the glass cabinets, where she keeps an assortment of ironstone and ceramic pieces. "These cabinets are beautiful and functional and give the room character," she adds. To contrast with the white walls, the floor remains unpainted. The newer table takes on a vintage mood with layers of old French hemp fabric. Indoor and outdoor chairs lend a casual cottage vibe. "I like furniture that can be used inside and out," Peg says. "It's a way of bringing the outdoors inside." A curvy Italian chandelier presides over a sumptious bouquet of lilacs.

ABOVE LEFT Peg grows a variety of plants and shrubs in her garden and owns quite a few old European zinc buckets, which come in particularly useful for tall flowers on woody stems, like these fragrant lilacs that bloom in abundance in her front yard.

ABOVE RIGHT The old carriage house is the only space that got some help after Peg moved in. "The foundation was a wonky cement floor that felt cold and dirty. Friends of mine came over one weekend and we all worked together leveling the cement floor, and then building a wooden one on top," she explains. "I wanted the room to look like a porch, as it connects two small patios. I can open the big main doors of the carriage house and the French doors leading to the back patio and create a larger space." Peg's grandfather's old gardening bench flanks a spacious table. "I love these old benches," she reminisces. "I remember them as a child. My grandfather came from Italy to the States, where he worked as a gardener. My siblings and I would sit on them in his back yard." United by their color and patina, the benches, tall shutters, and a sizeable light pendant work well together. "Using green in an outdoor room helps to bring the garden within," Peg says.

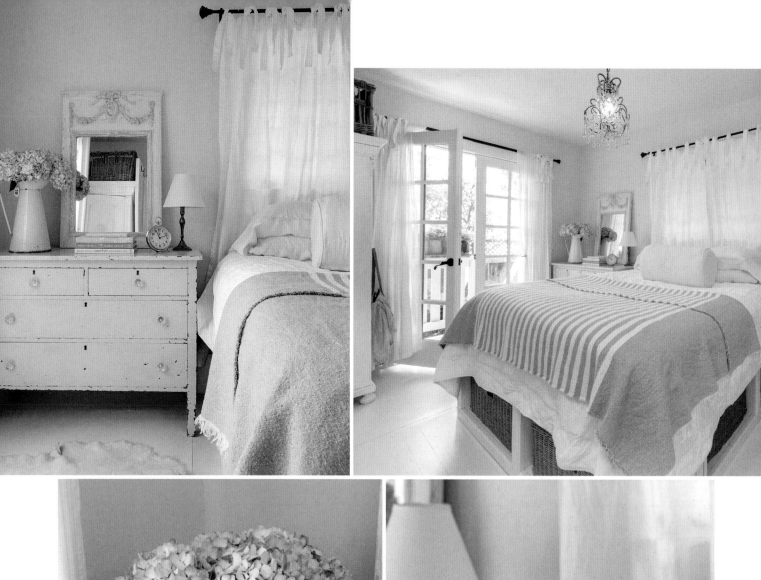
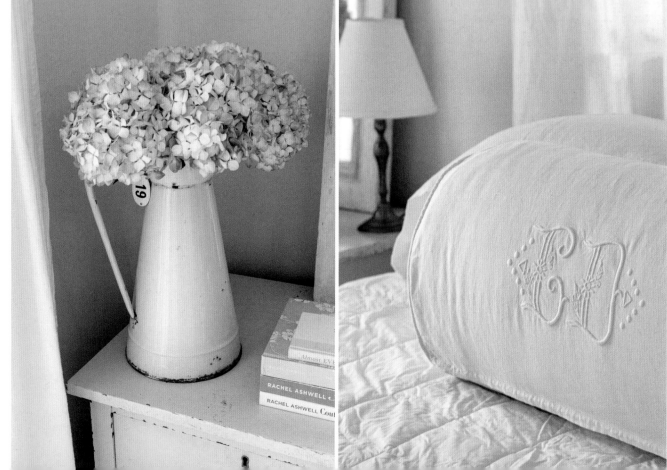

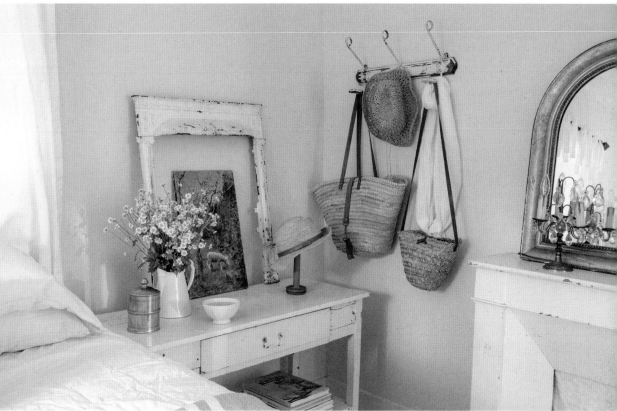

OPPOSITE ABOVE LEFT Peg injects subtle color notes with a soft-gray dresser. "Every color looks better with white," she says. The classic lines of the ornate mirror elevate the more rustic elements.

OPPOSITE ABOVE RIGHT One of the few alterations Peg did when she bought the house was to remove the master bedroom carpeting. "I found the old wood boards underneath and decided to paint them instead of replacing the carpet," she explains, adding, "What is more cottagey than painted floors?" Typical of homes built in the 1920s, the cottage offers very little storage. "Only two small closets," Peg says. "One in each bedroom!" She solved the problem with a platform bed. "It was the first piece of furniture I bought when I moved into this house," she remembers. "I needed space for baskets to store clothing." The antique armoire also became part of the solution.

OPPOSITE BELOW LEFT Enamel items have long been staples of cottage life. "Pitchers are useful and so easy to find at flea markets," Peg says. "And I love the look of little enamel plaques. They are great to put on top of a gift package when you have a meaningful number."

OPPOSITE BELOW RIGHT Peg appreciates the work that goes into old monograms. "The initials don't matter to me, but I like the feel of the linen and the beautiful, intricate handwork that goes into embroidering them," she says.

ABOVE A sideboard-turned-night table holds a bucolic painting set within an old iron fireplace inset. Market baskets keep pace with the pastoral scene. Illustrating the "high/low" look Peg favors, a simple wood fireplace becomes glamorous when paired with a gold Louis Philippe mirror and a sparkling girandole.

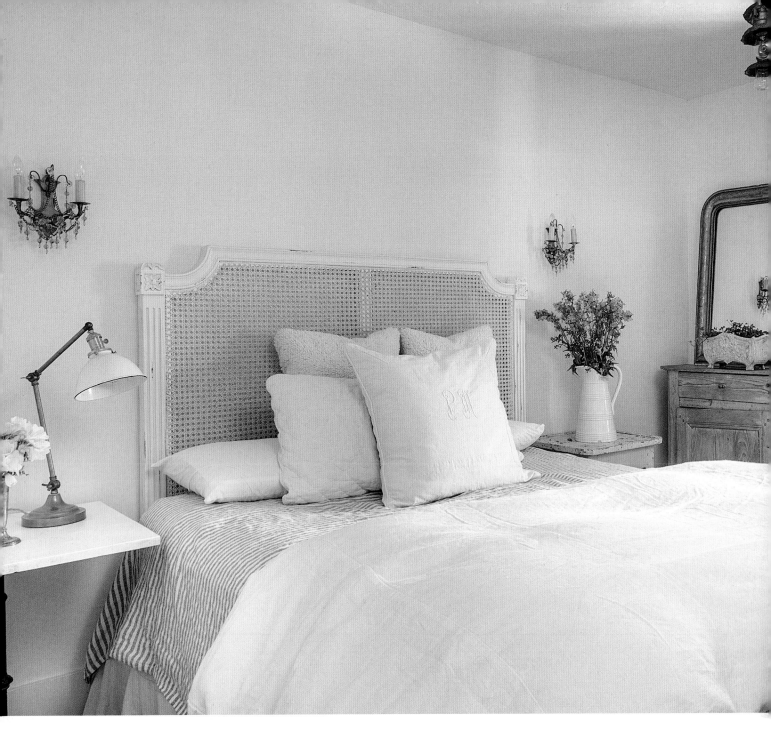

ABOVE "I fell in love with a similar bed frame from a store but waited too long and someone else bought it," Peg recalls. "I looked for another vintage piece and nothing else caught my eye until I found this one online. It's not vintage or French as the other one was, but it's pretty and I do love cane." A pine cabinet, an iron table with a handmade lamp, and another gold Louis Philippe mirror keep up with Peg's trademark mix of humble and elegant.

OPPOSITE Dainty Parisian sconces with pale blue glass beads are the perfect finishing touch for the French-inspired bedroom.

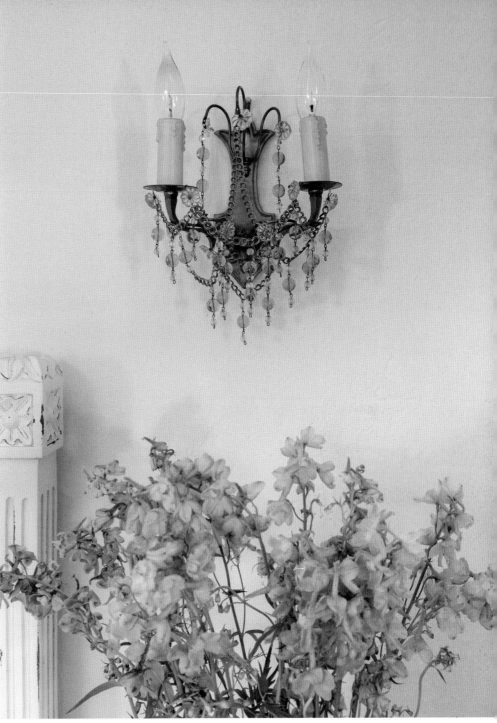

"When I finally joined Instagram I found a whole world of kindred spirits who had similar aesthetics and appreciation for vintage items, particularly French vintage." But most of all she credits her friend Maria Carr of Dreamy Whites Lifestyle as one of her greatest sources of inspiration. "I am always inspired by Maria. We have become good friends. I even traveled to France with her on a shopping trip."

Peg sees similarities between fashion and decorating. "I like the high/low look, like the relaxed yet elegant feel you get from pairing distressed jeans with a beautiful blouse," she explains. "In home decor it translates into juxtaposing a weathered piece of furniture with a glamorous chandelier."

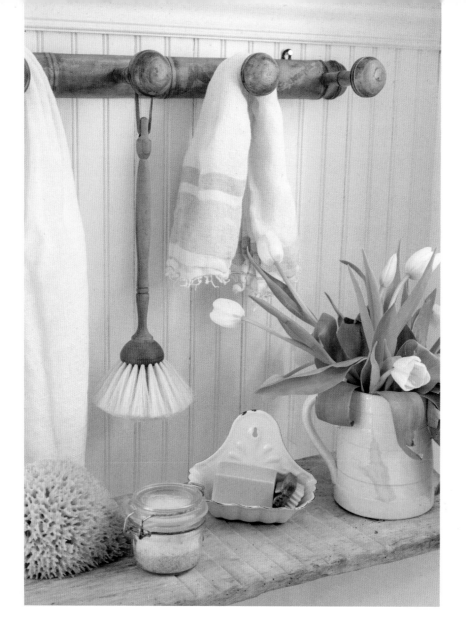

For many, finding the right combination of items can be challenging, but not for Peg. "I am lucky to live in the Bay Area because we have access to numerous antique stores, and so many dealers travel to Europe and bring back containers full of unique and beautiful pieces," she notes. "I have great opportunities to see all the fun and wonderful things that come in. If I find something that I love and feel will suit the house, then I will get it even if I have to relocate or replace an existing piece."

Whatever newfound treasures Peg brings home, she knows they will complement the white background of her cottage. "I love that it's a blank canvas waiting for your imagination."

ABOVE Peg keeps clutter at bay and bath necessities on hand with a bamboo rack (a popular item in French homes in the 1930s) and a simple wood board.

OPPOSITE Luckily the iron tub, bead board, and marble basket-weave floor tiles were already in place when Peg bought the house. However, she added her own stamp by painting the upper walls a pale gray, fashioning a curtain from vintage cloth, and hanging a chandelier that she purchased in France at the same time as the slightly larger one that illuminates her bedroom.

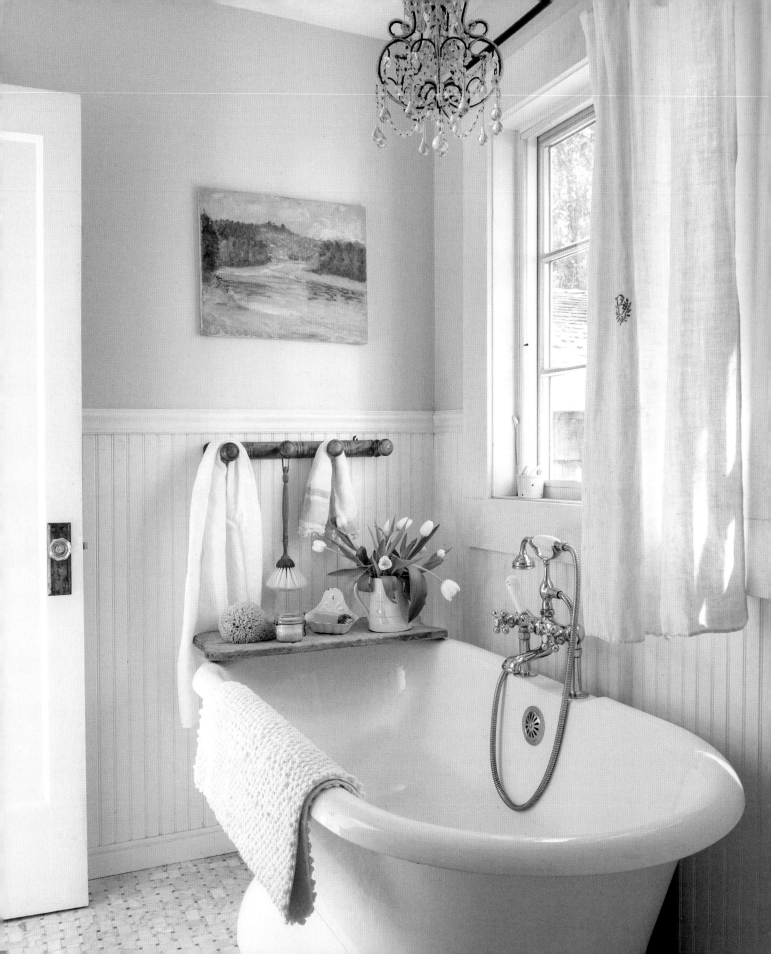

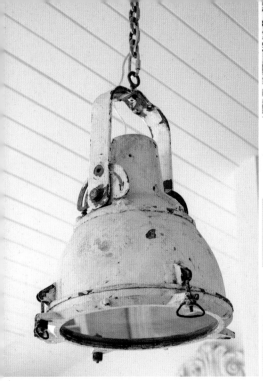

ELEGANTLY FRESH

FROM SOUTH AMERICA, WHERE SHE WAS BORN, TO CANADA AND MANY OTHER COUNTRIES IN BETWEEN, KAREN HALL'S LIFE, STUDIES, AND TRAVELS HAVE GREATLY IMPACTED HER OWN STYLE AND INTERIOR DESIGN CAREER.

After moving to the States over thirteen years ago and enjoying the perks big cities like Minneapolis and Chicago have to offer, she fell in love with the peaceful rural beauty of Sonoma, California, that reminded her of the French country life. "Having lived abroad, I'm influenced most by the history and timeless beauty of the homes and landscapes of France, England, The Netherlands, and Sweden," she says. "The heft of old stone, the enduring charm of natural gardens, the fields of wildflowers, and huge, old trees that have stood the test of time all have a comforting quality of endurance." It's no surprise that the Sonoma farmhouse Karen shares with her partner, John Tuoy, reflects her affection for, as she says, "everything that gets better with age."

ABOVE LEFT "I've had these marine lights forever and finally found the perfect place to install them," Karen says. "They're large and have their original finish, and a pair works perfectly over the island."

ABOVE CENTER Karen grows a variety of herbs and flowers in her large garden, and always keeps fresh cuttings in every room.

ABOVE RIGHT A marble mortar holds eggshells, which once crushed are sprinkled in the garden to moderate soil acidity while providing nutrients.

OPPOSITE "Because Sonoma is in Wine Country and is all about open-plan living, views to the outside, and plenty of entertaining, I wanted to keep the kitchen simple, clean, stylish, timeless, and, of course, functional," Karen explains. "There's no backsplash tile. Instead we ran the honed Bianco Carrara marble that makes up the countertops all the way up, to keep the look uncluttered. And, of course, there's a wine fridge in the island because you definitely need one when you live in Wine Country!"

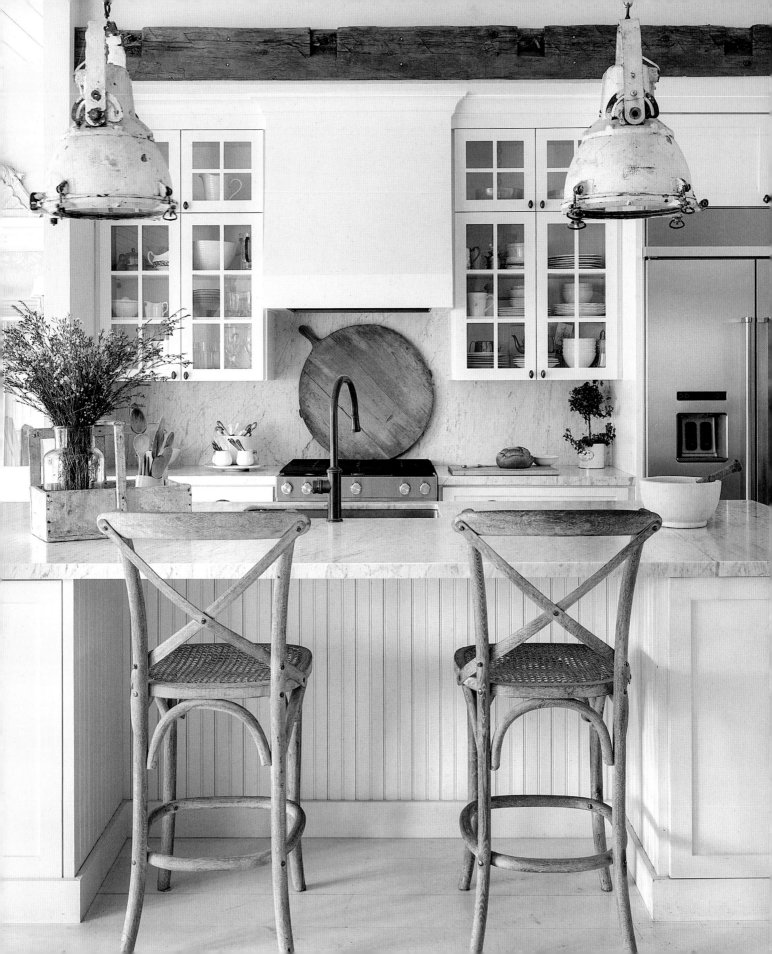

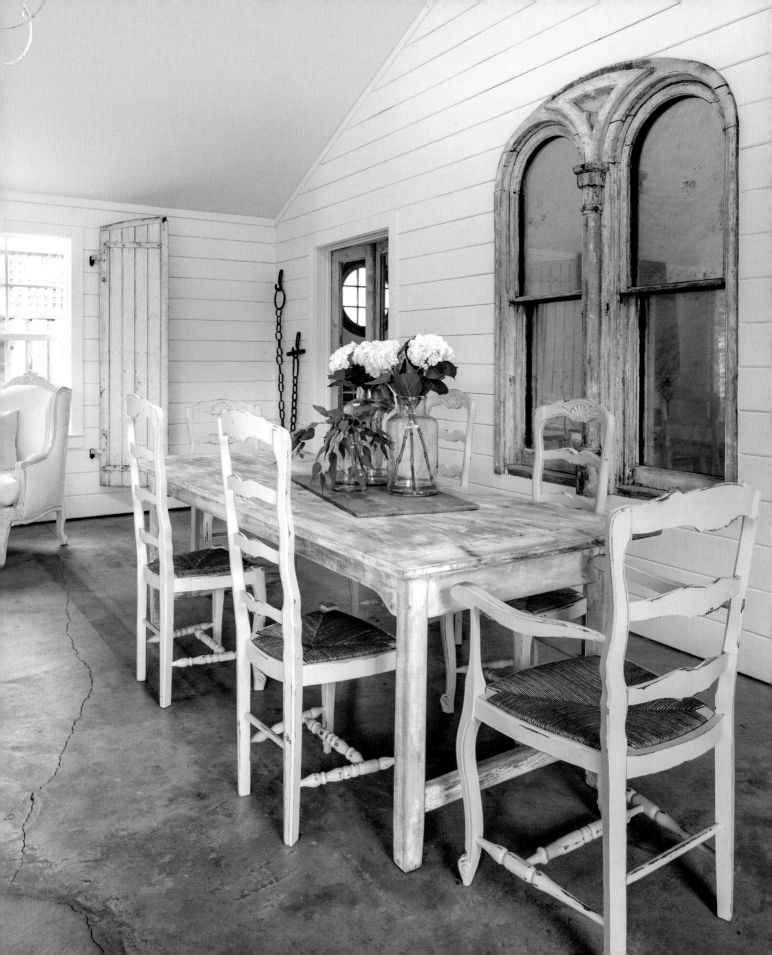

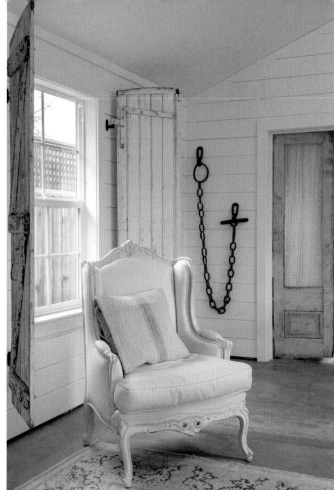

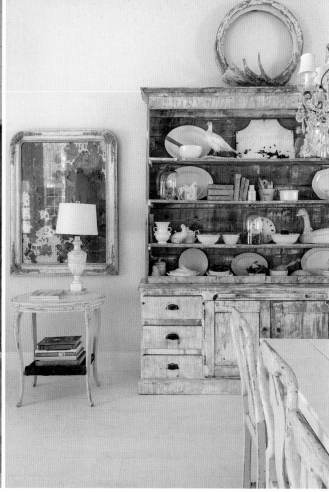

OPPOSITE Set against the dining room's primed and painted pine shiplap wall, a 19th-century arched architectural window frame outfitted with an antique mirror reflects a French table and rush-seat ladder-back chairs. "They were purchased years apart but they work perfectly together and are an integral part of the elegant French Country look I was aiming for," Karen says. The concrete floor finished with a satin sealer was left as is, imperfections and all, for added authenticity.

ABOVE LEFT The antique French shutters from the Loire region were a true find and one Karen particularly appreciates. "It's very rare to find four complete sets of matching shutters that all came off of the same house. They add so much textural interest to a room." Instead of traditional artwork, Karen hung a vintage chain with its untouched patina. The rustic piece makes a graphic and timeless statement and a fitting companion for the set of vintage doors leading to a pantry. "The character of old doors is hard to beat," Karen says.

ABOVE RIGHT Karen needed a large space to accommodate this imposing eight-feet-high by seven-feet-wide French hutch while allowing it plenty of breathing room. She found just the right spot against the wall facing the kitchen. The shelves display a variety of platters, old books, and nature-inspired items that rotate based on the seasons and the inspiration of the moment. "I find myself drawn to anything that has a bit of history, or that tells a story of where it may have been or how it might have been used or enjoyed," Karen says. "I'm often asked why I love vintage taxidermy. To me, it's a way of honoring and preserving the wonder and beauty of the natural world."

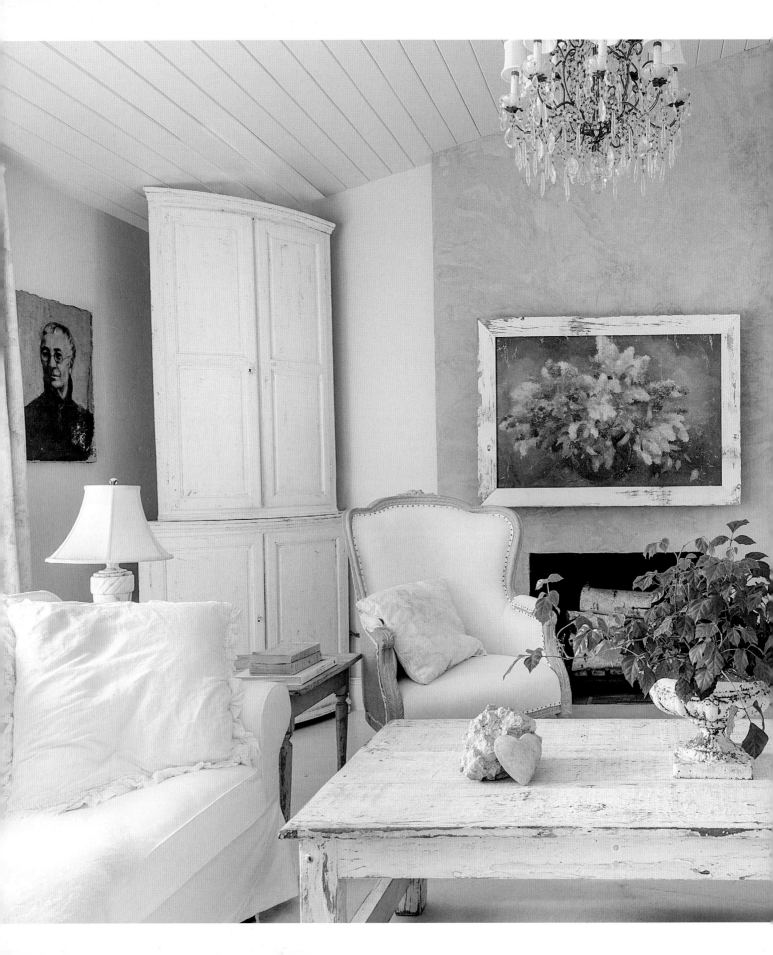

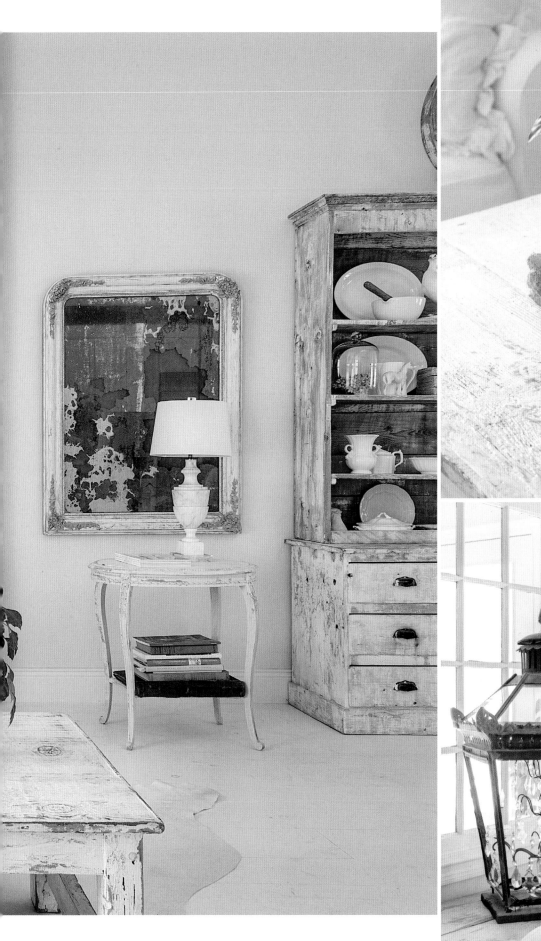

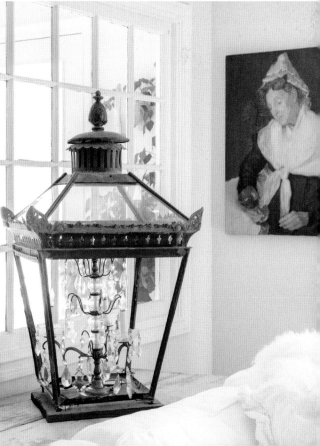

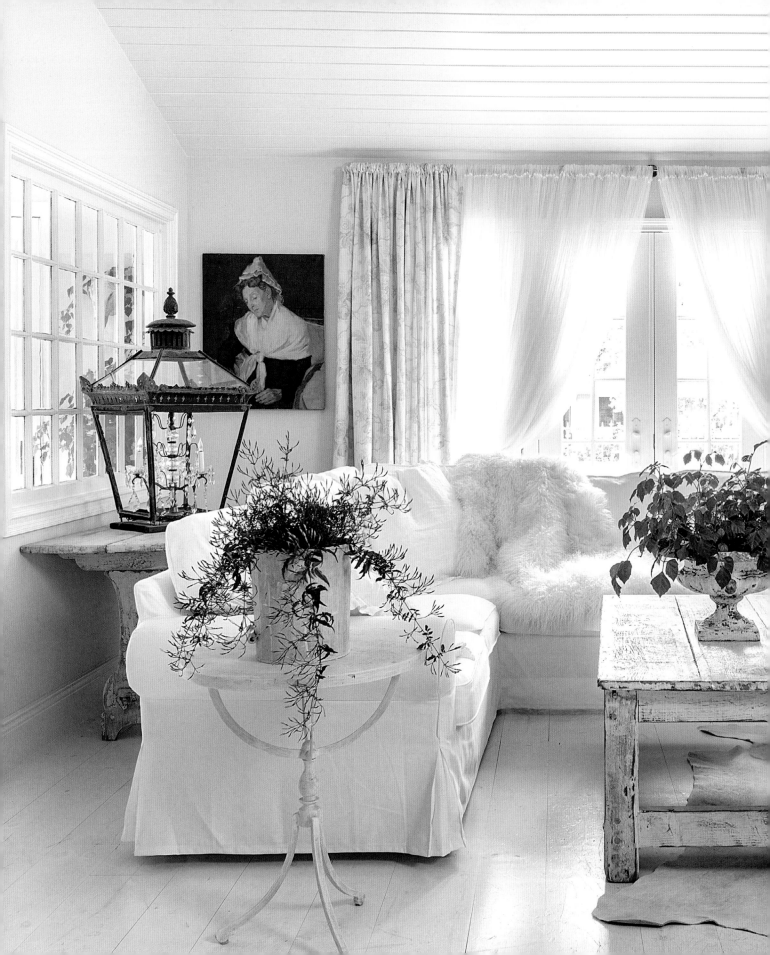

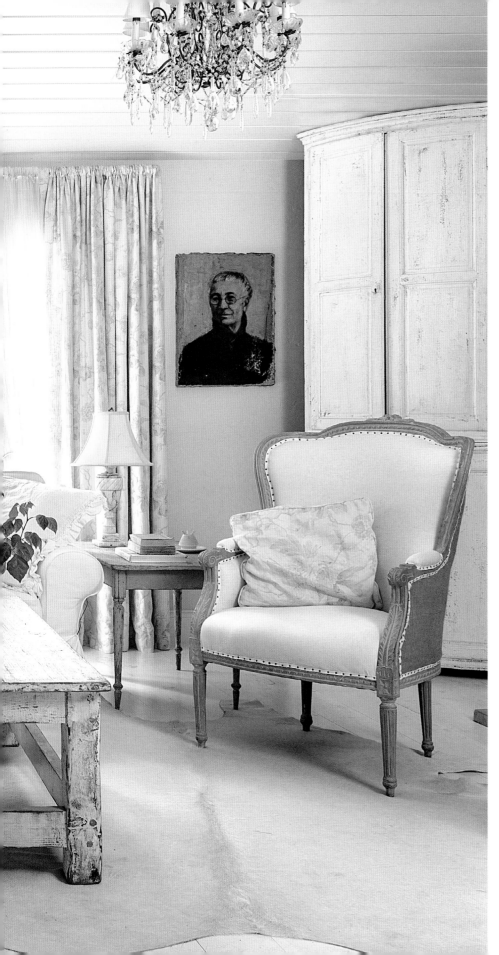

PAGE 164 The fireplace wall boasts a custom concrete-washed finish and an oil painting Karen purchased in Paris. "I removed it from its original frame and rolled it up to transport it back," she recalls. "The white wood frame was made from old fence boards that were on my property at the time." A French mirror with its original foxed glass stands above a table of the same provenance.

PAGE 165 ABOVE Karen values items that hold a special meaning, like this quartzite rock she found near her mom's home in Canada, and the wooden heart, a gift from a client.

PAGE 165 BELOW A Paris street gas lantern dating back to the 1900s is given pride of place on a Swedish table Karen placed behind the sofa. It has been electrified with a girandole and is one of Karen's prized possessions.

LEFT The living room embraces refinement and rusticity because, as Karen says, "Age and imperfections are always welcome in our home and life. Pieces that are a little weathered and worn and not too shabby always speak to me." The distressed finish of the simple coffee table, the linen and burlap of the armchair, and the gently weathered Swedish cabinet illustrate that premise. Oil paintings in darker tones add impact and balance to the serene space.

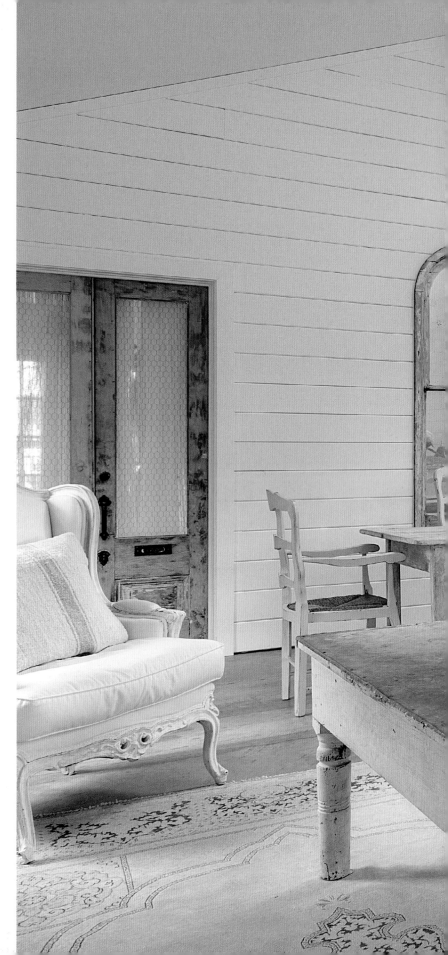

RIGHT A chandelier (one of a pair) hangs from one of the two reclaimed beams of the family room's vaulted ceiling. Though they are neither antique nor vintage, Karen loves them for their French Country-inspired design. "I have had them for years and finally had a place for each. They are huge, at over four feet wide." The wool Savonnerie rug, from an antique store just outside of Paris, warms up the cool concrete floor. An old farmhouse table with a zinc top was, at some point in its lifetime, cut down to coffee-table height. Glazed pottery from Spain and an English ironstone bowl add a worldly touch. The down-filled sofa has been slipcovered with cotton duck cloth for practical beauty. In the background, a French antique oil painting in its original gilded frame hangs by an imposing English cabinet, housing pieces from Karen's collection of ironstone. Found antlers gathered on walks evoke the farmhouse's location.

Restoring the soul of the old farmhouse that the couple purchased in 2015 was a major undertaking. "The entire home was taken down to the studs, including removal of the roof, with only the foundation and the fireplace wall left standing," Karen says. "We also added five hundred square feet to accommodate a master bedroom suite." The exterior was rebuilt with stucco and stone replicating the finishes seen in old French farmhouses. On the inside, influences from bygone eras and forgotten trades form a lasting connection with the French, Nordic, and English Country styles Karen favors, all deftly unified by a sophisticated white palette. "Perhaps it's because of my profession and the fact that I'm always working with others on their homes or offices (some of which are saturated with color) that I find a white palette to be gentle, peaceful, and comfortable," she says.

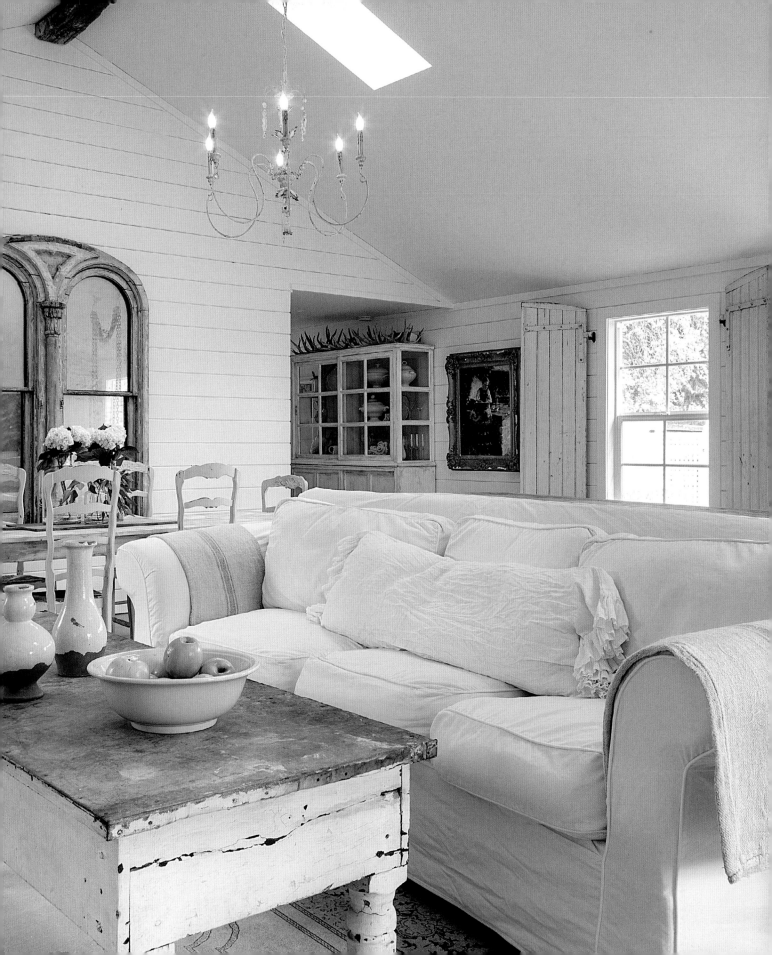

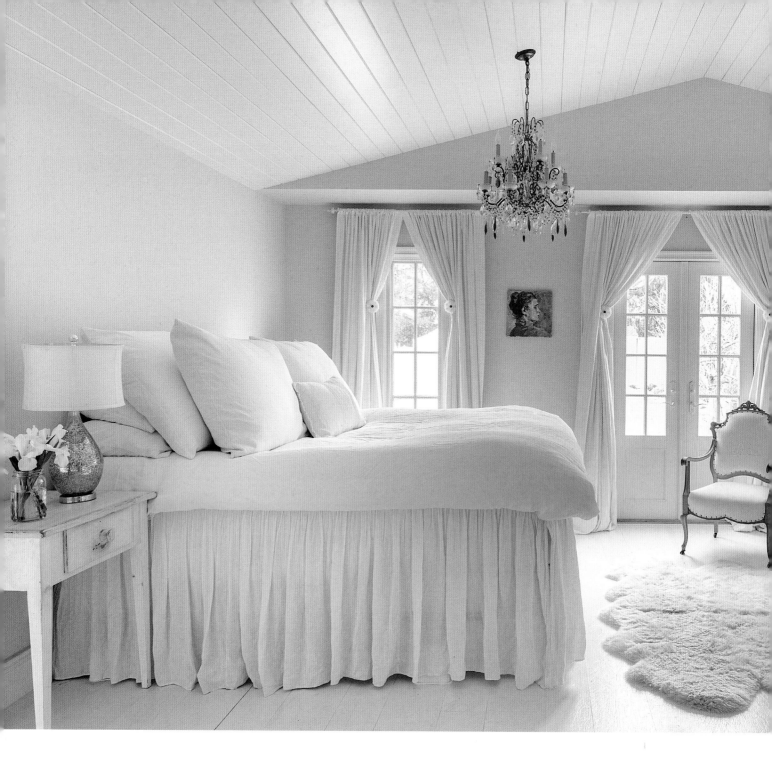

"It's a simple, uncomplicated, and very versatile base, which can be layered to define a particular mood or style." The three colors of paint used in the home and the classic elements set the tone for rooms oozing with light and timeless charm. "White is romantic and livable, and allows antiques, whether chalky painted, gilded, dark, or natural wood tones, to shine," Karen notes, adding, "White goes with everything!"

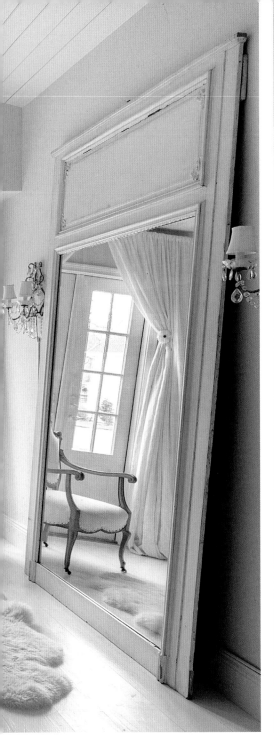

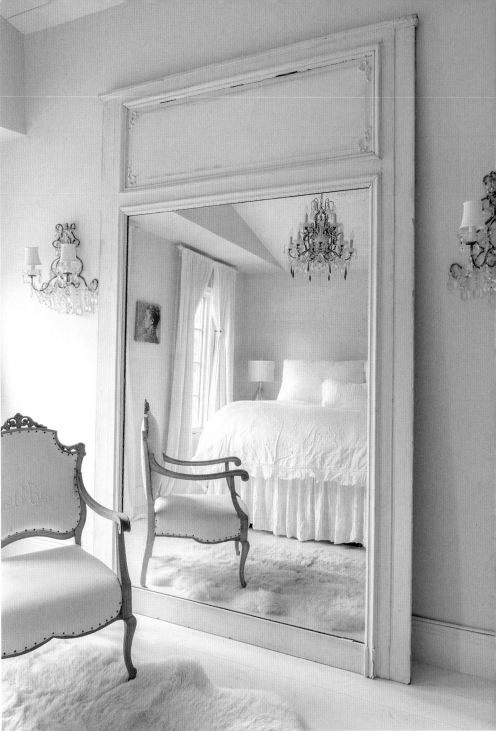

ABOVE LEFT The master bedroom's deliberately simple design elements weave an ethereal cocoon. Painting the walls and ceiling with different shades of white and bringing in texture with whisper-soft linens, a plush sheepskin rug, and a linen-upholstered chair add definition and interest and eliminate the potentially stark look. The imposing mirror takes the space to the next level. The oil painting and the chandelier's lavender-hued glass drops contribute subtle touches of color.

ABOVE RIGHT Karen found the chair frame in New Orleans. "It would have originally been gilded, but it had already been stripped to its current condition. I had it rebuilt and upholstered with vintage French monogrammed linen," she explains. "The best part of this gorgeous chair story is that it wasn't until I picked it up and took off the covering that I realized the initials in the monogram are the same as my late maternal grandmother's!"

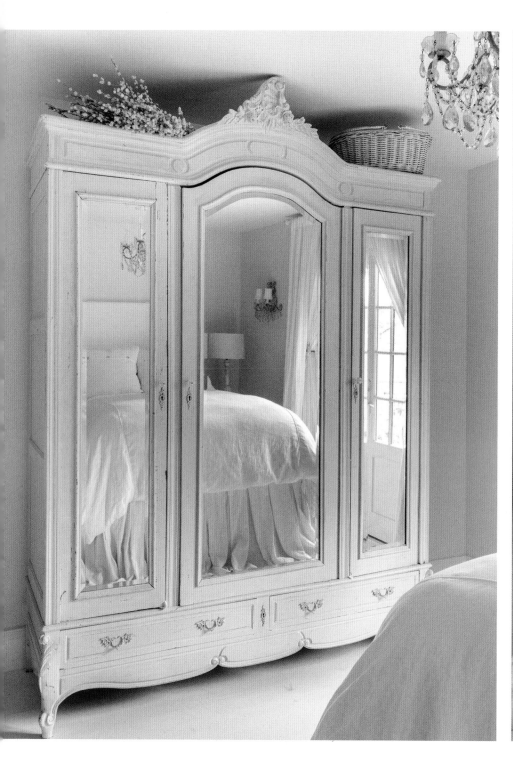

ABOVE Karen painted the walnut armoire
white and aged it with a soft gray undertone.

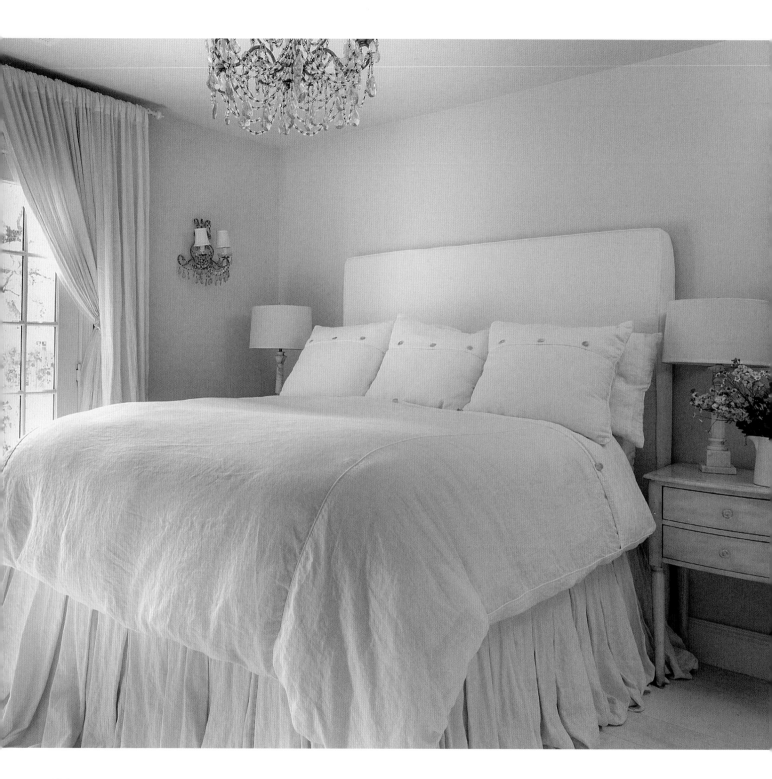

ABOVE The guest bedroom's French doors were installed as part of the renovation and lead to an iron-railed Juliet balcony complete with a table and chairs for visiting friends to enjoy their morning coffee while overlooking the garden. Karen designed the curtains, duvet cover, and Euro shams, and had them custom made in 100% white Irish linen. "Even the buttons are mother of pearl," she says. Turquoise glass drops drip from a macaroni beaded Italian chandelier and a pair of sconces from the 1920s.

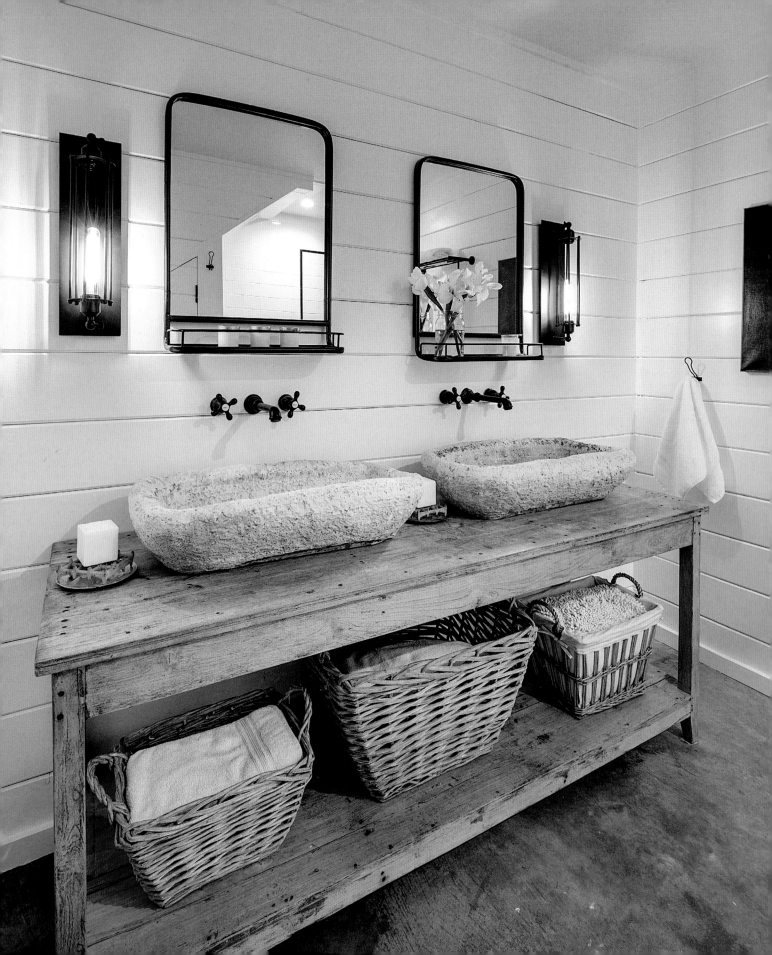

OPPOSITE For the guest bathroom Karen wanted to set a more casual style, and found exactly what she was looking for in an old, solid teak piece from a school science laboratory and a pair of stone vessels from France. "I loved the idea of combining modern and sleek with industrial and farmhouse," she explains. "The mirrors are perfect because they have shelves, which are very functional, the wall-mounted fittings take up less space on the counter and are necessary with vessel sinks, and the black finish adds a bit of drama."

RIGHT A pair of antique doors defines the entrance to the master bathroom and frames what was once a Gothic window in an Oregon girls' school. "I kept it exactly as I found it because I just love how it looks," Karen admits. "As for the doors, I have used them in three different homes. They're from France and have their original faded blue paint and glass. The top portions open like a window. They'll go wherever we go!"

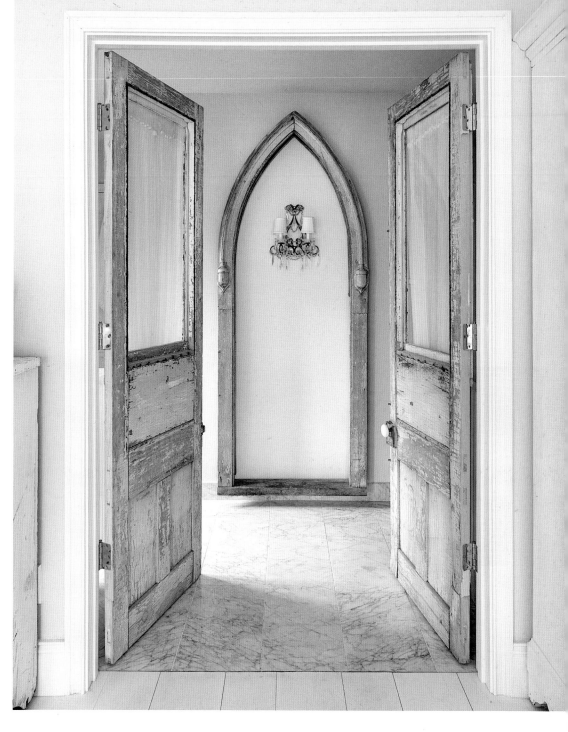

For Karen a home has to be more than an attractive place. "Whether it's an architectural salvage or a one-of-a-kind sculpture, I feel there should be something unique and personal to the rooms," she says. "A bit of history, a touch of texture, and a timeworn finish give a home its personality, depth, and character, and, most of all, its sense of 'being.'"

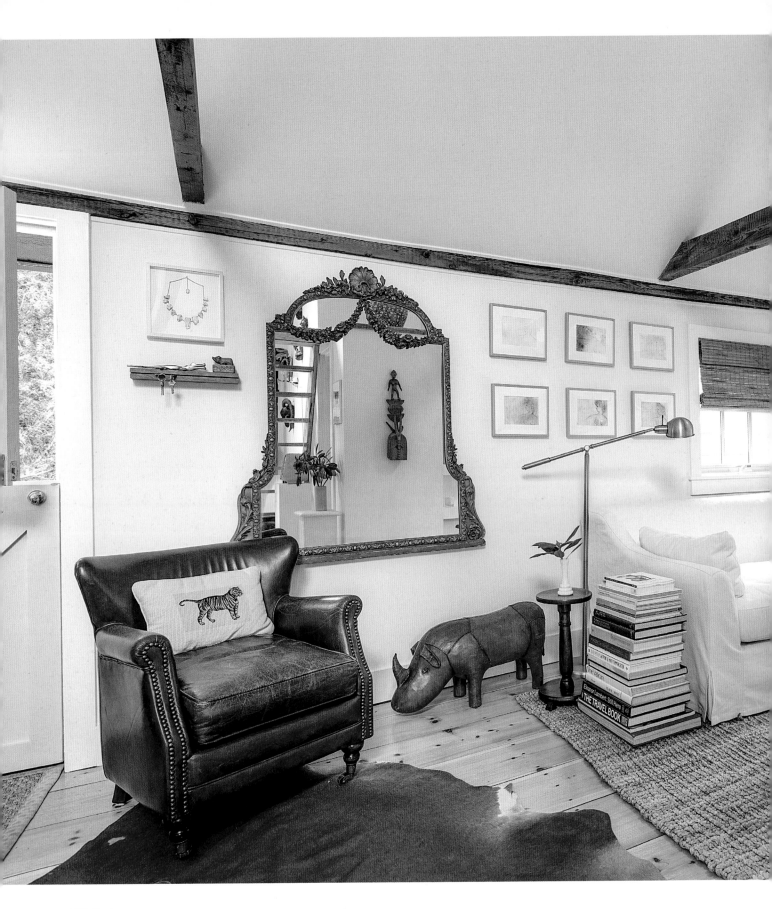

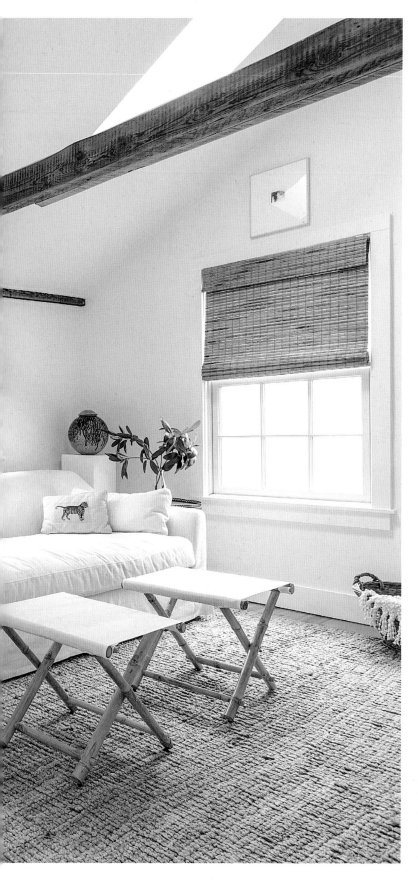

ARTFUL LIVING

BERNADETTE HEYDT TRULY PERSONIFIES THE SAYING "THE APPLE DOESN'T FALL FAR FROM THE TREE."

Her late grandfather was a prominent contractor in New York City and one of the main contributors to building several of the Big Apple's most iconic landmarks. Her admiration for those accomplishments, combined with growing up alongside her father's love of restoring unique properties, led her to her passion. "I knew interior design was a field I wanted to pursue after years of witnessing my father's appreciation for how architectural design can be both beautiful and functional," she says. But it wasn't until she was nineteen and living in Italy that she decided to pursue her calling and enroll at the acclaimed Istituto Lorenzo de' Medici in Florence, where she received her bachelor's degree in interior design.

LEFT Art, animals, and greenery are staples of Bernadette's decorating. The majority of the photography, etchings, and paintings in the loft are by her father, William Heydt, a renowned watercolorist and photographer. "Nature brings a space alive," she says. "And animals add a whimsical element." The vintage 1980s Abercrombie and Fitch rhinoceros and the pillows with hand-stitched tigers are a case in point. A jute rug, hide, leather chair, and shiny floor lamp add impact and charisma to the calm scheme and keep the design interesting. The intricate mirror her grandparents brought back from a trip to Italy strikes a classic note, adds a singular beauty, and contrasts with the mostly modern furnishings.

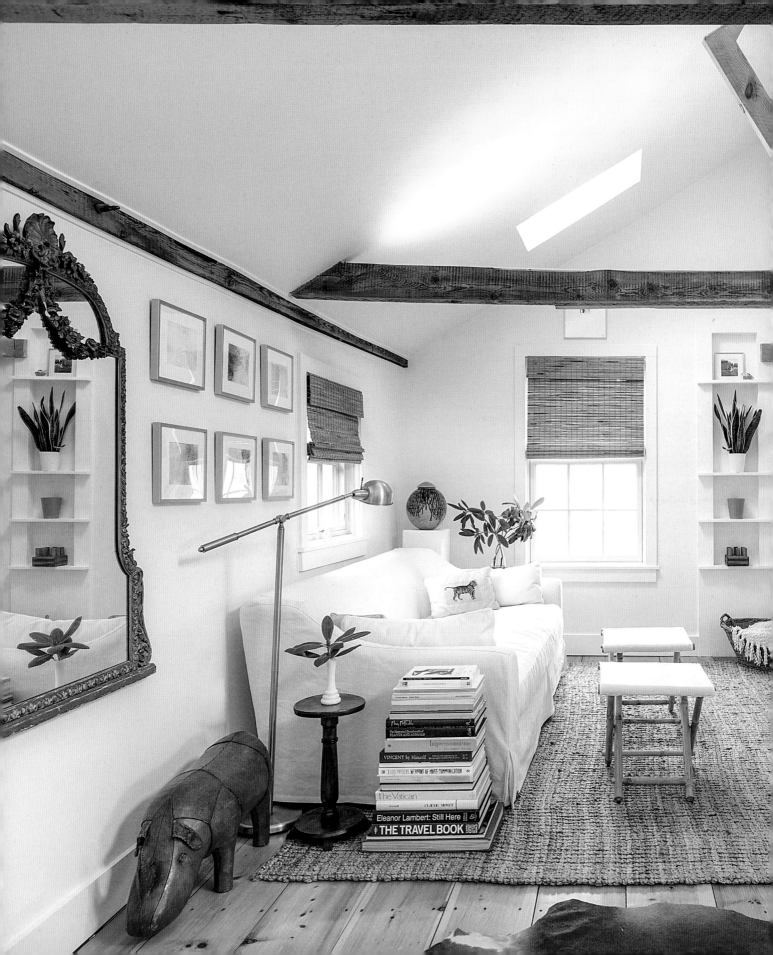

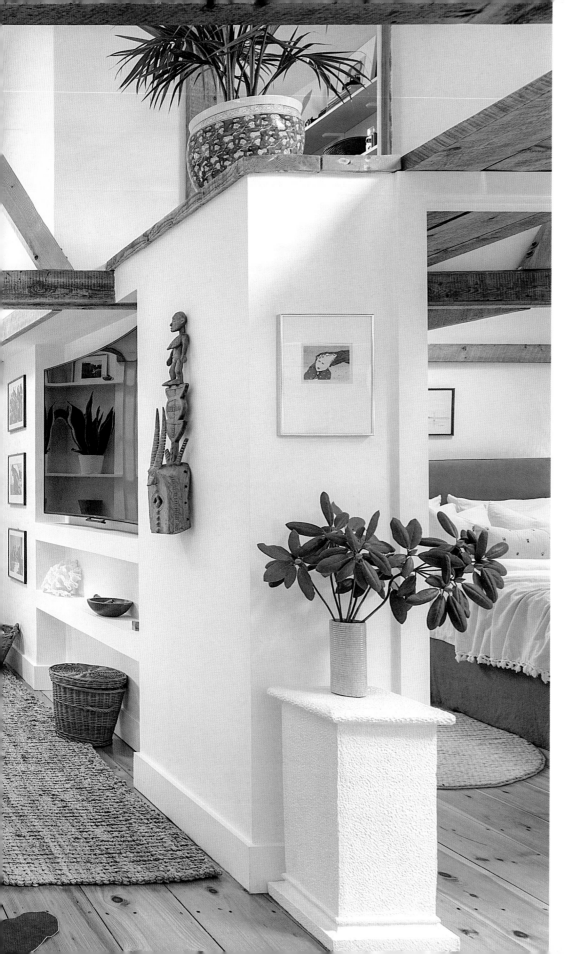

LEFT Despite its compact size the mood of the living room is one of serenity, uncluttered simplicity, and cohesiveness. Built-in niches and shelving allow for tidy displays. Bernadette chose bamboo shades for the windows for texture and privacy but also to bring a coastal vibe into the space. Beautiful raw materials like the original beams and wide plank pine floor speak of the loft's historic charm and character.

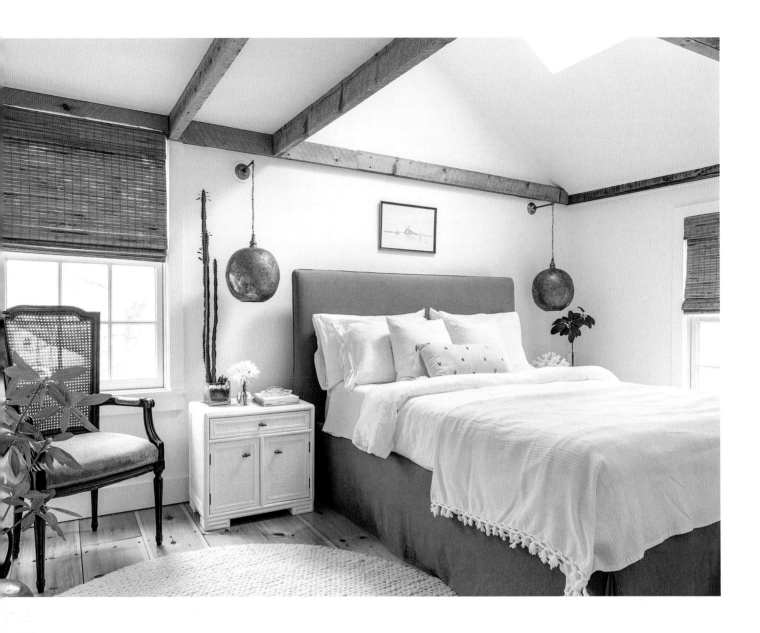

ABOVE The gray linen of the bed sets off the all-white bedding and the darker textile adds contrast to the bedroom. Bernadette worked with an artist on Etsy to create the proper shape, size, and finish for the pair of handmade Moroccan pendants. Rattan and bamboo nightstands painted white supply stylish storage while a wool rug offers comfort.

OPPOSITE ABOVE LEFT A pretty vignette brings together ocean and earth with the chiseled lacy contours of a sculpture-like white coral and the simplicity of fresh greens.

OPPOSITE RIGHT A pair of pedestals signals the entrance to the master bedroom. The ladder-like stairs lead to two small rooms, one Bernadette's studio, the other her husband Andrea's office. A fifteen-foot plank bridge links the two spaces, making the trek from one to the other a bit daunting for the uninitiated.

OPPOSITE BELOW LEFT Coral appeals to Bernadette for its sculptural form and natural beauty. "It's also a way to include a bit of the coast we live by," she says.

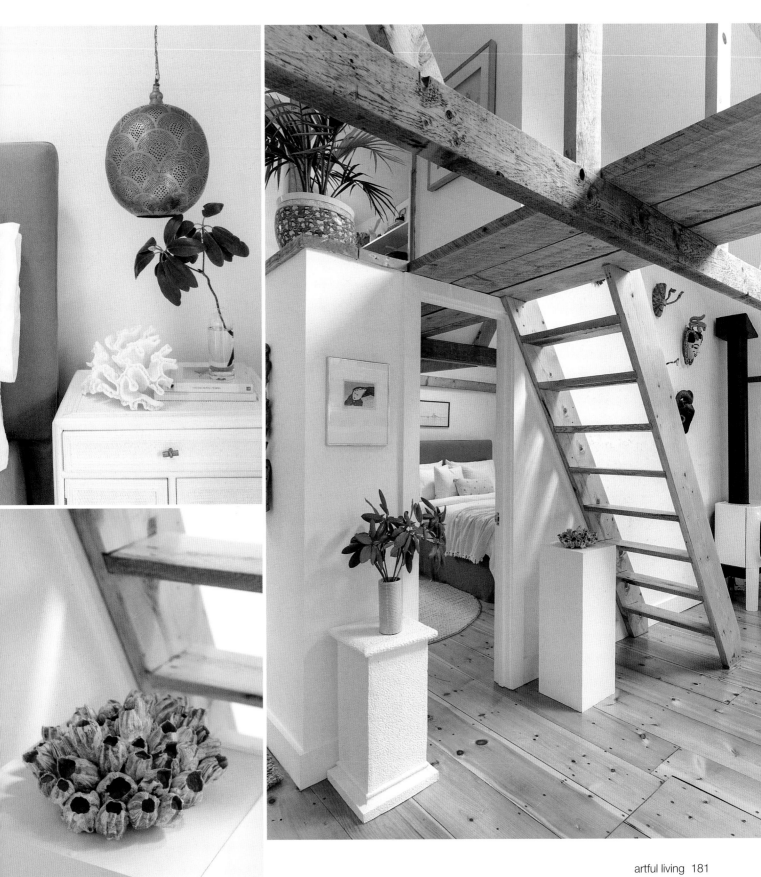

RIGHT The kitchen and eating area's sober furnishings sustain the prevalent airy design established in the adjacent living room, and help keep the space orderly. With its clean lines and organic wood, the handsome dining table Andrea built is the focal point of the space. The chairs that once belonged in the waiting room of a 1960s New York City advertising firm are Bernadette's favorite pieces. She had them re-covered in a performance fabric that facilitates everyday use. A leather pig (another 1980s piece from Abercrombie and Fitch) brings a bit of levity to the decor. The butcher-block island is another of Andrea's creations, which he crafted from white oak.

OPPOSITE Although the kitchen cabinetry and shelving are sleek and fuss-free, books, art, plants, and wooden accessories lend a familiar feel.

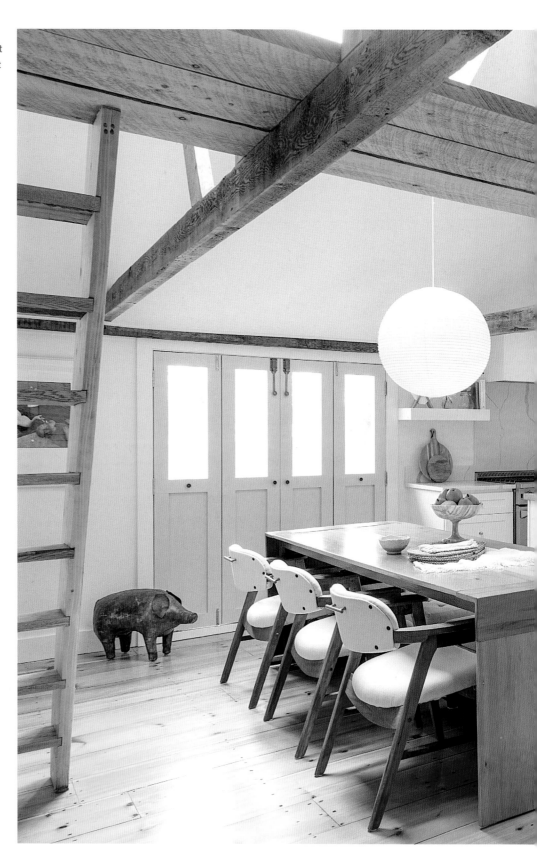

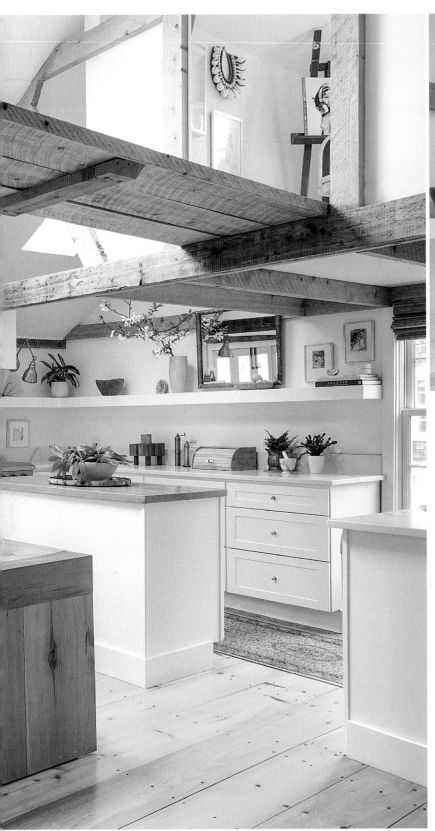

Fast-forward to 2013 when Bernadette, who owns Heydt Home, an interior-design firm, and Heydt + Mason, a full-service creative agency, and her Italian-born husband, Andrea Pietrangeli, a videographer, moved back to the States to pursue their careers. Shortly after they settled in Newport, Rhode Island, they purchased a property composed of three buildings dating back to the early 1800s. Throughout the years the complex has served various functions, but it was originally used as horse stables and storage for their carriages. Today, craftsmen, painters, sculptors, and photographers call the lovingly renovated compound home.

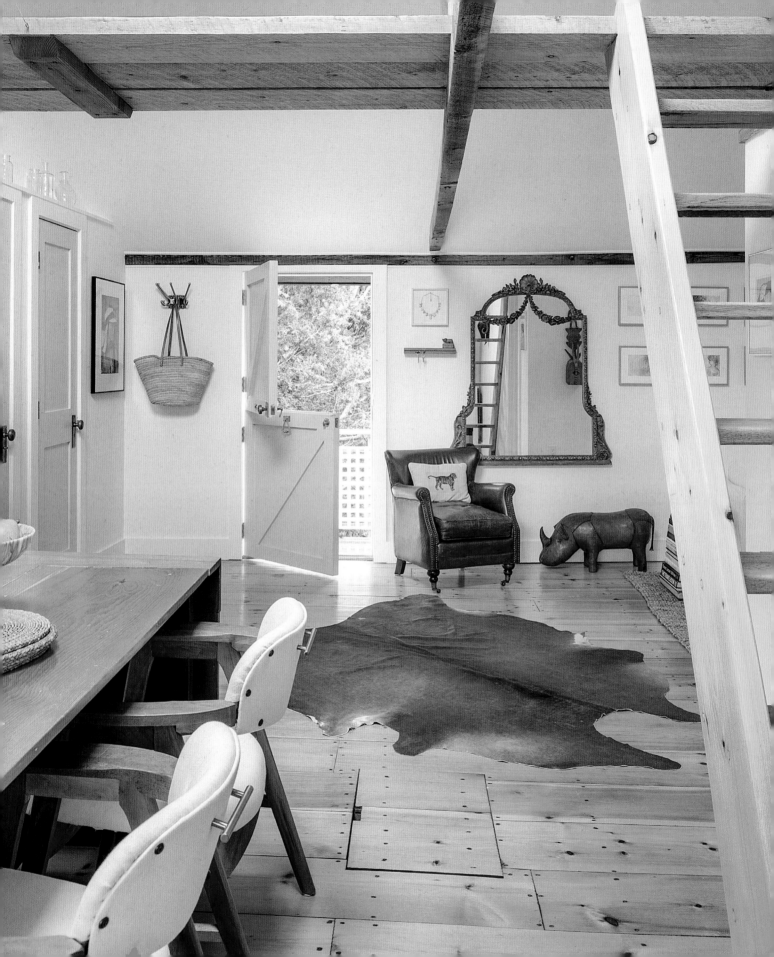

OPPOSITE Rather than replacing the original Dutch door with a modern one, Andrea refurbished it to keep its quaint charm and historical value. Above the leather chair, a key holder marries function with a minimalist aesthetic. While on an excavation trip to Mongolia the couple picked up dinosaur bone shards that Bernadette's uncle, a jewelry designer, wrapped in gold to make a necklace for her thirtieth birthday. Bernadette had it framed to display the beautiful piece. The reflection of an African wood sculpture appears in the mirror.

RIGHT Bernadette created a gallery wall with a collection of African masks her parents purchased from street vendors in New York City and from various trips.

Despite its tiny footprint, the loft Bernadette and Andrea designed and share lives large and well. Built on a foundation of white, the space feels luminous, light, and airy. And though the floor plan is wide open it emanates an intimate vibe. "After many years of living in Europe, a large home didn't seem like a necessity," Bernadette explains. "Considering the space is only 700 square feet, the key goal was to keep the layout open and only add walls where it was absolutely necessary while keeping functionality, balance, proportion, and scale in mind."

Inspired by her years abroad, Bernadette wanted to incorporate the crisp white stucco look seen in the homes of southern Italy. "We had to be strategic with the layout and maximize the use of space, so we built shelving into the walls to add storage, and in doing so we were able to achieve the Mediterranean feel we

were after," she says. Her creativity comes through in her European minimalist yet cozy approach, the neutral backdrop, and by relying on natural materials like wood and leather to add texture and warmth.

"I love mixing modern clean lines with vintage or worldly items," says Bernadette. "The marriage between the two aesthetics brings out an authenticity that is both elegant and unique."

The idea of living in a tiny home can be intimidating, but when everything you own serves a purpose and is used on a daily basis, and when it means you display only meaningful pieces, the tradeoff is worth it. "Designing a tiny home requires thoughtful solutions in order to fit all the utilities modern life demands," Bernadette concludes. "Yet there is nothing we lack that a 2500-square-foot house has, maybe just fewer rooms to vacuum!"

LEFT A shell necklace the couple bought in Bali while visiting the island hangs by a couple of Bernadette's own artworks.

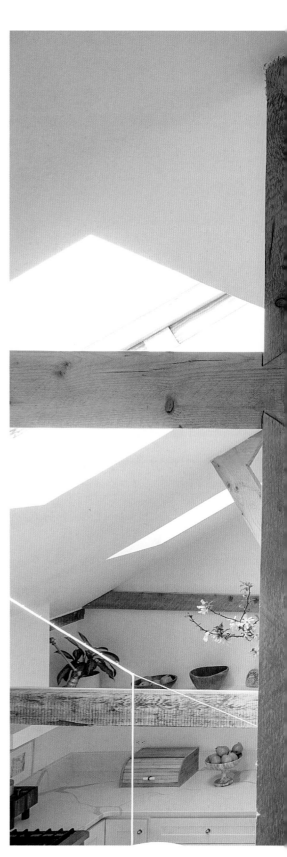

LEFT Her tiny, pristine studio is where Bernadette engages in another favorite endeavor: painting. "I have been painting since I was fifteen," she says. "My father is a painter, so it runs in my blood." Equally small but as efficient, Andrea's office is on the other side of the plank bridge that connects the two rooms.

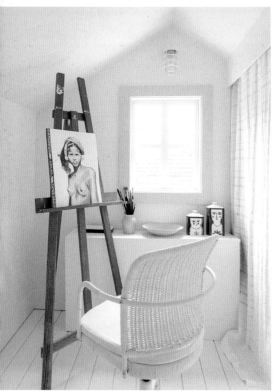

RIGHT High above the main living areas, the couple set up two small rooms where they can pursue work and hobbies. White walls bounce the light harnessed by several skylights. Wood beams add definition and warmth.

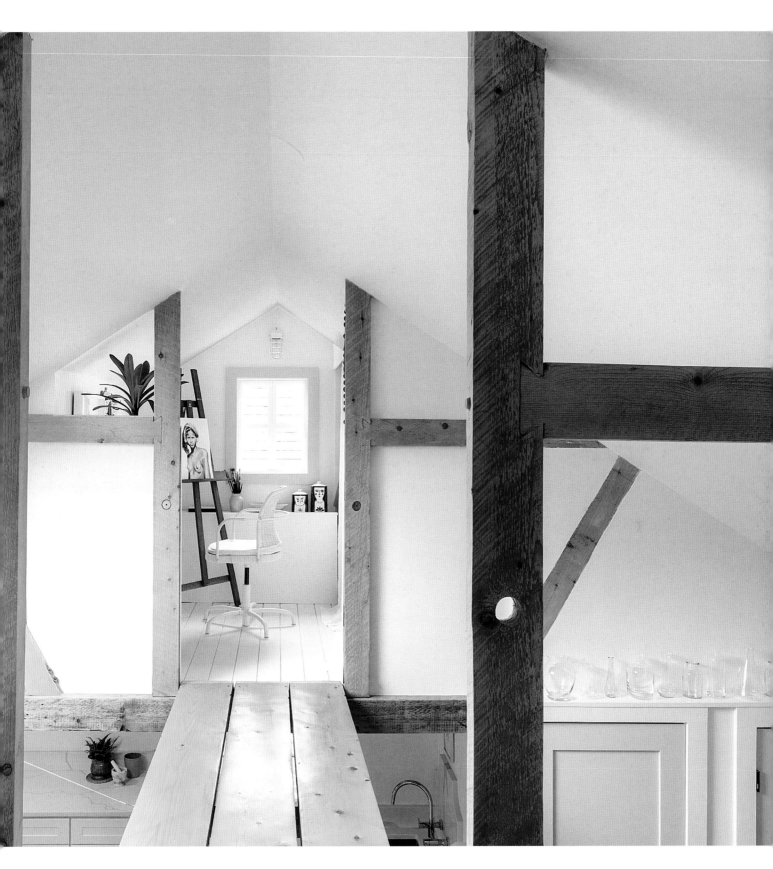

BELOW With their natural good looks, a honeycomb sponge and a Beechwood brush provide texture and a spa-like flair to the serene bathroom.

OPPOSITE The bathroom embraces the crisp, minimalist sensibility prevalent in the loft. Simple cabinetry, classic tiles, and a sophisticated marble floor contribute cohesiveness and modernity. Rattan sconces bring texture and a coastal hint and emulate the color of the slender wood beam. Instead of a traditional cabinet, a niche makes room for a few essentials, while everyday toiletries are kept out of sight in dedicated drawers.

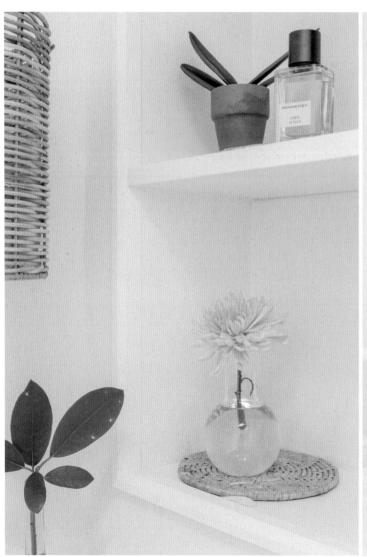

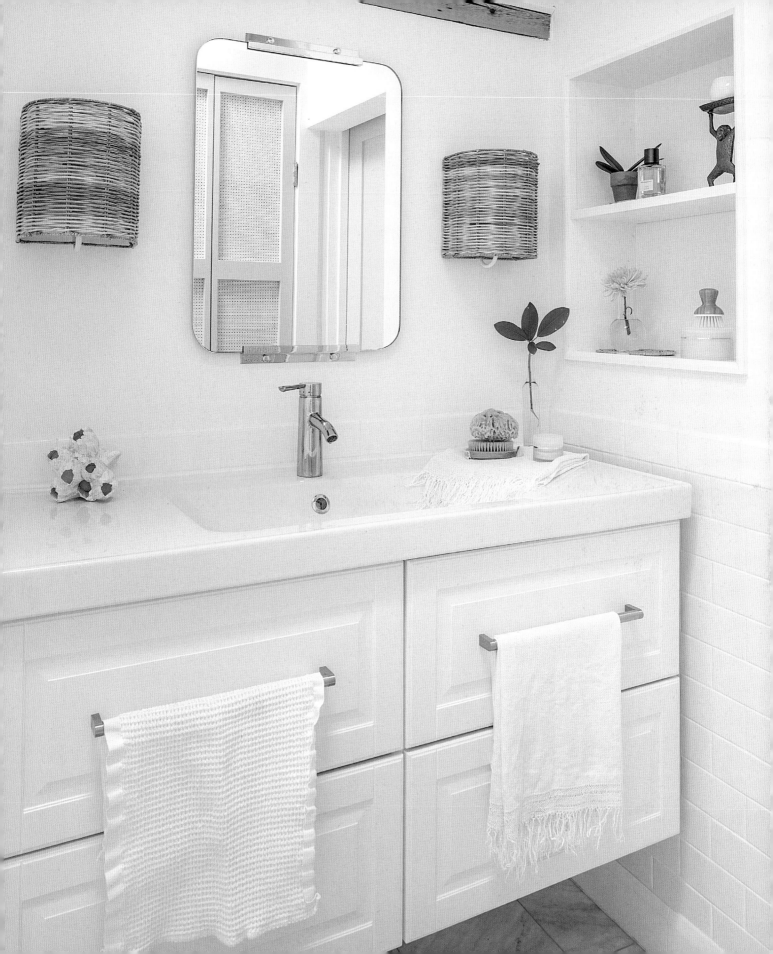

LEFT "Even though the horse isn't old, it's been dropped so many times that it really deserves to be an antique," Leah says. "It's one of those pieces that I just don't have the heart to part with. I tend to love imperfect things, so to me all the gluing back of parts has only made him more valuable."

RIGHT The table and antique mirror forge a connection with the stone wall and barn door, which Leah loves because they remind her of those from the English homes of her youth. "We love antiques and pieces that show that they've lived a life," she says.

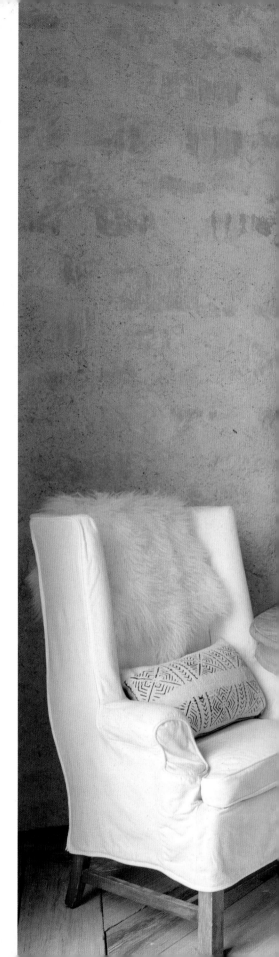

SOPHISTICATED NEUTRALS

OVER THE COURSE OF THE PAST TWENTY-TWO YEARS, LEAH ANDERSON AND HER HUSBAND, STEVE BROWN, HAVE REMODELED OR BUILT FROM SCRATCH THIRTY-ONE HOMES. "AS BOTH BUILDER AND DESIGNER WE HAVE GROWN AND LEARNED A LOT SINCE WE STARTED," LEAH SAYS. "I THINK WHAT'S MADE US SUCCESSFUL IS THAT WE ALWAYS PROCEEDED AS THOUGH WE'RE GOING TO LIVE IN THE HOMES OURSELVES."

After spending many years in Devon, England, the appreciation for old homes has never left Leah. "Unfortunately, we don't have a lot of buildings with character in our part of the world, so our only choice was to try and mimic an old stone house," she says.

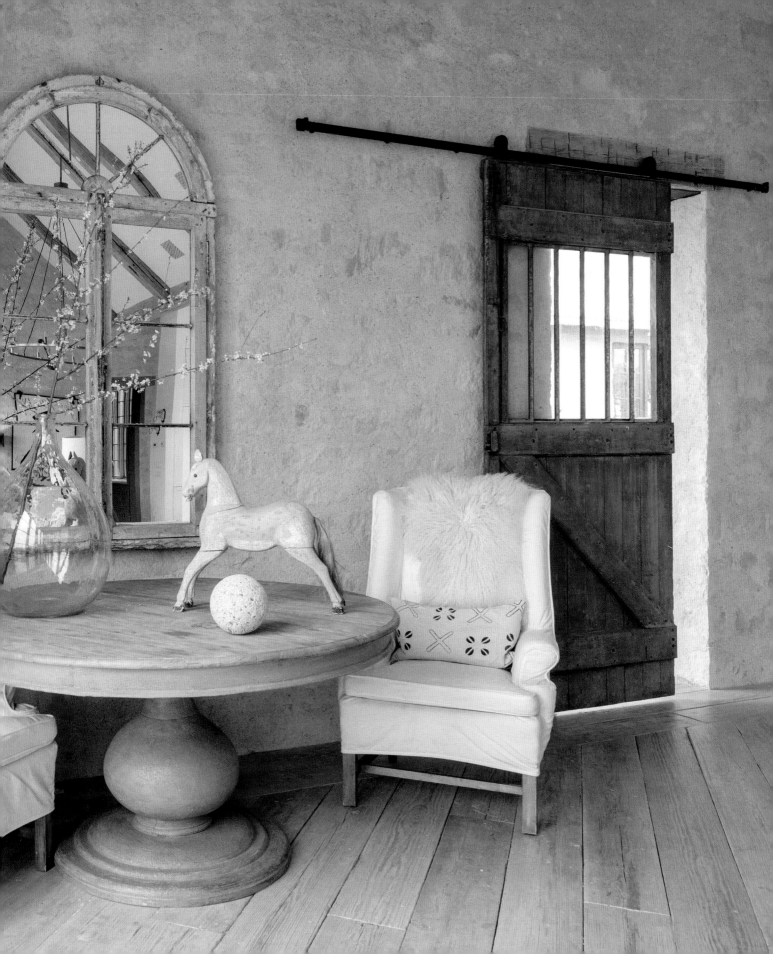

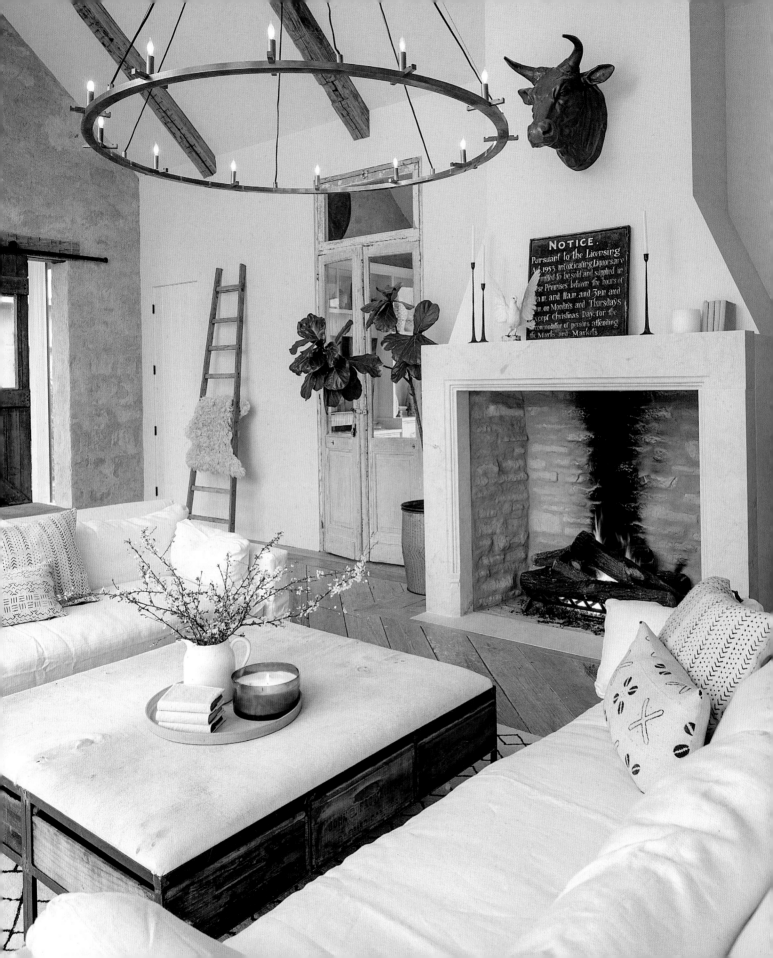

OPPOSITE "This is a very large room with twenty-eight-feet-high ceilings, great architecture, and views," Leah says of the living room. "It was important to make it feel cozy, but it needed a special feature to compete with the view." To create that unique focal point, Steve and Leah designed the fireplace, which was carved out of solid marble from France. A voluminous yet streamline chandelier lessens the room's loftiness. Leah chose sofas slipcovered with white Belgium linen for their organic feel. The custom-made coffee table sports a cowhide fitting to the farmhouse.

BELOW Pillows with a subtle pattern add just the right touch of contrast to the white sofa. "We change them out depending on the seasons," Leah says. "It's always fun to find new ones."

The couple's latest project, a 5,600-square-foot Californian farmhouse, is a modern take on classic architecture and sits on nine acres complete with horse stables and other buildings designed for storage. "The concept for this house was to make it appear like an original old barn that was added onto over the years," Leah says. "It took us fourteen months to build and another two months to complete the landscaping." Steve was the builder and Leah the general contractor and interior designer, but each plays parts in both areas. "We definitely argue but we also respect each other's opinions. There isn't a piece of wood that Steve hasn't touched," Leah says. "Once the framing is done and the flooring installed, that's when I step in." This has been the couple's largest and one of their favorite projects to date. "We owned the property for a few years before building," Leah explains. "This was important as it gave us time to really think through how to design and create a meaningful home built for longevity with robust materials."

ABOVE With seasonal displays of garden cuttings, an old planter keeps nature in focus.

OPPOSITE "We love how narrow the dining room oak trestle table is, because no matter how many people are at the table, we can talk to each other and no one is ever left out of the conversation," Leah explains. "The wood was never finished with a varnish and stains easily, but that only adds to the character." The George The IV, an old pub sign from England, and the locally found zinc-topped sideboard are two pieces Leah has had for many years and plans to have for many more. "They are irreplaceable!" she emphasizes. Black accents from the lamps, tray, and sign contribute dramatic yet unobtrusive touches.

OVERLEAF The living room, dining room, and kitchen form an open space conducive to convivial gatherings of family and friends. The massive island that anchors the kitchen is an integral part of the house and the couple's lifestyle. "It's quite easy for us to balance practical with aesthetic because we're casual people," Leah says. Slender pendants add an artful touch and a modern note. A buffet that holds antique stoneware and prized glasses was custom-made to fit the space. The mirror and the wooden goat have always found a spot with every move. The doors leading from the kitchen to the family room had been stripped of their paint and Leah chose to keep them as they were: "I love it when pieces tell a story and aren't perfect." On the opposite wall, one of Leah's cow paintings highlights her love of animals.

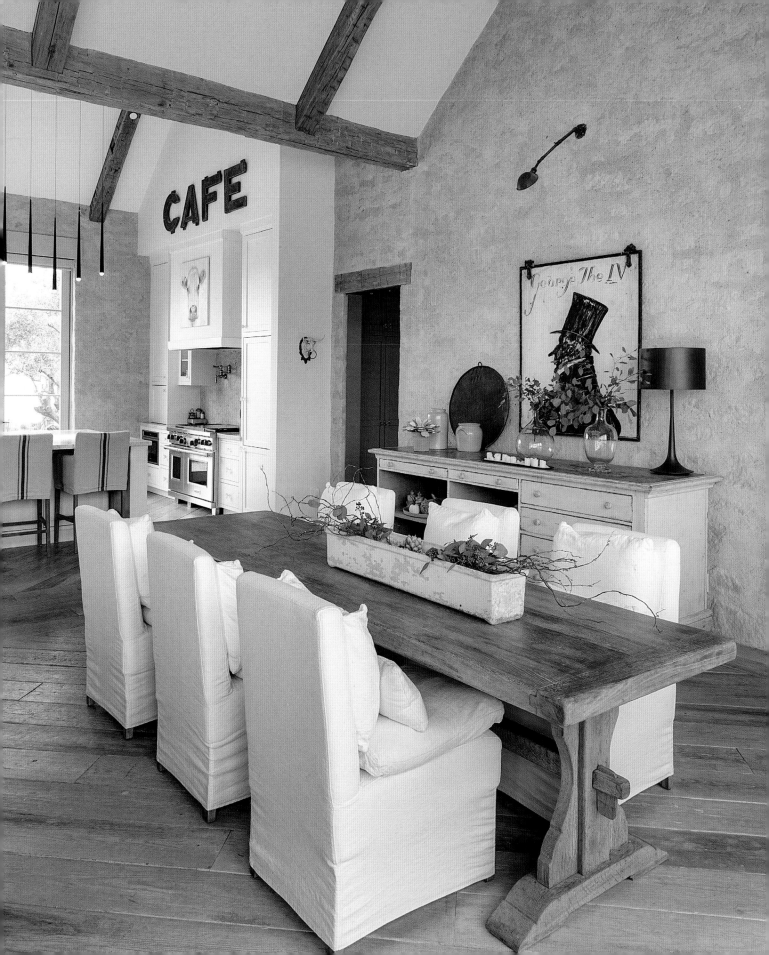

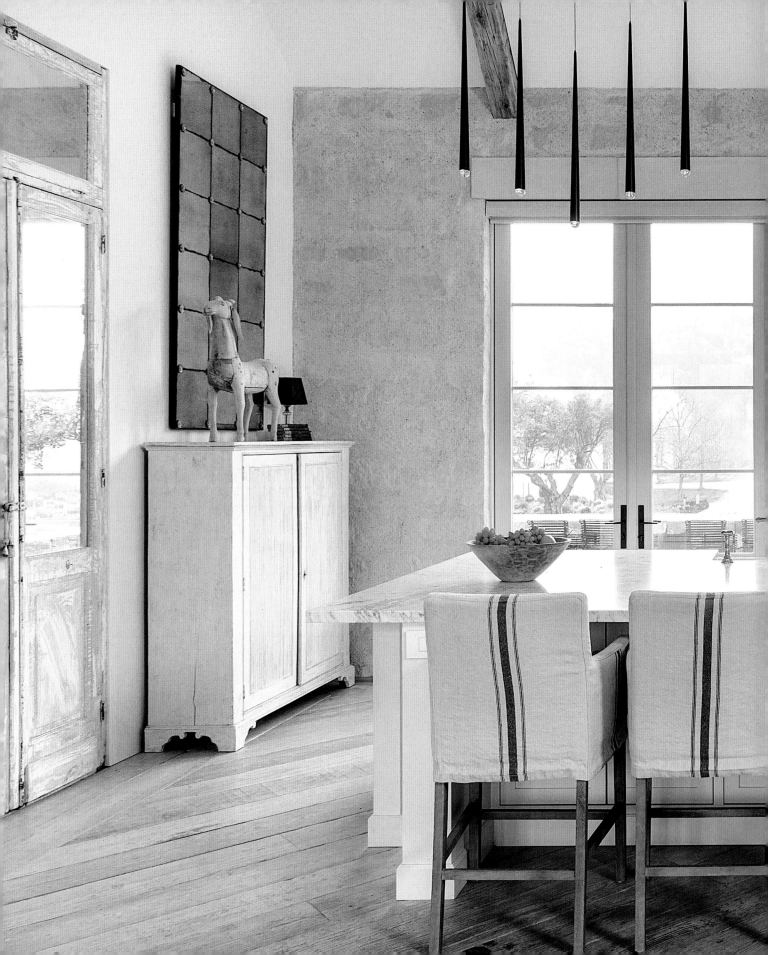

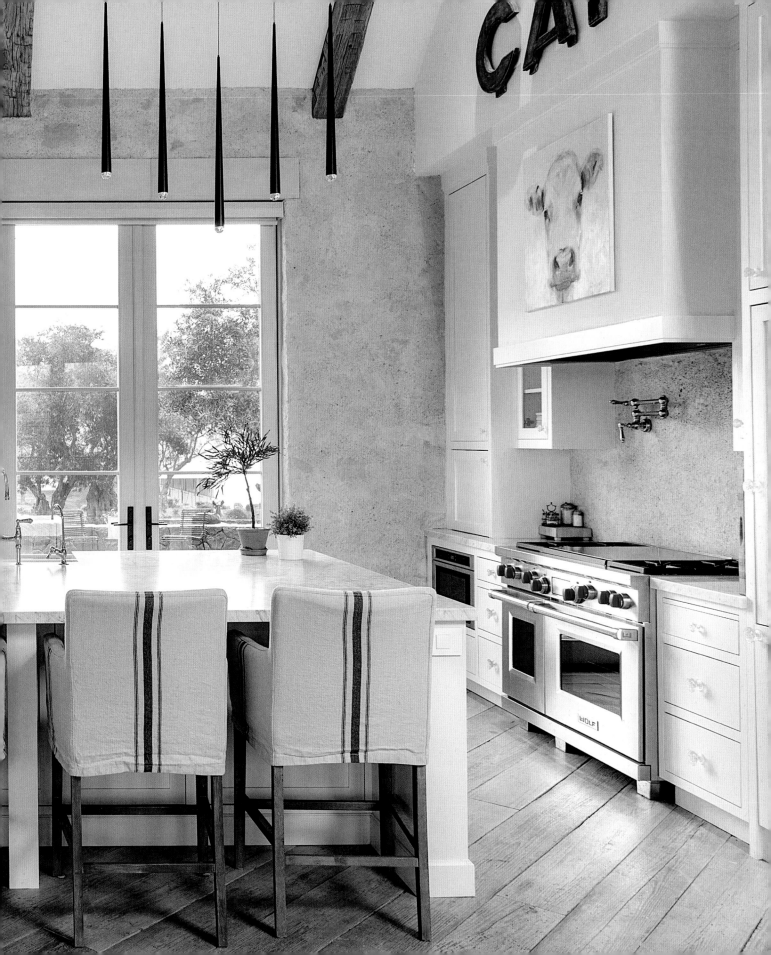

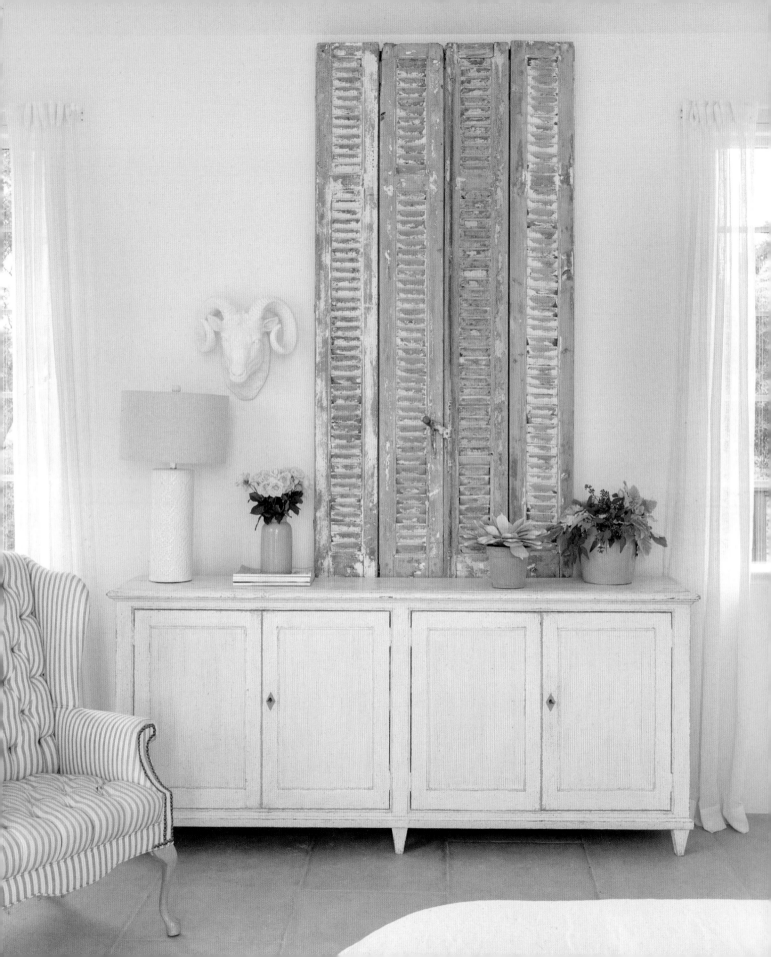

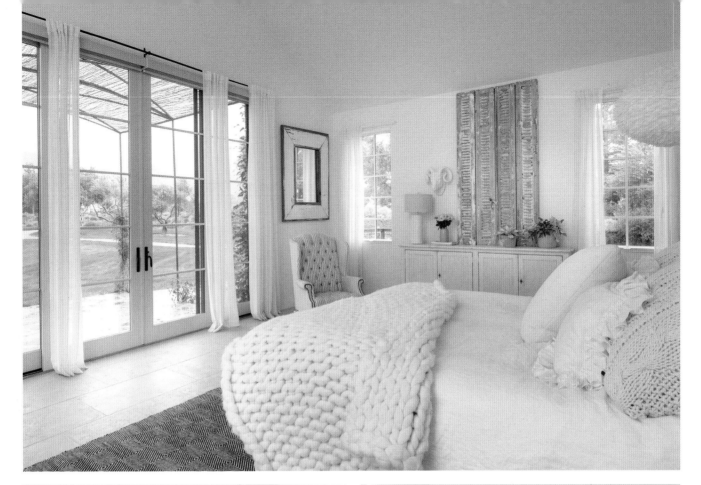

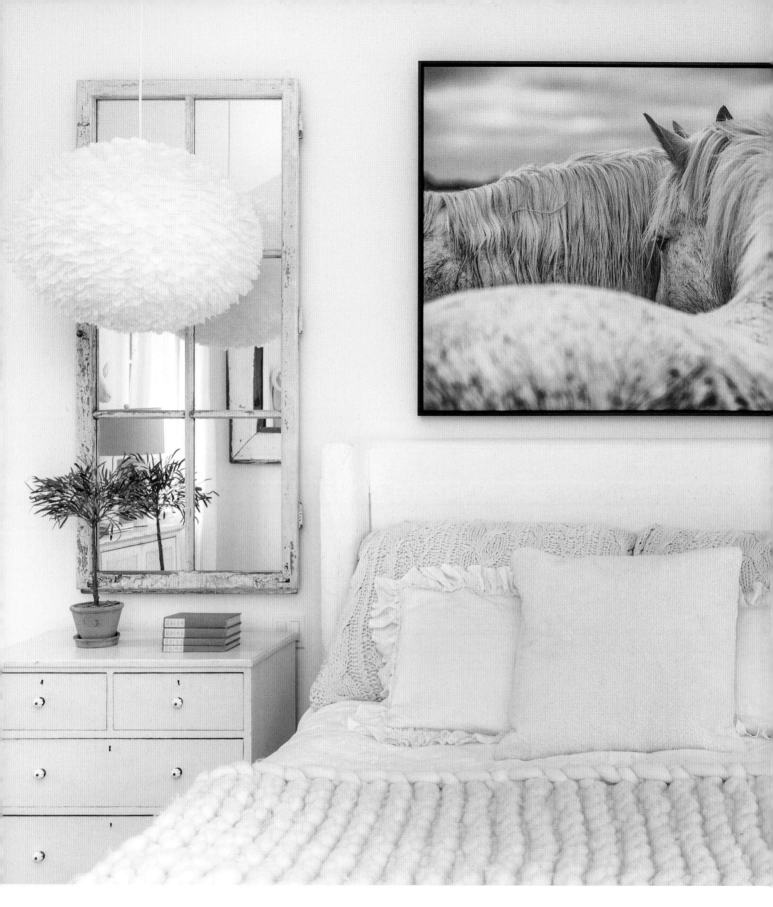

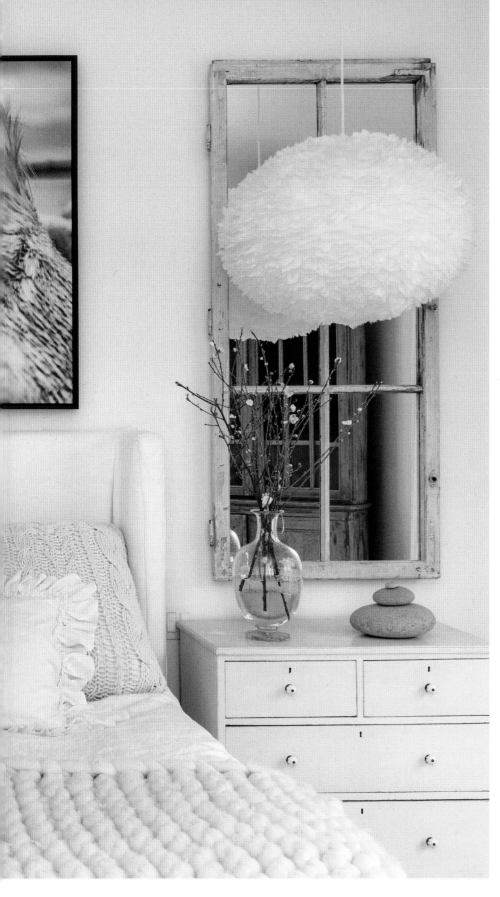

PAGE 198 Simple ceramics in matte and neutral finishes add interest without competing with the bedroom's focal point. The ticking chair has followed the couple's moves from one home to the next. "It shows lots of wear and tear, but I always seem to need it somewhere," Leah remarks.

PAGE 199 ABOVE "I've always had a love affair with white," Leah says. "I find it the most soothing of all the neutrals." The view from the master bedroom fosters a calming vibe heightened by rustic and elegant decor choices. "I always try to only surround myself with things I love, and the master bedroom is no exception," Leah says. "I honestly couldn't imagine doing a house and not putting anything old into it! The shutters are the stars of the room. They have just the right amount of peeling paint and their colors are fabulous. To me this is what a perfect patina is. The Swedish sideboard's low profile lets them shine."

PAGE 199 BELOW LEFT The silvery gray of the succulent and the faded blue of its container unite with the hues of the shutters.

PAGE 199 BELOW RIGHT Though disparate in shape, style, and fabric, the pillows are unified with hushed tones of white, cream, and ivory that bring layers of texture to the monochromatic scheme.

LEFT Leah chose a palette of snowy whites to create a serene ambiance in the master bedroom. "I like it to be gentle and ever so soothing," she says. To that end she paired feathered light pendants reminiscent of wispy clouds with antique mirrors to reflect their diffused glow. Unfussy antique Swedish dressers add to the space's pleasing symmetry. "We live on a horse farm and animals are a huge part of our life," Leah says. "I adore this print," she adds, pointing to the artwork above the bed. "I love the connection between these two horses."

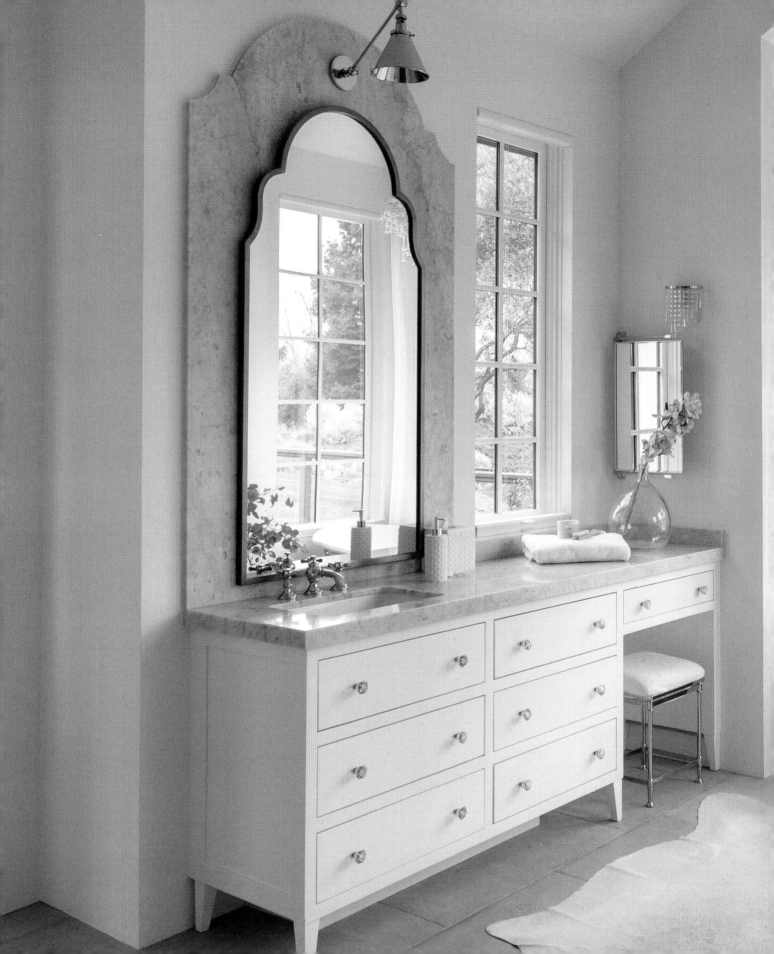

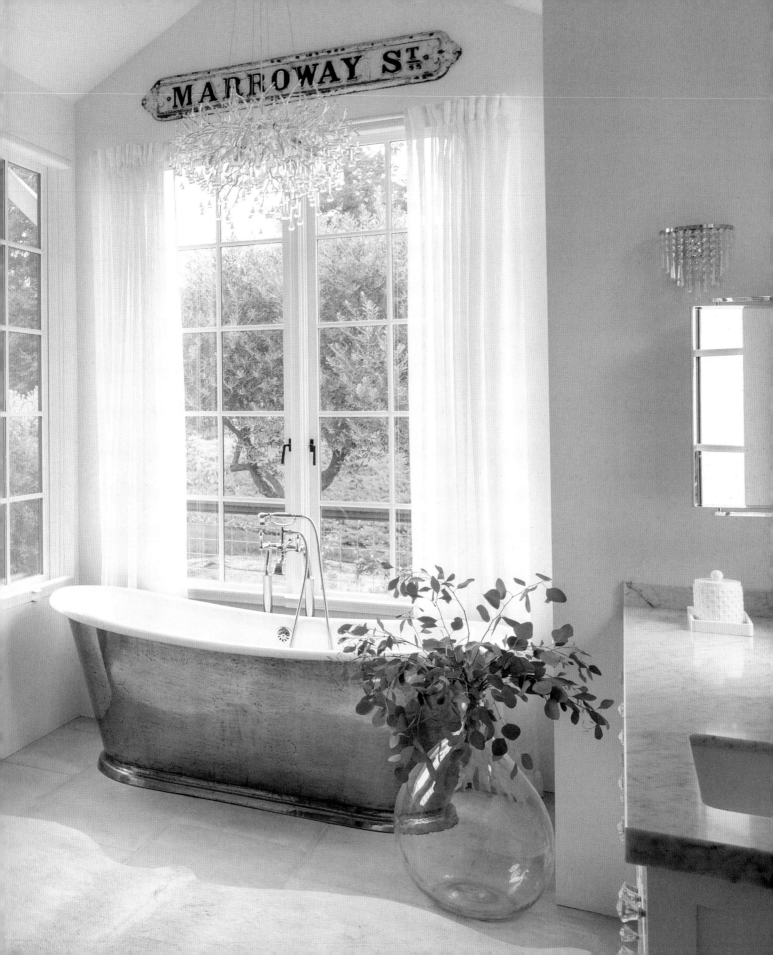

Thoughtful and organic, Leah's aesthetic resonates from room to room with a blend of European influences, contemporary clean lines, earthy basics, and neutral textures that offer warmth, comfort, and utility. "I always rely on using a combination of vintage or antique pieces, like old doors and shutters, not just in the actual furnishings but into the architectural details as well," she says. But, as happens with any project, there were some challenges which had to be overcome. "One of the biggest ones was the limestone for the floors. They were shipped over from France and the limestone had reacted to the salt air. There was this unsightly black line where each piece had overlapped. We had to use a blowtorch to heat up the stones, and then scrubbed them with a combination of bleach and water," Leah recalls. The other challenge that the couple had to contend with was the land. Once the home was built it became clear that to create a timeless feeling and not just a house sitting out by itself would require a lot of landscaping. "After planting over 122 olive trees and copious amounts of shrubs, iceberg roses, and boxwoods it was done!" Leah exclaims.

As for the design and the furnishing of the house, Leah says: "The first rule was being true to ourselves and the location. Our home is comfortable and casual because that's who we are. We live on an active farm so that means using tough materials like stone, carpets, and floors that can handle dogs, cats, and people coming and going, casual furniture that anyone can feel comfortable sitting on with their feet up, and lots of throw blankets and comfy pillows. Nothing that would stress us out if it got nicked or scratched." When asked if she has a favorite room, she is quick to answer: "Any room that has our family in it, including our animals. We use every part of our house, but most of the time you'll see us all squeezed into the same room surrounded by all our pets."

Though the beautifully crafted home stays rooted in practicality, it captures the couple's affinity for design and eye for balance, and Leah's signature whites, which are enlivened with meaningful elements and poetic inspirations that embrace California's simple life and warm hospitality. But in the end, the farmhouse's innate sense of gravitas and material sincerity stems from the family who lives there.

PREVIOUS PAGE In a room with interesting architecture Leah prefers to keep the furniture practical but quietly elegant, to act as a complement to the space rather than upstaging it. "The idea of putting a marble slab behind the mirror was a way of adding a subtle dramatic touch," she says. "I tend to love simplicity, so I always keep that in mind when designing a room and furniture."

OPPOSITE "When you have such gloriously natural light, having a whole wall reflecting it makes it even more complex and beautiful," Leah notes. The gray limestone floor with hints of blue undertones offers the perfect foundation without overpowering the room.

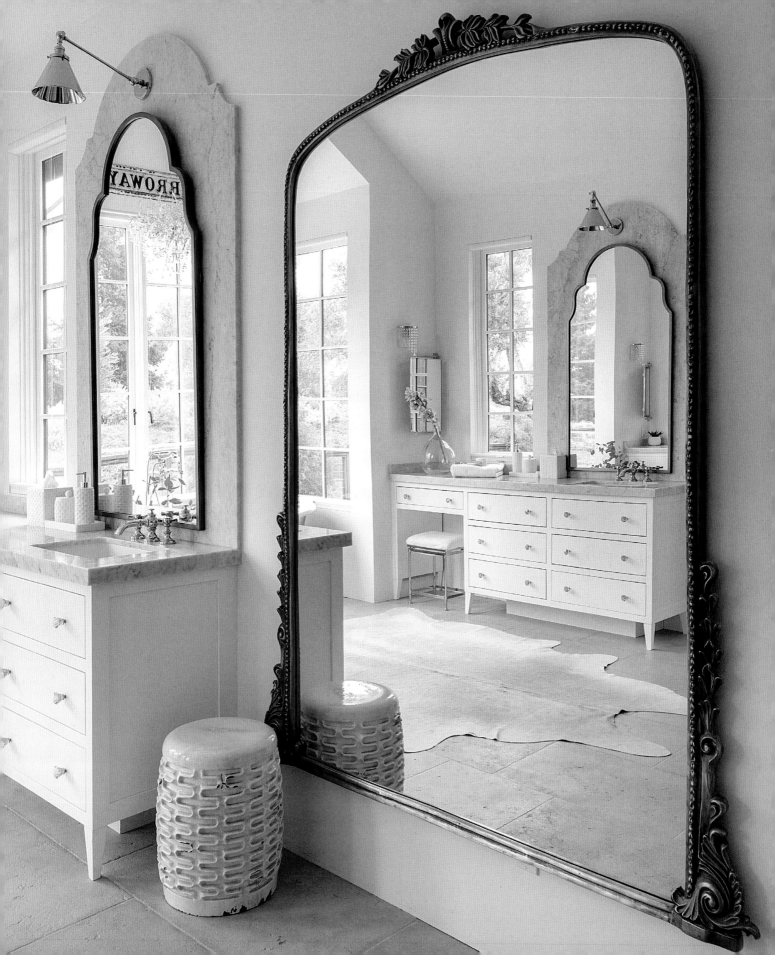

RESOURCES

SUBLIMELY SIMPLE

paint

Throughout the house
Farrow & Ball All White 2005

EARTHY INFLUENCES

paint

Throughout the house
Benjamin Moore porch paint color matched to
Farrow & Ball Cornforth White

furniture

Master bedroom
Shelves: ikea.com
Sunroom/back porch bed: elsiegreen.com
Pillows: elsiegreen.com; target.com;
worldmarket.com
Light pendant: baytihome.com

Outdoor dining space
Light pendant: baytihome.com

Living room
Sofa: rh.com
Sisal rug: ikea.com

Dining room
Table and chairs: elsiegreen.com

Kitchen
Shelves: ikea.com

Porch
Bed: grenouillefrenchvintage.com
Curtains: potterybarn.com

COUNTRY CHARM

paint

Throughout the house
Benjamin Moore Simply White

furniture

Living room
Artwork: kitreuther.com
Black trunk and black barn door:
tumbleweedanddandelion.com
Ivy dishes in hutch:
tumbleweedanddandelion.com

Master bedroom
Artwork: kitreuther.com

RUSTIC HAVEN

paint

Throughout the house
Valspar Du Jour satin finish

furniture (mostly thrifted)

Sitting room
Fireplace bells by artist Melissa Paxton:
muddyhart.com

VINTAGE VIBES

paint

Living room
Walls: Valspar Secluded Beach
Trim: Clark+Kensington Silent White
Floor: Clark+Kensington Ultra White

Bedroom
Clark+Kensington White Opal

furniture (most items bought on eBay, Etsy, and other internet market places)

Living room
Sofa: ikea.com
Floral pillow: cabbagesandroses.com

CELESTIAL ROMANCE

Posh on Palm
327 W Venice Ave, Venice, FL 34285
Phone (941) 786 1008

paint

Walls: Sherwin Williams Agreeable Gray
Trims and ceilings: Sherwin Williams
Snowbound

furniture

Guest bedroom
Dresser: baconsfurniture.com
Shell mirrors/floor lamp/curtains: POSH
Rug: overstock.com

Den
Sofa: arhaus.com
Rug: overstock.com
Chandelier: High Point Market, NC
Table lamp: potterybarn.com
Mirror: Round Top Antique Market, Texas
Curtains: POSH/Bella Notte

Entryway
Oak bureau and mirror:
scottantiquemarket.com
Chair: POSH

Master bedroom
Bed: americansignaturefurniture.com
Mirror: arhaus.com
Nightstands: baconsfurniture.com
Rug: overstock.com
Curtain: POSH/Bella Notte
Chandelier: overstock.com

Living room
Sofas and ottoman: arhaus.com
Sideboard: Round Top Antique Market, Texas
Lamps: High Point Market, NC
Rug: overstock.com

Dining room
Chandelier: arhaus.com
Mirror: Round Top Antique Market, Texas

Kitchen:
Light pendant: potterybarn.com

ZEN ELEMENTS (jodigdesigns.com)

paint

Throughout the house
Walls: Sherwin Williams Creamy 7012
Base and trims: Benjamin Moore Chantilly
Lace

FANCIFUL CHIC

paint

Walls: Sherwin Williams Sky High
Ceilings and trims: Sherwin Williams
Dove White

furniture

Living room
Sofa: birchlane.com
Fireplace mantel: fancyflea.net
Coffee table: birchlane.com
Sideboard: birchlane.com
Acrylic chair: amazon.com
Light pendant: ikea.com
White stool and armchair: Home Goods
Sea rope by Dore Callaway:
etsy.com/shop/burlapluxe; IG: @burlapluxe

Dining room:
Table: birchlane.com
Acrylic chairs: Home Goods
Faux hide: overstock.com
Bar trolley: pier1.com
Mirror: Home Goods

Foyer
Buffet: Home Goods

Master bedroom
Bed: wayfair.com
Dresser: pier1.com
Chunky throw: target.com
Faux-fur pillow: zgallery.com
Shaggy pillow: overstock.com
Light pendant: ikea.com
Print: caryndrexl.com
Curtains: Home Goods
Faux hide: overstock.com
Shaggy white rug: Home Goods
Silver basket: Home Goods

Porch
All furniture: Home Goods
Curtains: ikea.com

COTTAGE CLASSIC

paint

Master bedroom and guest bedroom
Benjamin Moore Dove White

Bathroom above bead board
Farrow & Ball Ammonite

Carriage house
Farrow & Ball Ammonite

furniture

Master bedroom
Curtains: potterybarn.com
Gray dresser, white table, and lamb painting:
ashcroftandtibbles.com
Fireplace mantel and French market baskets:
dreamywhitesatelier.com
Table lamp: dwvintage.com
Ceiling fixture: bdantiques.com

Guest bedroom
Bed: wayfair.com
Pine cupboard: elsiegreen.com
Mirror: antiquesfromfrance.com

Living room
Drop-leaf table: winsomenest.com
French grain sack: ashcroftandtibbles.com
Striped pillows: dreamywhitesatelier.com
White cupboard: IG @ white_hen_farmhouse_
decor
Bistro table: elsiegreen.com

Carriage house
Trio of paintings: dreamywhitesatelier.com

ELEGANTLY FRESH

Ashcroft & Tibbles
Interior Design & Antiques
1115 Solano Ave., Sonoma, CA 95476
Phone (707) 780 7299

paint

Master bedroom
Walls: Benjamin Moore Paper White
Ceiling and floor: Farrow & Ball All White

Guest bedroom
Walls: Benjamin Moore Paper White
Trim and doors: Farrow & Ball All White
Entry to master bathroom: Benjamin Moore
Paper White

furniture

Living room
Corner cupboard: eloquence.com

Master bedroom
Bed linens: bellanottelinens.com

Bathroom
Vessels: elsiegreen.com

ARTFUL LIVING (heydthome.com and heydtmason.com)

paint

Throughout the house
Sherwin Williams PRO30 Flat White

SOPHISTICATED NEUTRALS

(leahandersondesigns.com)

paint

Master bedroom and living room
Benjamin Moore White Dove OC-17 matte

Bathroom and guest bedroom
Benjamin Moore White Dove

furniture

Master bedroom
Antique mirrors: sonomacountryantiques.
com
Dresser by bed: sonomacountryantiques.com

Living room
Chandelier: rh.com
Coffee table: uberchichome.com
Barn door: elsiegreen.com
Mirror: chateausonoma.com
Wooden horse: wisteria.com

Dining room
Zinc-topped sideboard:
sonomacountryantiques.com

Foyer
Library table: elsiegreen.com

ACKNOWLEDGMENTS

In 2020, traveling for work was no longer an option and for me that meant no more planning photo shoots for magazines or books. I needed to come up with a creative project that would give sense to my life. I knew my idea for a new book was the answer, although at that time reality meant it was only a dream. However, I decided to try to put the wheels in motion and wrote the proposal for this book. In November 2020, I sent it to my publisher, Cindy Richards, and held my breath. And, as always, Cindy came through, and I am forever indebted to her. Thank you, Cindy, for your trust and support and for giving me hope and light.

Many thanks are also due to Peg Shrader, Karen Hall and John Tuoy, Leah Anderson and Steve Brown, Colette and Randy Miller, Carole and David Kulber, Jodi and Johnny Goldberg, René and Randy Cogar, Betsy and Graham Mears, Shannan and Drew Haupt, Bernadette Heydt and Andrea Pietrangeli, and Susie and Mark Holt

for opening their homes to us. They welcomed us with open arms at a time when the cloud of the pandemic was still a concern. Their willingness, hospitality, and generosity made difficult circumstances easy, fun, and ever so rewarding.

Thank you also to my long-time favorite photographer Mark Lohman for his creative eye, passion, patience, and flexibility. But it takes a consummate artist to create the layouts that, in the end, make a book visually beautiful and compelling. And that tour de force is the work of Sally Powell. Thank you Sally for your exquisite designs. Heartfelt thanks also go to production manager Gordana Simakovic. Last but not least, the copy editor's work is the "icing on the text," so to speak, and once again I have to thank Martha Gavin for her insightful and kind editing.

With much love and gratitude to all.
Xo Fifi

INDEX

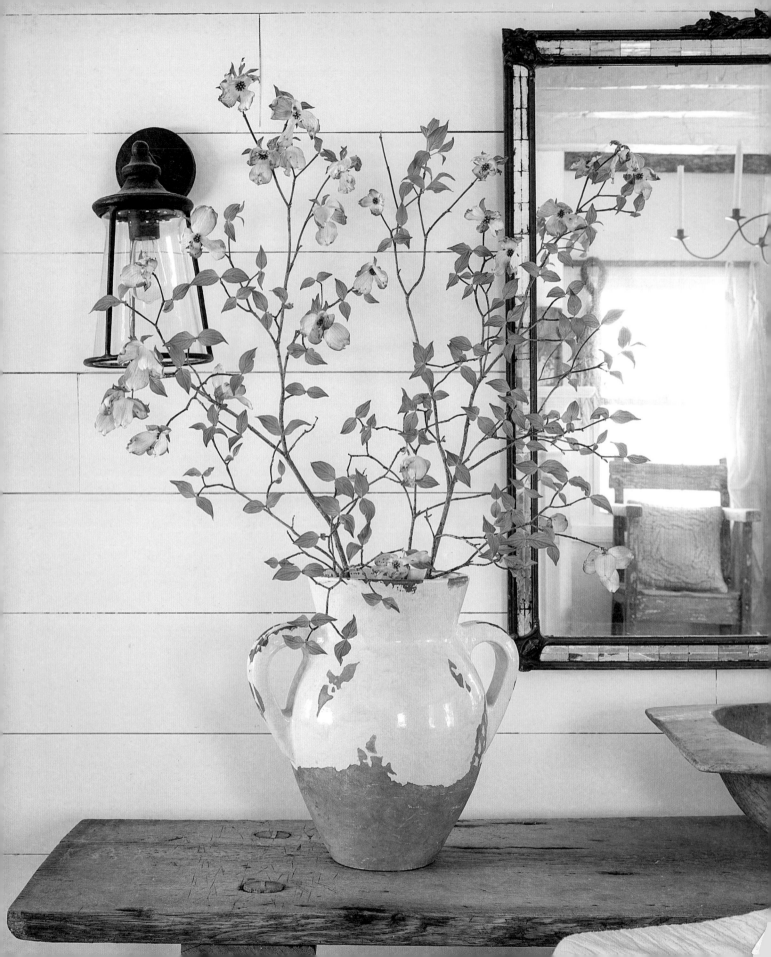